Contents

Contents

HOW TO
cheat
IN
Maya
2012

Tools and Techniques
for Character Animation

Eric Luhta
Kenny Roy

Amsterdam • Boston • Heidelberg • London • New York
Oxford • Paris • San Diego • San Francisco • Singapore
Sydney • Tokyo

Focal Press is an imprint of Elsevier

ELSEVIER

Focal
Press

Focal Press is an imprint of Elsevier
225 Wyman Street, Waltham, MA 02451, USA
The Boulevard, Langford Lane, Kidlington, Oxford, OX5 1GB, UK

Notices

Knowledge and best practice in this field are constantly changing. As new research and experience broaden our understanding, changes in research methods, professional practices, or medical treatment may become necessary.

Practitioners and researchers must always rely on their own experience and knowledge in evaluating and using any information, methods, compounds, or experiments described herein. In using such information or methods they should be mindful of their own safety and the safety of others, including parties for whom they have a professional responsibility.

To the fullest extent of the law, neither the Publisher nor the authors, contributors, or editors, assume any liability for any injury and/or damage to persons or property as a matter of products liability, negligence or otherwise, or from any use or operation of any methods, products, instructions, or ideas contained in the material herein.

Library of Congress Cataloging-in-Publication Data
Luhta, Eric.
 How to cheat in Maya 2012 : tools and techniques for character animation / Eric Luhta, Kenny Roy.
 p. cm.
 Includes index.
 ISBN 978-0-240-81698-2
 1. Computer animation--Computer programs. 2. Maya (Computer file) I. Roy, Kenny. II. Title.
 TR897.7.L844 2012
 006.6'96--dc23
 2011018490

British Library Cataloguing-in-Publication Data
A catalogue record for this book is available from the British Library.

For information on all Focal Press publications
visit our website at www.elsevierdirect.com

11 12 13 14 5 4 3 2 1

Printed in the United States of America

How to Cheat and Why

The truth about cheating

When we hear the word cheating, we usually think of something negative; deception, trickery or chicanery. However in this book, cheating is a good thing. If you've watched someone who's a master of something work at it, it can seem unreal, almost like they're...cheating! But really they just have experience and in-depth knowledge of how to achieve something. They know the most efficient way to do a task and make their tools work for them.

That's the goal of this book: to give you in-depth knowledge of animating with Maya so you can skip over the trial-and-error, constant web searches, and pouring through internet forums. Computer animation has its technical side, and just about all animators have struggled with it from time to time. There's nothing more frustrating than knowing what you want to do, but not being able to figure out how to do it. Our hope is that this book alleviates the often rocky start of learning to animate with a computer, and becomes your go-to guide as you grow as an artist of motion.

The Philosophy

Throughout our teaching experiences, one of the methods we found to be extremely effective in quickly transferring knowledge to someone else was isolation of a concept. While learning one thing at a time seems pretty obvious, we haven't met many animators who didn't learn by juggling a bunch of technical concepts in their student projects. While it's definitely possible to learn in trial-by-fire, it can make for some discouraging times. With this book we hope to avoid that approach, and give you a firm grasp on the technical concepts of animation. You can quickly absorb the techniques and then easily apply them to your own work, without trying to figure it out in the middle of a project. You will understand how to employ Maya's tools faster and get down to concentrating on making your animation look amazing, rather than why that prop keeps popping out of the character's hand.

As luck would have it, the *How to Cheat* series is perfect for this style of learning. Every page spread is geared toward a specific concept, which allows you to go through the book cover-to-cover, or skip around to the things you want to know about. The choice is yours.

Scene files and examples

Just about all of the topics have an accompanying scene file. Most of the topics enable you to follow along, employing the given technique in a prepared animation. Once you understand the technique and have practiced using it in an animation, it will be very easy to transfer it over to whatever you're working on. For chapters that are one long project, scenes are included in a progressive order, so you can jump in anywhere and learn what you want to learn without having to start at the beginning.

Having the scene files for an animation book should prove extremely useful, as you can take a look under the hood and examine the curves and see the movement for yourself. As great as books can be, you really have to see an animation in motion in the end.

Throughout the book, we use a character rig named "The Goon", constructed by Industrial Light & Magic Technical Artist, Sean Burgoon. It's a very fast, stable rig, and has just the right number of advanced features without getting too complicated.

The scene files are included for Maya 2012. If you're using an older version of Maya, just have "Ignore Version" checked in the File > Open options.

What you need to know

While this book starts at the beginning as far as animating is concerned, it does assume a basic knowledge of getting around Maya. You should be able to navigate the viewports (orbit, pan, dolly in 3D space), understand the interface, and be comfortable using the move, rotate, and scale tools. This information is covered in countless places on the web and in other materials, and we'd rather keep the book focused than rehash what's easily found elsewhere.

Going further

Visit the book's website at www.howtocheatinmaya.com. There you can find all the scene files for using the book, as well as previous material from the 2010 edition that couldn't be included here due to space. Happy animating!

Eric Luhta & Kenny Roy

Acknowledgments

Eric Luhta:

This book is dedicated to my beautiful wife Lesley, for her support, unending patience, and boundless love – I love you • Mom and Dad for always supporting and encouraging me • Sean Burgoon for so generously letting his Goon rig be a cornerstone of this book, and for sharing his knowledge in his interview • Kenny Roy for hitting the ground running and being such a great collaborator on this book • Kyle Mohr for many of the character poses and artwork found on the cover and throughout the book • Justin Barrett for creating the fantastic TweenMachine tool • Chris Williams and PJ Leffelman for their interviews and insight • Bobby Beck • Adam and Sarah • All the animators who have taught me so much, mentored me, and been a tremendous inspiration: Pete Nash, Bret Parker, Doug Dooley, Carlos Baena, Shawn Kelly, Amber Martorelli, Juan Carlos Navarro, Chris Williams, Ron Pucherelli • Dylan Brown for his incredible leadership, mentoring, vision, and artistry • The Animation team at Pixar Canada; I will never feel deserving of working with such amazing and inspiring people: Claus Pedersen, Jon Mead, Guillaume Belanger, Daniel Floyd, Kyle Mohr, Enrique Oliva Piferrer, Joel Beaudet, Michiel de Kraker, Stewart German – long live the mancave!

Kenny Roy:

I dedicate my portion of this book to my wife, who has always supported me and taken great leaps of faith with me through my animation career. It's been an interesting journey but you've always been there. Thank you, Tamaryn • Mom and Dad, you are the model of support, thanks for everything • Dan and Matt, it was really helpful to grow up with two ingenious, creative, awesome brothers • Eric Luhta, thanks for making me a part of this and being the easiest guy in the world to work with! • Focal Press, for being very supportive of your authors and believing in this book • Jenn Emberly, for putting up with my antics as an intern and teaching me so much • Hael Kobayashi, for giving me a chance and being a mentor through the years • Bobby Beck, for creating a home for me at AnimationMentor. You are leading the charge for all animators, keep it up • Cathleen Hylton for being such a great person and a joy to work with • And to all the members at www.Kennyroy.com, you challenge and inspire me, Rock On!

How to Use This Book

We've designed this book so that you can use it in the way that best serves your needs in learning to animate with Maya. You can start at the beginning and read it straight through if you like, as the chapters are ordered progressively. The first few talk about fundamental concepts: the principles of animation, workflow, and how animators think about the tools available in Maya. Then we start practicing some techniques in the context of animations already started for you, finally moving on to guiding you through doing projects in blocking, cycles, polishing, lip sync, and much more.

If you've been animating for awhile, but need some new tips or approaches to problems you've been having, you can simply go to any topic that interests you, and pick it up right there. Even the chapter-long projects include a series of progressive files so you don't need to start from the beginning. We've also completely updated the book for Maya 2012, and cover all the exciting new animation tools and how to use them.

Throughout the book we use the abbreviation of "f01" to mean frame 1, or whatever frame number we're talking about. Frame numbers are also included on every screenshot where they're relevant, to make things as clear as possible.

In the upper right corner of each cheat you'll see a globe icon whenever there are accompanying files, which is almost always. Underneath it the file names are listed for easy reference, and you can download all the scene files, rigs, and material from the previous edition from the book's website.

The projects are separated by chapter, and some of the projects also have Quicktime movies of the chapter's final result. Also included is the Goon rig in several versions (regular, ninja, and demon). For additional info and updates, be sure to check out the website:

www.howtocheatinmaya.com

Squash and *Stretch*

Anticipation

STAGING

straight ahead>>> PoSe to pOSE

Overlapping Action

f o l l o w t h r o u g h

S l o w In/Slow O u t

a r c s

s e c o n d a r y action

TIMING

EXaGGeRaTioN

SOLID drawing

a p p e a l

1 Animation Principles

THE PRINCIPLES OF ANIMATION, identified and perfected by the original Disney animators, guide us when we make technique and performance choices in our work. They are not rules, but rather guidelines for creating appealing animation that is engaging and fun to watch.

These seemingly simple concepts combine together to inform the most complex animation and performances on screen. Though some translation of these principles must occur for animators to utilize these concepts in Maya, this chapter offers a clear explanation of them and shows you how you can begin applying them in your own work.

Squash and Stretch

L AUDED AS THE MOST IMPORTANT PRINCIPLE, *squash and stretch* gives characters and objects a sense of flexibility and life. Also, this principle dictates that as characters and objects move and deform, their volume generally stays the same.

Some of squash and stretch can be dictated by the object actually smooshing into something, as in our example. The ball we are going to animate the squash and stretch on needs this principle added not only to give the sense of the material the ball is made from (soft rubber), but to give it a little bit of life.

With characters, squash and stretch can mean many different things. It can be combined with anticipation to make a character "wind-up" for an action in a visually interesting way. One example would be as a character prepares to move, he may squash his spine, making his figure bulge out. Then as he springs into motion, his form elongates and stretches thin to retain the same volume. Whenever possible, use squash and stretch on your characters to give a sense of strain (a character reaching for something high overhead), or to give a sense of fear (a character squashes into a little ball in a corner to avoid being seen by a predator).

Start looking for squash and stretch in professional animation and in life and you'll see quickly how much this simple principle adds to the illusion of life we give objects and characters.

1 Open squash_Stretch_start.ma. We have an animated bouncing ball with the squash control keyed at 0 on f01 and f16. Hit play on the timeline and see how the ball seems neither alive, nor like it's made from rubber. This lifeless plastic ball is in need of some squash and stretch!

f09

4 At f09, the momentum continues downward through the ball, making it squash even more into the ground. Set the squash to -0.4 and key the control.

f08

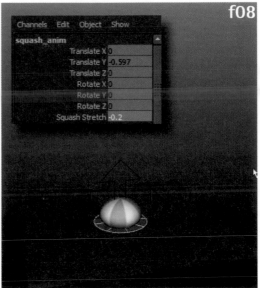

f08

squStretch_start.ma
squStretch_finish.ma

2 Go to frame 8, and check out this dead ball! When it hits the ground, we expect a ball made from rubber to react! It needs to squash, so select the middle squash_anim control and translate it down in Y to the base. The location of this control determines where the ball squashes from.

3 Adjust the Squash Stretch amount in the channel box and key the entire control. The ball contacts for 2 frames, so this frame will be the start of it squashing, about -0.2 or so. Also notice that as the ball squashes down in Y, it bulges out in X and Z, retaining its volume.

f07

f11

5 Go back to frame 7. As the ball falls, it would stretch out from the air resistance and the anticipation of hitting the ground. Translate the control back to the middle of the ball (Y is 0) so it stretches from its center, adjust the stretch control, and set a key.

6 At f11, center the squash control in Y, stretch the ball slightly and key it. Since the first and last frames are set to 0, the ball returns to its shape at the top of the bounce. Play back the animation with the controls turned off and watch this principle shine.

HOT TIP

Squash and stretch isn't only about physically squashing and stretching in a cartoony manner. Also think about squash and stretch in the broader sense of being the contrast between compressed/ contained and outstretched/ extended.

5

Anticipation

ANTICIPATION IS THE PRACTICE of moving a character in a certain way to prepare the character and the audience for the action. Most often, anticipation means moving the character a small amount in the opposite direction of the main action. Since a lot of animation is very physical, many times anticipation is a necessary part of getting the correct physical performance out of the character. For instance, a character jumping must bend his knees first. A pitcher must bring his arm back before he throws the ball. This natural motion that occurs in everyday life is what makes anticipation as an animation principle so effective. We are very accustomed as humans to tracking fast-moving objects by taking a cue from its anticipation, and then looking ahead of the object in the opposite direction. So as animators we must take advantage of this hard-wired trait of humans and use it to our advantage. We can make it so that the audience is always looking at the part of the screen that we want them to, by activating the visual cue of anticipation.

Anticipation also serves a purpose in fine-tuning your performance choices. Disney animator and animation legend Eric Goldberg is known for relating anticipation directly with thought itself. This makes perfect sense; if we see a character really "wind-up" for an action, it is clear to us that the character has planned the action well in advance, and is thinking about how to move. On the other hand, if a character moves instantaneously and without warning the motion comes across as unplanned. Think of the difference between the apparent thought process of Popeye swinging his arm back to punch an unsuspecting Brutus, and Brutus's head when the fist hits him on the back of the head. Popeye was planning to wallop the big bully, but Brutus was not thinking at all of the fist about to hit him! So as you are working, pay close attention to how much anticipation you are using in your animation. It may just mean the difference between a thinking, planning, and intelligent character, and a character simply reacting to the world around him.

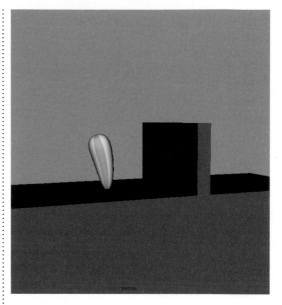

1 Open anticipation.ma. In this scene, a bouncing ball looks at a wall, and then deftly hops over. Play it a few times and see if you can spot the anticipation before the jump.

4 Now play with the handle itself! Drag it way out towards the left and playback the animation. See what a different impression you get as to the thought behind the jump? Subtle changes in anticipation can have incredible results.

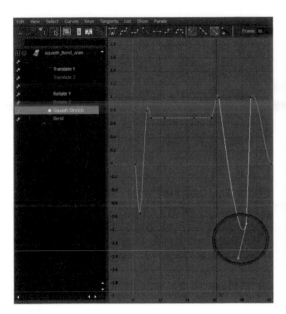

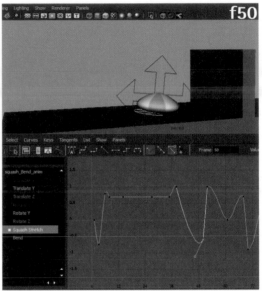

anticipation.ma

2 If you select the squash_Bend_anim control on the ball, you will see there is a keyframe on the Squash Stretch control at f50 with an unlocked tangent. This is the frame of anticipation. We are going to play with this anticipation and see what looks best.

3 Select the squash_Bend_anim control, and open the Graph Editor. See that key frame with the unlocked tangent handles? Try moving that key up and down and finding a good size of squash for this anticipation. Watch the animation over and over again to see what looks best. Remember, it's up to you!

HOT TIP

Play your animation at speed! We know that timing is vitally important in animation. You get so much more information playing your animation at speed than you do if you just scroll through the timeline.

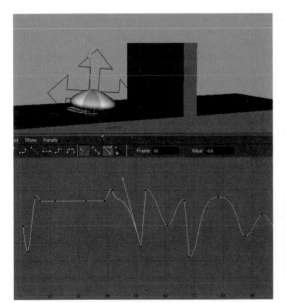

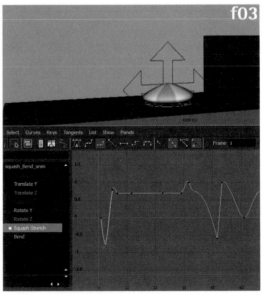

5 Or does this look better? Remember, if you keep the number of keyframes you use to a minimum, you can spend more time making adjustments and less time wrestling with technical trouble. What new impression does this anticipation give you? What is the ball **thinking**?

6 At f03 is another little anticipation that I sneaked in. Play with the size and timing of this one as well, and start training your eye to hone in on the most powerful and engaging performance.

Staging

STAGING IS A FUNDAMENTAL that encompasses a mass of artistic sensibilities. Staging involves framing the camera in a way to best capture the action. It involves making sure your animation has been planned to best communicate the motion, the character arc, the story. Simply put, staging is how you create the scene.

Ideally staging starts with your planning phase. Thumbnailing your poses is the best way to make strong pose choices at the start of a shot. If you are not a strong drawer, then perhaps you rely more on photo or video reference to give you cues to begin your work. At this very early phase, staging means you are thinking about how your posing and the layout of the scene is going to clearly show the motion.

As you begin your scene, staging becomes more complex. How are you going to maintain the high level of communication throughout the life of the shot? Will you be able to hit all of the poses that you'd like, or are the poses going to have to be changed to work when the character is in motion? Staging means that you are thinking about the entire action at this point. Adjusting the camera, making tweaks to the layout, and finding just the right balance in the composition all improve your staging of the scene. When you are finished blocking, generally the major staging decisions are decided. This does not mean that staging is over!

As you finish the animation, there are still staging considerations you must be aware of. Where is the audience's eye going to be looking at every moment of the shot? If you've animated the scene correctly, you have a very good idea of what the audience should be paying attention to at every second. As your shot is finished and moves through the rest of the pipeline, other decisions that hone in audience's focus are going to come into play: lighting, effects, and editing.

As animators, our staging choices have far-reaching impact on the success of a shot in communicating an idea. We'll practice these staging concepts by repositioning a bouncing ball animation, the camera, and some lights to find the greatest impact.

1 Open staging_start.ma, and set one of your panels to look through "renderCam". Yikes. This scene has a lot of staging problems. The camera is in a position where it cannot see any of the action, the ball has been positioned very oddly, and the light is casting a shadow on the entire main action. Let's make some adjustments.

2 Rotate, pan and zoom the camera around until you've found an angle that shows off the animation nicely when you scrub through the timeline. This is a nice angle for me.

staging_start.ma
staging_finish.ma

HOT TIP

It's easy to forget that staging is more than just the camera angle. If you're working on a production, you may not have any control over the camera angle chosen for a shot. If this is the case, you must design your staging within the camera you've been given. This might entail "cheating" poses so they look their best in a particular camera.

3 Let's adjust the position of the animated ball to make the action read clearer, shall we? Grab the "all" group in the Outliner, and scrub through the animation. See how the ball is pushed far towards the edge of the set, and hits the wall on frame 65? Let's reposition it to be a little more centered, and to not hit the set on its path.

Staging (cont'd)

4 Much better. I moved the group back to the world origin, and the animation is working much better to camera.

6 In a perspective panel, press the 7 key to enable the lighting, and make sure Show > Lights is enabled in the viewport menu. Select the light and transform and rotate it until it gives a nice ¾ lighting angle. The action should be lit so that we get a fully lit view of the scene, but also so that the shadows are angled so they show the detail and depth of the set.

5 Hit the render button to see how the lights are positioned. Uh oh, the main action is happening in deep shadow!

7 Now click render when you have repositioned your light. Beautiful!

HOT TIP

If you select a spotlight, and then go to the "Panels" menu in any panel and choose "Look Through Selected", it will create a temporary camera view that matches the view as seen from that spotlight. Many Maya users find using Maya's in-panel camera moving tools to position lights is a fast and easy way to stage the scene. Maya even gives you an in-panel preview of the light's Cone Angle!

Straight Ahead/Pose to Pose

THIS FUNDAMENTAL DESCRIBES the two basic approaches to block in a piece of animation. Straight ahead means that an animator creates the base animation by posing the animation in a frame, then moving forward one or more frames and posing again. This approach is akin to stop-motion animation, in which you have to pose every one or two frames because the camera needs to capture that frame on film before moving forward. Pose to pose means that you create the key poses, and then essentially time the rest of the animation by inserting blank or "hold-poses" in between your key poses. This is akin to a non-linear approach in which you can test different timings of a shot by simply sliding poses around on the time slider. Both approaches have their advantages and disadvantages.

Straight ahead animating should be used when the action is very mechanical or physical. This is because the ability to perceive the motion as you frame through the animation in slow motion is far greater than trying to imagine what pose the highly mechanical or physical movement is going to hit. Let's take an overlapping antenna, for instance. With this kind of highly physical action it would be impossible to imagine where the antenna is going to be without framing through the animation and adjusting the pose as you go. This is what we'll do to practice this concept.

Pose to pose animating should be used for creating character performances. Unlike highly physical actions, the key poses a character hits are going to tell the story. So in order to be sure that you arrive at these golden moments, you should pose them out and retime them as necessary to make the motion work. We bias our work in performance animation to feature the pose because, without a strong sense of the character's body language, the emotional story gets lost. We're going to create a pose and retime it using Maya's Dope Sheet.

1 Open straightAhead_start.ma. This bouncing ball looks familiar, but now it has an antenna on top. Let's practice animating straight ahead and make the antenna flop back and forth.

4 When the ball hits the ground at f08, the antenna will not react yet because the momentum needs time to travel up through the ball. Key the antenna straight up.

f01

f04

straightAhead_start.
ma
straightAhead_finish.
ma

2 On f01, the ball is at the top of its arc, so the antenna will be travelling upwards, trying to catch up. Select all the antenna controls, and key them upwards.

3 Go to f04. The ball has started falling and so the antenna will continue to move upwards as it catches up with where the ball was a few frames earlier. Keep an eye on the squash and stretch for a cue. Key the antenna a bit more up.

f10

f15

5 Now at f10, the ball is traveling upwards again, but the antenna will still be moving down from the impact of the ball hitting the ground a couple frames earlier. Key the antenna bending downward.

6 Finish the scene by copying f1 to the last frame (f15) as you do with all cycles.

13

Pose to Pose (cont'd)

7 Open pose_to_pose_start.ma. This character is waving to someone he thinks he recognizes, but then he realizes he doesn't know them! He retracts into an embarrassed pose, and looks away.

8 Let's create his embarrassed pose on frame 72 and then adjust the timing using the Dope Sheet. Select all of the controls in the body and hit S on frame 72. Pose Goon with his face and body exhibiting embarrassment.

10 Frame 72 is too soon for this final pose. Select the block on frame 72 in the Dope Sheet and middle-mouse drag it to a later frame, whatever looks good to you! I chose 100 and I like how Goon slinks into this embarrassed pose.

11 Goon now needs a breakdown to define the arc of this movement and make it less linear. Rotate the camera to his profile. See how the arm comes very close to his face? It is common to need to add breakdowns when you retime animation created pose to pose.

pose_to_pose_start.ma
pose_to_pose_finish.
ma

9 Open the Dope Sheet and find the Hierarchy/Below button and click it. Now if you choose Goon's root_CTRL in the panel you will notice all of the key frames load into the Dope Sheet. The Dope Sheet is a good tool for broad retiming of a scene.

HOT TIP

You can get a nice settle in a pose by selecting all of your controls, middle-mouse-drag and copy a pose from a few frames before your last key pose to a frame 6 to 8 frames later. This method needs adjustment to make it look perfect, but gives you a very quick and easy settle to start working from.

12 On frame 88, grab Goon's Root control and move it forward just a little. Also add a little bit of bend throughout the spine, and lastly move his hand forward so that it takes a nice arced path from the pose above his head to the pose near his face.

Overlapping Action/Follow-through

OVERLAP AND FOLLOW-THROUGH are the two most intuitive fundamentals in animation. Both basically deal with the principle that it takes energy to move objects and also to slow them down. Overlap is what we call it when an object "lags" behind the main action. Follow-through is what we call it when an action overshoots or goes past the end pose.

Overlap instills a fluidity to character animation. When added to your character's gestures, overlap makes the animation feel like the character has a natural limber quality to it. When a character swings his arm, the bending of the wrist creates a nice organic quality. Natural rise and fall in the spine in a walk cycle makes it feel calm, while an extreme amount of overlap in the spine in a walk can make the character look depressed and sad. In this way we can see overlap has a very major impact on the performance of a character.

With follow-through, the main thing you can show is a sense of weight with your character. The heavier the weight, the more energy it will take to stop the character. Use follow-through to emphasize this in your characters.

We've already had some practice with overlap in the last section, but let's get some more practice with a simple animation of Goon landing from a jump.

1 Open overlap_start.ma. Playing back the animation, you can see the Goon is landing on the ground from a jump. See, though, how his spine looks very stiff and unnatural. This scene needs some overlap and follow-through.

4 Don't stand him up too fast. Try a few different timings and sizes of pose at the end here as well. You'll notice that the weight of the character changes drastically with only a few frames of difference!

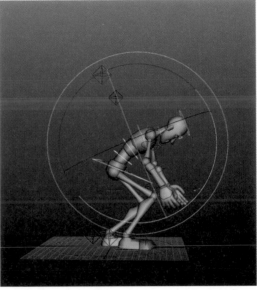

overlap_start.ma
overlap_finish.ma

2 Select the controls in Goon's spine and set a key on frame 1. Just like the antenna that you animated in the last section, we are going to have his spine "lag behind," or overlap as he falls. As Goon falls, set a key on the spine, having him straighten up a bit. I like this pose.

3 When he hits the ground, we need the action to follow through. This means bending Goon back over as he lands. Try a few different choices of pose and a few different timings as well.

HOT TIP

Simply offsetting the curves is a common trick, but it will rarely get you finished overlap and follow-through. You will almost always need to diligently polish the curves to get "final worthy" results!

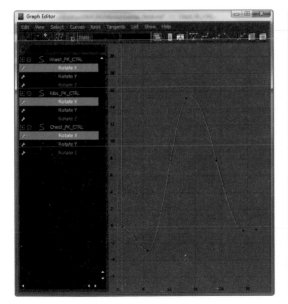

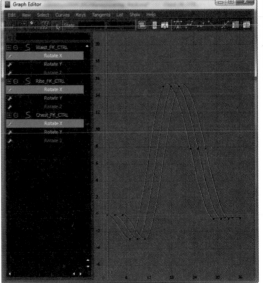

5 Let's also offset the overlap to get even more natural follow-through in this action. Select the controls of the spine, and open the Graph Editor. Isolate just the Rotate X channels; it should look like this.

6 Offset the ribs by moving them two frames forward, and offset the chest by moving them four frames forward. Now play the animation back, and you have even nicer, fluid overlap in the spine!

17

Slow In/Slow Out

SLOW IN AND SLOW OUT, also called ease in and ease out, refer to the spacing of the keys when an action comes to a stop, changes direction, or a character transitions from pose to pose. This principle means to animators that we typically decelerate objects as they come to a stop rather than have them come to a dead halt instantly ("slowing in" to the pose). It also means we should gradually accelerate objects as they begin to move and not have them instantly be at full speed ("slowing out" of a pose). In the Graph Editor of Maya, this principle is simply illustrated by flat tangents. It is easy to see how an object slows in to a change of direction in the graph editor when we look at the curves of a bouncing ball. As the ball arrives at the top of its arc, and also the flat tangent of the Y curve, it decelerates evenly before changing direction and accelerating again.

This is not a blanket rule, however! Not every action should slow in and slow out! In the bouncing ball animation, when the ball hits the ground there will be no slow in or slow out. Instead, we animate those tangents with a very sharp direction change as a result of the ball hitting the solid ground and having to change directions instantly. Consider also an animation of a character running. The feet are going to be really pounding the ground, meaning the legs are going to be still accelerating as the foot hits the ground. "Flatting" all of your tangents in the Graph Editor is a common mistake, as is having flat tangents be your default tangent type. True understanding of slow in and slow out means understanding which situations should have nice eased poses, and which ones should have stark direction changes. We are going to take advantage of Maya 2012's new editable motion trails to practice when to use slow in and slow out. Also check out the Splines chapter for more details on slow in and slow out.

1 Open slow_in_start.ma This bouncing ball animation has a problem. Play the animation back. See how linearly the ball changes direction at the top of the arc? We have a Slow In to the pose of the ball at the top, where nothing would make it physically slow down. Let's fix that with the editable motion trails.

4 Select the bead furthest from the keyframe and drag it away from the keyframe. The arc smoothes out, and also the interpolation gets far less linear. Frame through the keys and see how the ball travels more distance per key than before. Undo and compare to before if you like.

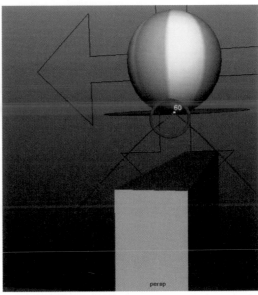

slow_in_start.ma
slow_in_finish.ma

2 Select the ball_anim control and create the editable motion trail by clicking Animate>Create Editable Motion Trail. (Motion Trails are discussed in-depth in the Techniques chapter.)

3 Select the f60 keyframe on the motion trail, then right click on the motion trail and select "Timing Beads In". You can now see the frame bias, or how much Maya will slow in to the keyframe when interpolating the in-betweens. In this instance, the In-Beads are squished right near the keyframe, creating way too much slow in!

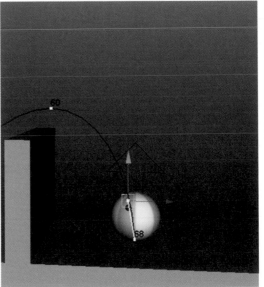

5 We also want the impact on the ground to be stronger, so let's create a "fast in" (the opposite of slow in) on the impact. Select the key at f68 on the motion trail that is on the right side of the wall, on the ground. Right click and check "Show In Tangent".

6 Select the tangent handle that is displayed, and with the move tool **W** move it to the right in the X axis until it is almost in line with the arc of the motion trail itself. Play the animation back and see the result. With character animation, VERY subtle changes make all the difference!

HOT TIP

You can view either the Tangents, Beads, or the Keyframe itself at a time, but never all at once. Maya does this to reduce scene overhead and to keep working with editable motion trails simple and straightforward. If you ever get confused, you can always delete and recreate the editable motion trail from the Outliner – doing so does not delete the animation itself.

19

Arcs

EARLY ANIMATORS OBSERVED the interesting fact that most natural actions follow an arched path. They then practiced applying this trait to their animation to create more appealing movement. This came to be known as the principle of *arcs*. To avoid giving mechanical, robotic performances, check your animation constantly by tracking objects on screen and make sure they do not follow linear paths. Remember to check your arcs from all angles first, but finally and most importantly from your camera view; this is the view the audience will see!

Another very common mistake is to only track arcs on major body controls. As animators, we tend to bias our attention to the controls that give us the gross pose of a character: Root, Hand IK, Foot IK, and Head. All too often, beginning animators will then try to track the arcs of their animation, but because of all the attention and time spent using only four or five main controls, will only look to these areas for smoothing. This can lead to a visual discontinuity within the animation of the body. Instead, you have to look at the entire body, and determine the forces in the body. A fantastic resource for learning how to determine the force in a pose is the book *Force: Dynamic Life Drawing for Animators*, published by Focal Press. Investigate how the entire pose itself has rapidly changing, dynamic shapes, all of which need to move naturally and on arcs.

For our purposes, we are going to adjust the arcs on a full-body turn animation. Our character is looking towards screen left, when he suddenly turns and looks towards screen right. There is no breakdown key in the middle of turn, meaning there is only a very drab, linear interpolation happening between the left and right poses. To fix this, we are going to add a breakdown and improve the arcs of the turn.

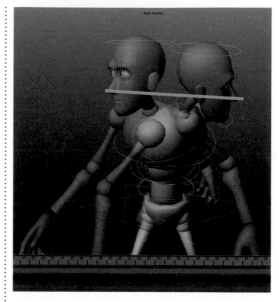

1 Yuck! This body turn is unnatural and mechanical. See how linearly the body and head turns from left to right? We are going to fix this immediately by adding a breakdown in the middle of the turn.

4 Don't forget the head usually leads the body in a turn! I like to have the head rotated slightly in the Z axis so that the chin is tilted on the head turn. This gives the head a little bit of natural motion.

2 Select the locator on the tip of Goon's nose named noseTrack_Loc. Then go to Animate > Create Editable Motion Trail. We will not be editing the motion trail in this scene, just using it for visual feedback. See how straight the head turn is?

3 Let's add the breakdown. Select the Center_Root_FK_ CTRL, Waist_FK_CTRL, Ribs_FK_CTRL, Chest_FK_CTRL, Neck_FK_CTRL, and Head_FK_CTRL. On Frame 21, create a pose in which Goon is bending a little bit over, making the motion trail bend into an arc.

arcs_start.ma
arcs_finish.ma

5 Now select the Root_CTRL and create another Editable Motion Trail. The body movement needs some arc smoothing as well!

6 On f21 and 28, create some breakdown keys by translating the Root_CTRL downwards and make a nice, arced motion. Motion trails are powerful tools, updated in Maya 2012 to be directly editable in panel. Track the arcs throughout the rest of the body to get nice smooth motion.

Secondary Action

THIS PRINCIPLE REALLY GIVES a scene some deep subtext. Secondary action is any action that is not the primary action in a scene. A character sharpening a pencil as he complains about his boss would be secondary action; the primary action has to do with the poses and body language involved in speaking to the boss. A character running his hand through his hair as he turns away from the mirror, giving himself a wink, would be good secondary. The main action in this example is the turn, but the hand through the hair adds a nice level of meaning to the whole scene.

The wonderful thing about Secondary Action is that there really is no amount that is too much. Especially with humans; we're constantly multitasking, constantly occupying ourselves with more than one thing at a time. The animation can, of course, become too busy. The fact is there is a balance, but for the most part your scenes can always use an extra level of animation and therefore subtext.

The way master animators truly utilize secondary action is by "coloring" the action to suit the subtext of a scene. This means changing the secondary action in pose, timing, spacing, etc. to distinguish it from a normal, "vanilla" performance of the same action. Let's look at an example. Let's imagine a scene where a mother is ironing clothes while looking out a window. Her husband walks into the room and tells her that their son has been killed in war. She is facing away from him, and still continues to iron. But her body language changes. Her hands start shaking. She looks like she's about to faint as her eyes well up with tears. The adjustments to the action of ironing clothes (the secondary action in this scene) is what we call coloring the action. Now imagine the same set up, with the wife looking out the window and the husband entering the room. This time, he enters and simply asks her how her day was, but this time, she found out that morning that she is pregnant. She answers him "Fine," and smiles. How would you "color" the secondary action in this scene? When she hears the husband enter the room, would she excitedly speed up her action? Maybe she got some baby clothes out of a box and that's why she's ironing. She'd then pause and look at the clothes as she describes her day to her husband. Suddenly, through secondary action, animators have access to an enormous amount of subtlety in a scene. I like to call Secondary Action the "Window to Subtext".

We are going to do a simple trick with Animation Layers to practice using secondary action to show subtlety in a scene. In our scene, Goon is sitting at the library, tapping his finger, very bored. Then someone who he really likes walks by, and his eyes follow them. By animating the weight of the animation layer with the finger on it, we are going to "color" that action; basically, he forgets to tap his finger while he is captivated by this person walking by. Secondary action can be so subtle, that sometimes just STOPPING a secondary action is enough to completely color it!

secondary_start.ma
secondary_finish.ma

1 Open secondary.ma. Playback the animation, and you'll see Goon is completely bored and tapping his finger at the desk. Then a person who he likes walks by and he is captivated.

HOT TIP

Check out
Chapter 11 for
an in-depth look
at Animation
Layers and how
to use them.

2 In the bottom half of the Channel Box your Layers tabs are all visible. When you select the layer tab labeled "Anim", you'll see that there is a "BaseAnimation" (with the entire body pose animated inside) and a "fingerTap" layer.

Secondary Action (cont'd)

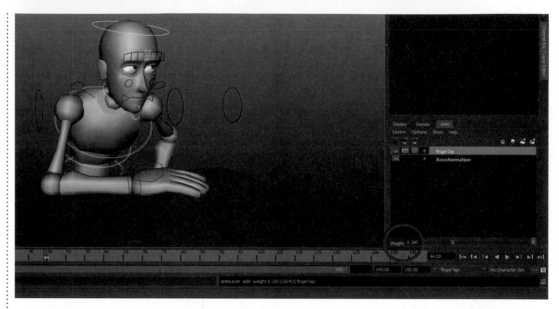

3 Maya 2012 has powerful tools for blending animation together. In fact, you can blend dozens of layers of animation together if you please; the only limit is what you can keep track of. Slide the Weight slider up and down and see how the finger tapping is affected.

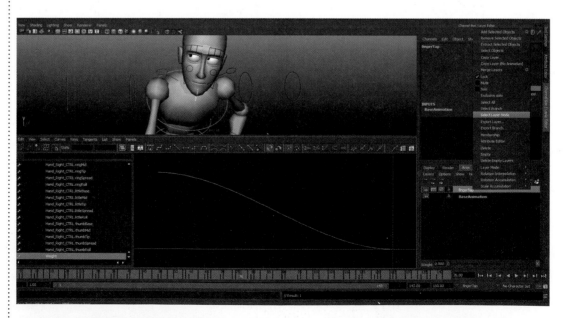

5 Advance 10-20 frames in the animation and slide the weight of the fingerTap anim layer down to 0. Goon is now so transfixed on this person that he's completely dropped his secondary action, a very powerful way of "coloring" it! To see your weight curve in the graph editor, right click on the anim layer and click on "Select Layer Node".

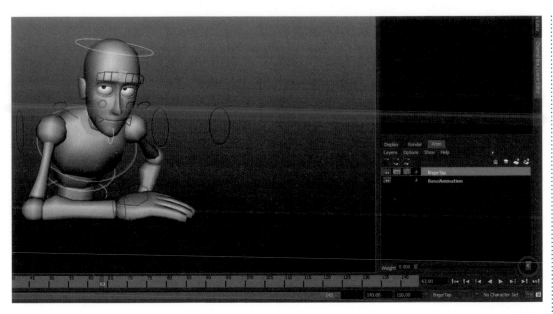

4 Not only can you blend animation, but you can key the weight! Find a good frame when you are sure that Goon has recognized the person walking by. Set a key on the weight of anim layer "fingerTap" by hitting the "K" (set key) button next to the weight slider.

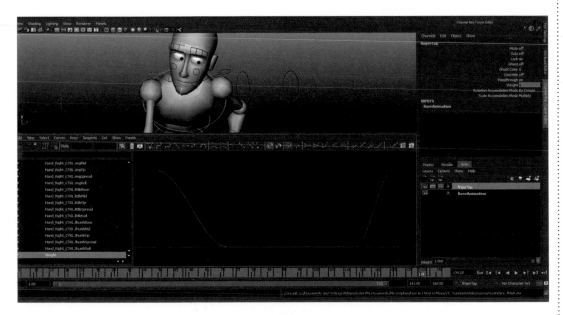

6 Experiment! Play around with the secondary action and see if you can tell different stories by animating the weight of the layer around. Maybe bring it back to 1 at the end of the scene and observe the resulting change in the subtext of the scene!

HOT TIP

If you are unsure about a secondary action, sometimes it can be better to key the main action on the master animation layer, and only when it is looking solid, key the secondary action on a new anim layer. You can always turn off the layer if the secondary doesn't work out, without fear of destroying your main action.

1 Animation Principles

Timing

TIMING IS LESS A FUNDAMENTAL than it is the very foundation of the art of animation. Animation is, of course, just a series of still images that flash by fast enough to create the illusion of motion. Our task is to use timing not just to accurately portray motion in realistic scenes, but to use timing as a method to convey meaning in a scene.

In character animation the main goal is to get your audience to emote with a character. As they succeed, the audience celebrates; when they fail, the audience feels their loss. As animators we can get so caught up in the physics and mechanics of the motions that we create that sometimes we forget that the timing of a scene can be improved to tell a deeper story. The pauses in between actions can have more powerful messages than the actions themselves.

In the last section, we adjusted the secondary action of the character to show that he is so captivated in that moment that his hand just naturally stops moving. It has a subtle, but powerful effect on the performance of the character. Although a full animation curriculum on timing is outside the purview of this book, we can definitely experiment with this scene to give ourselves some insight into the powerful effect subtle timing changes can have on a performance. We'll use the keyframe editing tools in the timeline and Graph Editor to make these adjustments.

1 Open timing_start.ma. The timeline of our secondary action exercise has been extended on the end to allow us to make some adjustments here. Pay particularly close attention to the performance at the end, where Goon looks back towards the desk.

4 Use the center double-arrow icon to move the selected keys forward 30 or so frames. We aren't going to choose a specific timing, because we want to observe the subtle differences that timing change. What does this new timing tell you? To me, the longer he pauses in this in-between pose, the more it looks like he's THINKING about what he saw.

timing_start.ma
timing_finish.ma

2 Let's extend the time that Goon spends looking towards the desk halfway between his gaze towards screen left and the final pose back towards screen right. Select all of Goon's controls. Don't forget to select Goon's eyeTarget_CTRL too. Position the cursor over f127 on the timeline, then *Shift* LMB and drag the cursor all the way past f150.

3 This red box is your selection on the timeline. The left and right arrows scale your keys in either direction. The middle double arrow icon moves the selection through the timeline. Drag each one of the arrows around and get familiar with their use, then Undo so that you are back to the original timing.

5 Let's play with the end too. Experimenting is fun! Select all of Goon's controls again and open the Graph Editor. Select the last two poses by dragging a selection box around all of the keys. Now scale the last two poses' keys by hitting *R* and then *Shift* MMB Drag to the right with cursor placed near frame 150. Release the mouse button when the last key is near frame 180.

6 Play the animation and it not only looks like he's thinking more, this slower transition to the end pose feels like he's a little melancholy. However, whenever you scale keys in the Graph Editor, your keys usually end up placed in between frames. Select all of the keys in the Graph Editor and click on Edit>Snap. Now the keys are back on integer frames.

Exaggeration

EXAGGERATION IS ONE OF THE SIMPLEST, yet most misunderstood principles of animation. Why? For decades novice animators have tried to blindly exaggerate their animation to try to recreate the amazing cartoony styles of the animators of yore. However, exaggeration doesn't necessarily mean better animation, or even more cartoony. Exaggeration must be used with a keen eye for the effect you are trying to achieve.

Find the core idea in your scene and figure out the best way to exaggerate the message. If you are animating a character getting pricked on the butt with a pin, then you are going to exaggerate the timing and spacing of him shooting into the air. If you are animating a character that gets scared by a spider, you might exaggerate the squash and stretch in his body by having his legs run away from his torso, stretching out his spine! In both of these cases we choose the main idea and exaggerate only where we need to in order to strengthen the message. Both scenes would look way over-complicated if we had exaggerated the posing, timing, spacing, composition, weight, anticipation, etc.

Your animation scenes in Maya should be as lean as possible. To illustrate how easy it can be to exaggerate a fundamental, we're going to take a finished walk-cycle and adjust the overlap in the spine using the Graph Editor. Your workflow must create animation that has minimal keys, therefore making it easy to change the animation later on. For our purposes, the overlap in the spine on a walk cycle is a great fundamental to experiment with, because it has such a large impact on the performance.

1 Open exaggeration.ma. Goon is walking a straight-ahead, "vanilla" walk with little performance to it. Select the controls in the spine and open the Graph Editor.

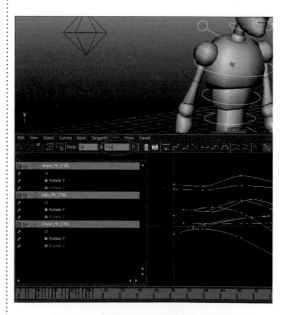

4 You can also perform the scale by using some of the math functionality in Maya. Select the controls in the spine and then in the Graph Editor value box (the right box of the two) type in "*=2". The * symbol means to multiply the values and the "=2" tells Maya how much to multiply by.

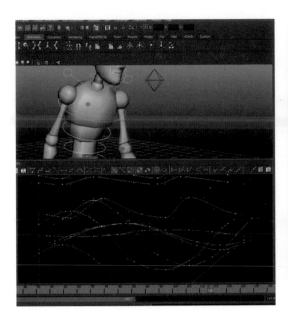

exaggeration_start.ma
exaggeration_finish.
ma

HOT TIP

To make
reselecting the
same channels
easier, select a
channel (Rotate
X for example)
and in the
Graph Editor,
go to the menu
and click Show
> Show Selected
Type(s). You'll
see that only
the selected
channel shows
on the left side
of the Graph
Editor now for
all selected
objects. This is
a good cheat
to use when
adjusting
a single
fundamental
like we did
on the spine.
Restore the
other channels
by clicking Show
> Show All. The
Graph Editor is
covered in depth
in Chapter 4.

2 As you can see, as of right now these curves are not
exaggerated at all. Hit **R** to use the Scale Tool in the
graph editor. Now select the curves in the spine and Middle
Mouse Drag up and down to scale these keys. Notice
that the point on the graph where your mouse starts the
dragging motion is considered the center of the scale.

3 Scaling keys up and down in the Graph Editor scales
their values, whereas scaling left and right scales
timing. Without the rest of the body's controls selected,
scaling the timing of the spine won't produce good results.

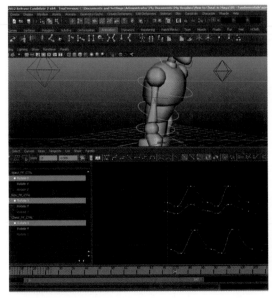

5 Playing back the animation now shows more
exaggeration in his spine, but it needs some tweaking.
Select just the Rotate X curves in the graph editor and then
hit **W** to use the move tool. MM drag them upwards to get
the spine to overlap more forward over his center of gravity.

6 Experiment! The best thing you can do to grow your list
of cheats is to find some more on your own. Use the
graph editor to exaggerate other aspects of the walk, like the
arms, or the Translate Y in the Center_Root_FK_CTRL to get
some more extreme up and down motion as Goon steps.

Solid Drawing

AT FIRST GLANCE, *solid drawing* has little to do with CG animation in Maya. What does drawing have to do with animating on the computer? On the contrary, this is an extremely important fundamental to remember when creating animation on the computer. Why? As CG animators, it is very easy to relax our artistic sensibilities and let Maya do all of the work. However, the moment you forget the art of pose, perspective, form, volume, and force, you will quickly see your animation dissolve into unappealing mush.

Solid drawing is a fundamental that persists from the hand-drawn days of cel animation. What it basically imparts is a dedication to the figure-drawing principles that the master animators all adhered to. When you started your drawing, you always had to begin with the same simple construction of the character: simple shapes combined with clean, meaningful lines, taking into consideration the line of action, the force of the pose, and the weight of the character. Perhaps most of all, perspective and a sense of the character's volume had to be extremely consistent. In other words, all 24 drawings per second of animation had to look like the same character.

In CG, we have a lot of help from Maya to achieve Solid Drawing, but we should pay close attention to make sure we aren't being lazy. Since we are working with 3D models, for the most part Maya takes care of staying "on model." Even still, you have to be careful not to pose your character in such a way that the body or face is distorted so much that it doesn't look like the same character. Most of the time this happens when an animator hasn't thoroughly tested the rig, and is using controls to create movement that were not intended for that purpose. In CG we can indeed go off model, and it is your job to avoid this.

We are going to fix a piece of animation that has some very bad counter-animated controls, and is also experiencing some skin-weight issues. Speaking strictly as an animator, you don't have to be as concerned with technical issues, but remember that CG animation is often a team effort, and solid drawing is the result of everyone working together.

1 Open solid_drawing_start.ma. This walk cycle looks a little off. The spine controls have been animated against each other. As a general guide, body sections that work together should move in harmony with each other. Going against the natural design of how something moves, even if intentional, can create off-model looking poses.

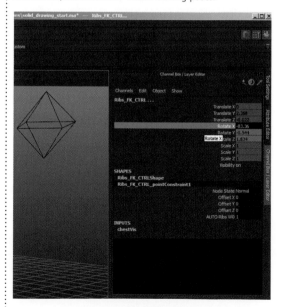

4 Delete the Rotate X curves. Notice that there are still values in Rotate X when you switch to the Channel Box. This is because Maya leaves a channel's value at the current frame whenever you delete ALL animation on a channel. Select the Rotate X channel and type in 0 and hit enter.

solid_drawing_start.
ma
solid_drawing_finish.
ma

HOT TIP

Instead of deleting the curves themselves in the Graph Editor, we can delete animation from a channel by right clicking on that channel in the Channel Box, and clicking "Delete Selected." This will delete the animation on the channel, not the channel or attribute itself. Remember, the channel's value will remain at the current frame value whenever you delete all animation.

2 A good way to see your controls is to use the X-Ray rendering in panel, either in the Shading menu or with the X-Ray button. This mode makes all of the geometry semi-transparent so you can see joints, edges, and curves very easily.

3 Select "Waist_FK_CTRL" and "Ribs_FK_CTRL" and open up the Graph Editor. As you can see, they have been posed in such a way that they are rotated against each other.

5 Now that the controls have been zeroed and the counter-animation removed, Goon is still leaving some vertices behind as he walks away. Select his chest geometry and switch to the Animation menu set. Click on Skin > Edit Smooth Skin > Normalize Weights.

6 Now the model should be behaving! Don't worry what that did, as it's a rigging issue that most animators won't have to deal with. The point is, with CG animation, artistic choices, like posing, and some technical choices, like skin weights, can have an impact on solid drawing.

Appeal

I T COULD BE SAID that all of the fundamentals combine to make *appeal*. Beautiful, organic timing is appealing to the eye. Interesting, dynamic posing is also appealing. Character designs, contrasting shapes and rhythm, are all fine tuned, worked, and re-worked to get the most appeal. Does appeal mean "good"? Not at all; the evil villains in our most beloved animations all have appeal. From their striking silhouettes to vibrant colors, even the bad guys must be appealing. Appeal is the pinnacle of our task as animators, it is the goal. Above all else we should strive to always put images in front of our audiences that are worthy of their time.

Let's focus on posing for our discussion of appeal. As animators our work takes place far after the characters have been designed, modeled, textured, and rigged. But even with appealing characters, bad posing can ruin the entire show. For instance, an arm pointed directly at camera loses all of its good posing from foreshortening; the animation must work well with the chosen composition. Take the camera into consideration and be sure that your staging is well thought out. The silhouette of your pose should be strong, without limbs lost within the silhouette of the body. And "maxed-out", or hyperextended arms and legs never look very good.

Twinning is another major issue in posing. In nature, nothing is ever perfectly symmetrical. Without being careful to avoid twinning, it sneaks its way into our animation. It saves time, for instance, to set channels on both sides of a character at the same time. If this is a cheat you use, then you must remember to go back through the scene and un-twin your poses. Arms, legs, hands, even facial poses can fall victim to twinning.

We must be mindful of the appeal of our animation by constantly critiquing our work and showing it to others.

To practice, we are going to take a single pose and make some adjustments to increase the appeal.

1 Open appeal_start.ma. You'll see Goon has been posed giving "thumbs up" to a character off screen.

4 Let's fix the maxed-out arm as well. Bring a little bit of bend into the elbow and make the wrist look more natural.

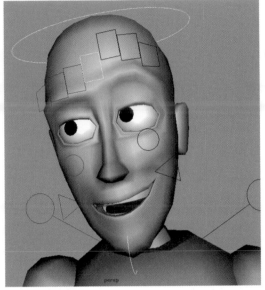

appeal_start.ma
appeal_finish.ma

2 This face pose could use a lot more appeal. Let's start
with the face. It's totally twinned, and the facial
controls are all at max. We can make this look better by
adding some asymmetry, and dialing back some of the
maxed out controls.

3 There we go! I added some asymmetry to the face in
the brows, cheeks, and mouth, and Goon is already
looking much better. I also made the pupils bigger and have
the lids touching them so he looks more friendly and less
wired.

HOT TIP

Always keep
an eye on the
renderCam.
As animators
we want our
animation to
work in 3D
as much as
possible, but
when it comes
down to it,
the animation
needs to look
good through
the main
camera first
and foremost.
Working
with the
renderCam open
somewhere is
good workflow
practice.

5 Surprise! Change your perspective panel to renderCam
and see how we've lost the entire arm pose in
foreshortening! This needs to be remedied.

6 Repose the arm to get a nice clean read on the upper
arm and forearm, and finally fix the the hand so that
the pose feels natural. This pose is much more appealing
than what we started with!

What Is "Workflow"?

by Kenny Roy

IT WAS YEARS into my teaching career, with hundreds of classes and thousands of hours of animation critiques under my belt, before a student suddenly asked me, "You keep on saying the word 'Workflow', but what does it mean?" I was stunned, because after all of my harping on the subject, it never occurred to me that the very concept of "Workflow" itself might be unclear to beginner animators.

Simply put, a workflow is the *step-by-step* process you employ to create a shot from start to finish. It adapts to the project, it grows and changes slowly over time, but on a shot-to-shot basis your workflow always stays the same.

This may sound like a no-brainer, but the reality is most new animators pay little to no attention to the actual *process* as they learn. Instead, they animate "by the seat of their pants," and judge the unpredictable results on screen for indication of improvement. Let's take a related example in another area of art to illustrate this point.

Back in school, I had a figure-painting teacher who was very strict. His name was Yu Ji. In his class, students were subjected to a constant barrage of commands regarding how and when to do each step of a painting. First, you wipe the canvas with some highly thinned burnt umber or raw umber paint until the entire canvas is a nice, fleshy brown. Then do a quick sketch in pencil to define the form. Immediately go over that with a thin brush with umber paint, completely filling in all of the shadow areas. THEN, and ONLY THEN, do you start mixing paint to try to match the colors you see. And even when it came to finally painting with color, Yu Ji sounded like a broken record as he walked through the class to correct the color choices of his students. "Is the color warmer or cooler than the color next to it?" "Is it lighter or darker?" "What is the color tendency?" (Within warm colors, was it more red, or yellow, e.g.) These same three questions were repeated at least a hundred times over the course of a 3-hour class.

It would be years before I realized that what Yu Ji was doing was teaching us good workflow, above all else. Everything we were forced to do helped us avoid the major struggles that befall young painters. Most importantly, these were tried-

and-true methods that produced better results. For instance, making the entire canvas brown made it so that we did not mix our colors too light just because they were competing with a blinding white canvas. Filling in shadow areas early on and foregoing minor details made the students focus on the large shapes in the form . Finally, his three questions made it so that we were mixing our colors based on the color *relationships* that we saw, barring preconceived notions from influencing our color choices. When I think back on it now, I cherish the amazing workflow that Yu Ji gifted his class, and I feel bad for thinking he was so strict!

Back to animation.

In animation, students typically start with a workflow that roughly resembles the order in which they learned the fundamentals. Pose the character with some rough timing and spacing, add some squash and stretch here, some anticipation and follow-through there. This is a messy way to work, and until you learn how to really let the fundamentals work in concert, your animation will lack the fluidity and beauty that the legends are capable of. There are just as many pitfalls awaiting novice animators as figure painters. In Yu Ji's class, we were forced to make our canvas brown so as to not wrongly exaggerate the colors; perhaps the first step in your workflow should be to thumbnail some REALLY pushed poses and try to hit them with the model. You would be doing this because you know that as you move forward with the shot and get into polish, many of the pose choices will become watered down to accommodate timing, spacing, and compositional constraints. Yu Ji made us fill in all of the shadow areas with brown before adding any details. Sounds a bit like getting body movement looking really good before adding facial animation, doesn't it? And finally, those three questions we asked ourselves reminded us to constantly critique our choices within the painting, and with the live model. Before you move into your polishing phase, it would be a good idea to establish a workflow step in which you look at the animation one more time and ask yourself some questions. "Are my poses as dynamic as I originally planned?" "Is there still contrast in the animation in pose, timing, and composition?" "Does this resemble the reference and observation I've gathered?"

Your questions might be different, but the main point is, both in figure painting and animation workflow, that you *do it every time*. Instead of leaping at a shot with no plan in mind, just begin at step 1 of your workflow. Stop animating feverishly for huge lengths of time only to step back and realize the shot has not progressed at all.

If at any time in the middle of animating a shot you catch yourself asking the question "OK, now what's my next step?" you know you've crossed into the world of workflow. Welcome! You are on your way to becoming a great animator.

■ Splines can wrangle you, or you can wrangle them. Not into being wrangled? Keep reading! (And I just won a bet to use "wrangle" in a caption 3 times.)

2 *Splines*

SPLINE CURVES, or just "splines" (or even just "curves"), are the lifeblood of computer animation. They're a surprisingly efficient and comprehensive method of representing motion. Much of your time animating will be spent perusing these little red, blue, and green intertwined curves, so it makes sense to get comfortable with them. This chapter is all about facilitating your comfort.

Opening the Graph Editor to what looks like a spaghetti dinner gone bad can be intimidating, but we'll make understanding splines a quick study. We'll go through the simple concepts that make reading them easy and so powerful. Then some cheats on editing splines will have you wrangling them under control in no time. Get ready to meet your new best friends in animation!

How Splines Work

UNDERSTANDING HOW SPLINES display their information is the key to making them work for you. Some beginning animators are intimidated when they see all those intertwined curves, but the concepts behind them are really quite straightforward. It takes a little practice to make it second nature, but only a few moments to really grasp the concepts we'll go over in this cheat. In no time, you will find that they are a surprisingly elegant way of working with your animation, and understanding them thoroughly will quickly create a noticeable improvement in your work.

The main idea with splines is that they represent changes in value over time. As the curve travels to the right, frames are ticking by. As the curve raises and lowers, it's an increase (travelling up) or decrease (travelling down) in the value of the attribute. If the curve changes direction, as it does at the middle key in the following diagram, the object it represents will change direction.

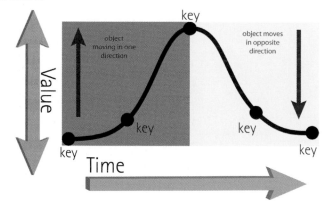

The thing to remember, and where it's easy to get confused, is that up and down do not necessarily correspond to up and down for what you are seeing in the viewport. That may seem counter-intuitive at first, but it has to do with how the character rig is set up and there are many possible scenarios with that. For some attributes, like translate Y, the curve will actually look like what the body part is doing, but most don't. The thing to take from this cheat is that up and down are simply changes in value, not a direct visual correlation to what you see in the viewport.

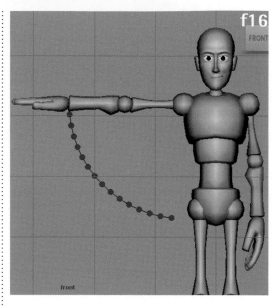

1 Open HowSplinesWork.ma. From f01–f16 the character is raising his arm. Take note of how even the movement is. Every frame, the arm moves the same amount.

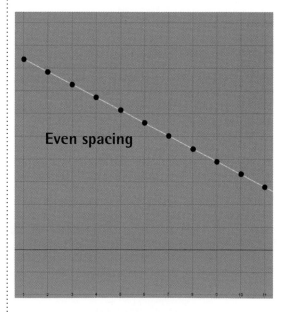

3 If I plot each frame along the curve, we see that they are all equidistant, just like the spacing tracked in the viewport. (Some curve colors in this chapter were changed in Photoshop for better clarity on the page.)

HowSplinesWork.
ma

2 Open the graph editor and look at the upper arm's rotate Z curve. Notice that it's a perfectly straight line. This corresponds to the even spacing of the motion we see in the viewport.

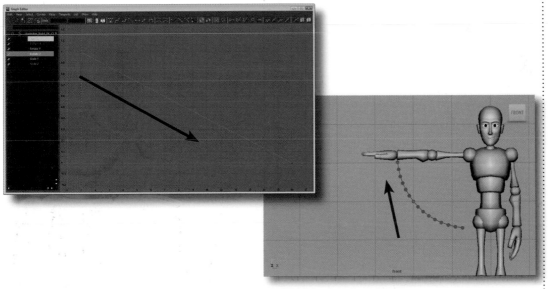

4 Also notice that the curve is travelling downward while his arm is raising. Remember that we said the up/down in curve direction is simply a change in value, not a direct representation of the viewport.

How Splines Work (cont'd)

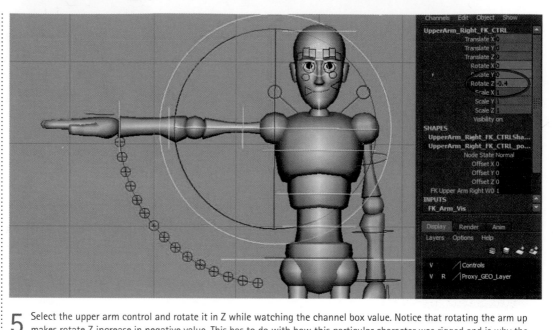

5 Select the upper arm control and rotate it in Z while watching the channel box value. Notice that rotating the arm up makes rotate Z increase in negative value. This has to do with how this particular character was rigged and is why the curve travels down, since down is an increase in negative value in this case.

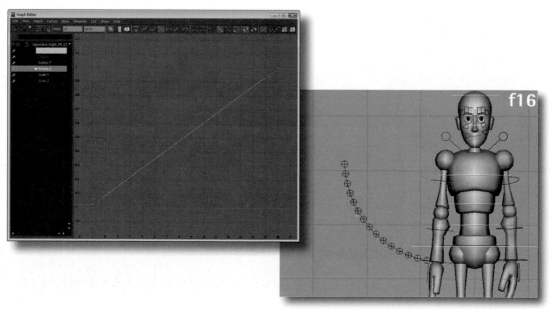

8 Continue making adjustments to the keys in the curve and watching the animation until you're comfortable with the concepts. Here I switched the positions of the keys and now he does the opposite motion.

6 In the Graph Editor, select the key at f16. Use the move tool **W** and **Shift** MM drag it up. Shift dragging with the move tool will constrain movement to either horizontal or vertical motion, whichever you do first.

7 Since the curve travels downward a much shorter distance, therefore increasing negative value only a little, his arm now moves up only a short distance. Tracking the motion shows us how much tighter the spacing is.

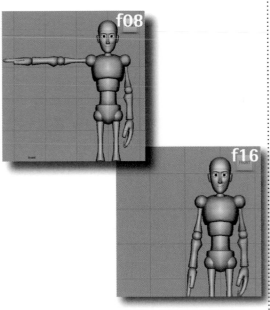

9 Hold **I** and middle click the curve at f08 to insert a key. Select the entire curve and press the flat tangents button. Then use the move tool to MM drag f08's key down and f16's up to look like above.

10 From f01-f08 the arm travels up. When the curve changes direction, the arm travels back down.

Splines and Spacing

LET'S TAKE A MORE IN-DEPTH look at how changes in our spline curves affect the spacing of a motion. If the curve's direction over a given range of frames is mainly horizontal, the value is not changing much. Therefore the attribute will be moving very little in the viewport.

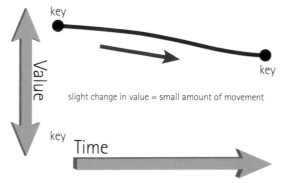

slight change in value = small amount of movement

If the direction over the frame range is predominantly vertical, a larger change in value is happening and the movement will be large.

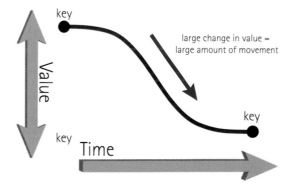

large change in value = large amount of movement

Finally, if the curve is perfectly horizontal for a frame range, that curve's attribute will hold perfectly still, as there is no change in value. We'll try some things in this cheat that will make these ideas perfectly clear.

Throughout this cheat, we'll make some pretty stark changes in the speed of the movement while never changing the number of frames (timing) it happens over. Timing and spacing are intertwined, but problems in spacing tend to be less forgiving than the number of frames you're using.

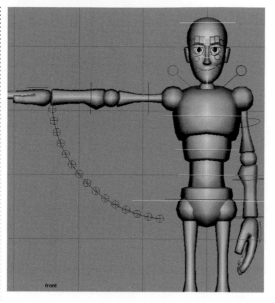

1 Open TimingSpacing.ma. We'll start with the upper arm moving up with linear, even spacing. Open the graph editor and select the R upper arm's rotate Z curve.

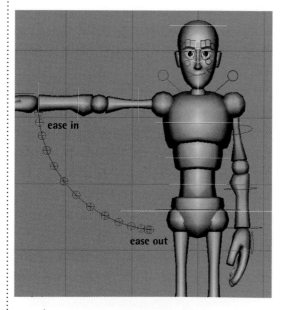

3 Play the animation and notice how the movement is much smoother. There is an ease-out when the arm starts moving, and an ease-in to where it stops.

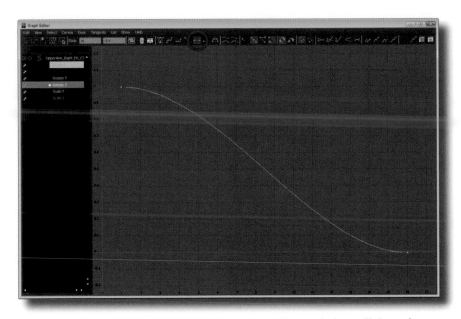

TimingSpacing.ma

2 Select the entire curve and press the flat tangents button. The curve's shape will change from a straight line to a smooth "S" shape.

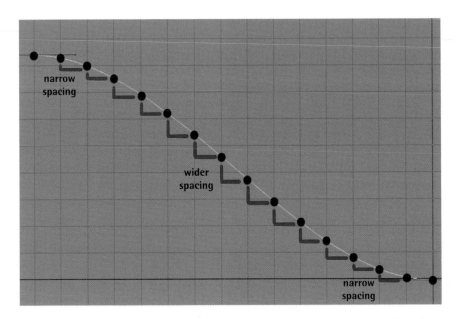

4 Plotting the spacing on the rotate Z curve shows how the curve's spacing corresponds to what we see in the viewport. The arm moves shorter distances in the beginning and end, and wider in the middle.

Splines and Spacing (cont'd)

5 Go to frame 10 and set a key on the R upper arm. Select the key you just set in the graph editor and click the auto tangent button if the curve is not smooth. This will keep that key's tangents smooth no matter where you move it.

6 Use the move tool **W** and **Shift** MM drag the key up so it's a little under the value of the first key.

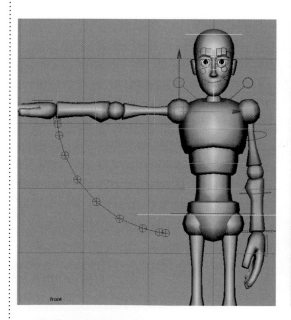

9 Now the opposite happens, where the arm moves quickly at the beginning, and eases in to the end pose more gradually.

10 Select the last key at f16 and look at the value field. In my case it's -0.4.

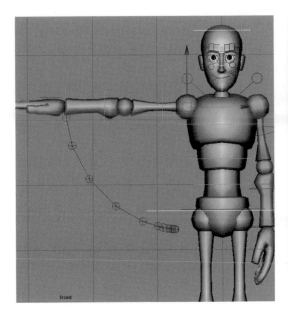

7 Play the animation and notice how much we've affected it. The arm moves very little during the first 10 frames since the spacing is so close. The value changes very little until f11, where the wide change makes it move quickly.

8 Edit the key at f10 so it's close to the value of the end key.

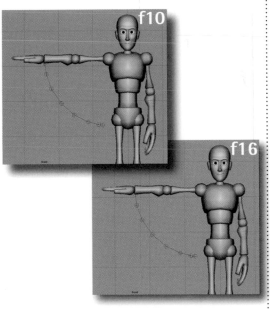

11 Select the key at f10 and enter the value of f16's key into the field to make it the same. Since we set this key to Auto Tangent, it will automatically become flat. This will ensure that the curve holds at the same value through those frames.

12 Now the arm travels with an ease out and ease in from f01-f10, but holds still until f16. Since there is no change in the up or down of the curve while the frames tick by, the arm holds still.

45

Tangent Types

T ANGENTS AND THE STYLES AVAILABLE in Maya are the other side of understanding splines. If you've used graphics programs like Illustrator, tangents will be familiar to you. They're the handles that exist around a keyframe and are used to adjust the curve's angle and direction before and after the key. As we've just seen in the previous cheats, the curve's slopes have a profound effect on the animation's spacing, so having a solid grasp on how tangents work is invaluable.

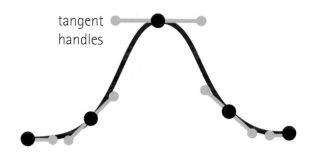

tangent
handles

Maya has several different tangent types, which are really just preset angles for the handles (albeit useful ones). The handles are completely customizable, and Maya's tangent types are mostly a starting point. Using only the "out of the box" tangent types tends to make the motion look very "CG" and uninteresting. However, knowing which ones will bring you most of the way to your desired result will go a long way towards speeding up your workflow. Here we'll take a look at Maya's tangent types and what sort of situations they're best for.

New in Maya 2012 is the AutoTangent function, which is a great time saver. This isn't a new tangent type, but rather a setting that will adjust your keys' tangents automatically depending on their location. Keys at the extremes (wherever a change in curve direction happens) will be flat, while transitional keys (keys where the curve is the same direction on both sides) will be smooth. As you edit the keys, the tangents will automatically orient to whatever situation they're in. Awesome!

1 The tangent type icons are along the top of the graph editor. Simply select any or all keys and click whichever type you need. The first icon (with the "A") will enable the AutoTangent functionality for the selected keys and/or curves.

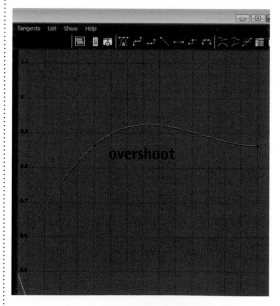

4 Spline tangents will make a smooth transition between keys and don't flatten out. They're great for keys that are transitional (going the same direction each side of the key), but with extremes (keys at which the curve changes direction) they can overshoot, which is difficult to control.

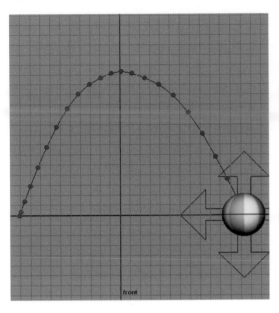

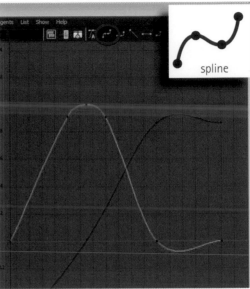

TangentTypes.ma

2 Open TangentTypes.ma. In the front view we have a very basic animation of a ball going in an arc.

3 Select the ball control (Show > Nurbs Curves in the viewport menu if you don't see it) and open the Graph Editor. Select all the curves and click the spline tangents button. Notice how the ends of the curves become straight.

HOT TIP

Once you're refining an animation, you usually won't use one tangent type for all keys, but rather the appropriate type for the particular keys and situation you're working on.

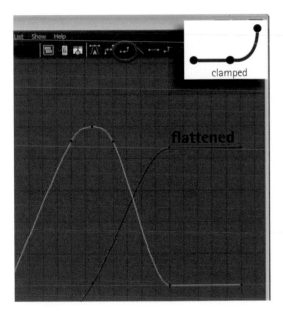

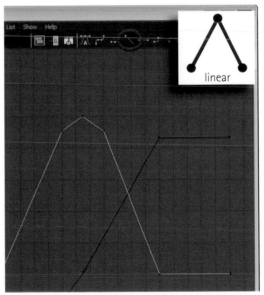

5 Select all the curves and press the clamped tangents button. Clamped are almost the same as spline tangents, except they will not overshoot on adjacent keys that are the same value or very close in value. Notice that the overshoots from before are now flat.

6 Next press the linear tangents button. Linear tangents simply make a straight line from key to key and therefore make very sharp angles and transitions.

47

Tangent Types (cont'd)

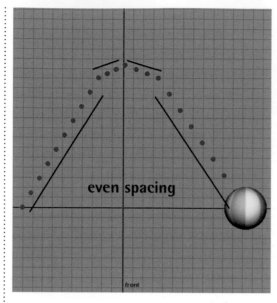

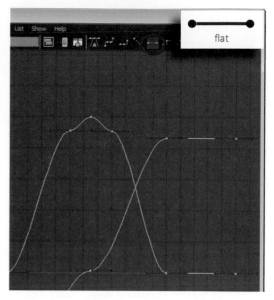

7 Notice the spacing in the path of the ball is even between each key. Linear tangents are good for times when an object is traveling and then impacts another object at full momentum, such as when a ball hits the ground.

8 Next are flat tangents, which make a plateau at each key. They're common at the extreme keys, where a curve is changing direction, easing in and out of the key. In transitional keys, they will make the object slow down in mid path.

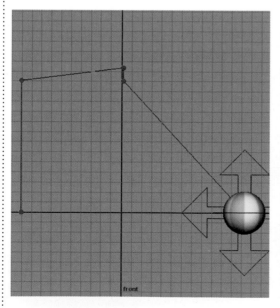

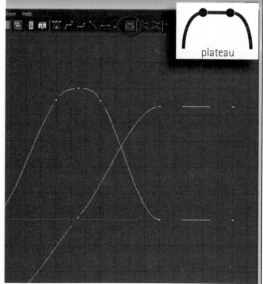

11 We see here that the ball pops to each position when it gets to that frame. Stepped keys are most commonly used for blocking in full animations, and for attributes that need to change over a single frame, like IK/FK switching or visibility.

12 Finally we have plateau tangents, which are almost identical to clamped in that they won't overshoot, and will flatten out extreme keys. The main difference is that they also flatten the start and end of the curve as well.

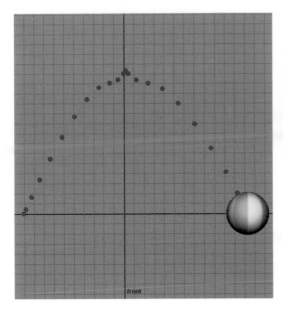

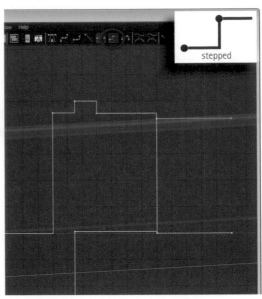

stepped

9 Notice the spacing on the ball easing out and in to each key. Flat tangents are a good starting point for keys you want ease outs and ins on. They will also hold flat through keys of the same value and never overshoot.

10 Next are stepped keys, which do not interpolate at all. They will hold still until the next key frame. Because of this they create these stair-like keys.

	spline	Smooth interpolation, good on transitional keys where curve is the same direction on both sides, tends to create overshoots in the curve
	clamped	Smooth interpolation, doesn't overshoot keys with close or identical values, first and last keys in curve are splined, good for moving to spline mode from stepped keys
	linear	Direct line from key to key, makes spacing between two keys perfectly even, sharp angles in curves, works well for keys where an object is meeting another at full momentum, some use for blocking to avoid any computer created eases
	flat	Creates plateaus at keys that are perfectly flat, automatically puts an ease out and ease in on a key, never overshoots, good for keys at extremes (where the curve changes direction) and keys where a value needs to hold through frames
	stepped	No interpolation between keys, simply holds until the next key frame, commonly used for pose-to-pose blocking, attributes that you want to switch over 1 frame such as constraints, IK/FK, creating camera cuts, etc.
	plateau	Same as clamped, except first and last keys in the curve are flat

13 To recap, here's a chart of some common uses for different tangent types. To reiterate, these are just starting points that may be helpful, and not rules by any means. AutoTangent isn't a tangent type, but rather an automation function. It basically sets keys to spline or flat tangents dynamically as you edit key frames, depending on the situation. Keys at extremes (where the curve changes direction) are made flat, while transitional keys (where the curve continues in the same direction) are smoothed to a spline tangent.

Tangent Handles

N OW THAT WE HAVE A GOOD UNDERSTANDING of Maya's tangent types, we can look at customizing the handles to create any type of curve we want. Maya's tangent handles offer the ultimate flexibility of any animation/graphics programs, so we should obviously take advantage of this power. Keep thinking about the spacing you want for your animation, then how a spline should look when it has that spacing, and use the handles to make it happen.

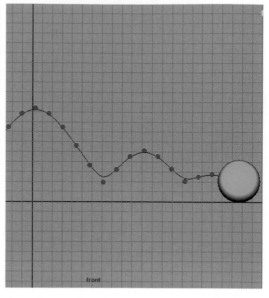

1 Open TangentHandles.ma and you'll find a simple bouncing ball animation. Select the ball control and open the Graph Editor.

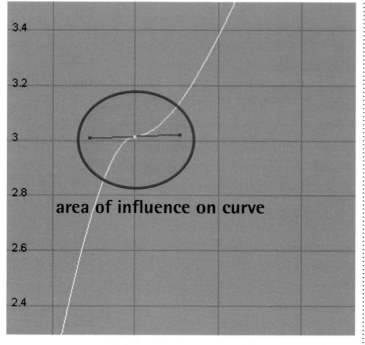

area of influence on curve

There are two types of tangent handles, weighted, and non-weighted. We'll go over them in this cheat, but they're really just styles of working and all up to preference in the end. Everything we talk about here is simply a way to get differing levels of control using the tangent handles. Note that I didn't say *more* control! Any curve shape you can get using handles you can also get by using more keyframes. At the end of the day, it's up to you and how you like working, so experiment with everything. My philosophy is it's best to get a handle (ahem) on all of the tools available, and then pick the best one for the job at hand.

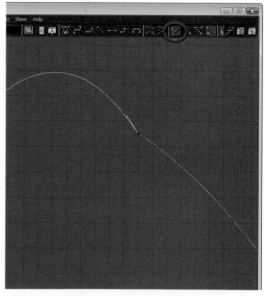

4 Select a handle and press the break tangents button. The left handle will turn blue, indicating they are now independent and you can drag select and then move them individually to get any curve shape you want.

TangentHandles.ma

2 Select the translate Y curve and examine the tangent handles. They are currently non-weighted handles, which means they are all the same length relatively and have the same amount of influence on a curve.

3 Select the move tool **W** and select any handle. MM drag it to rotate it. These handles are unified, which means they are attached and act as a single piece when moving either of them.

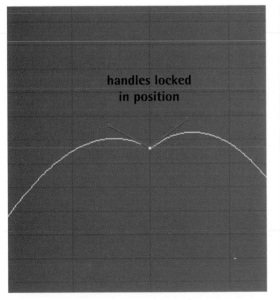

handles locked in position

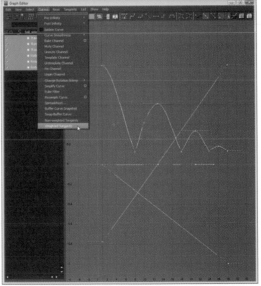

5 You can break tangents, position them, and then press the unify tangents button to lock them in that shape. They will then rotate as a single unit again. You may get erratic curve behavior if you do this with a very sharp angle, however.

6 Undo all your edits and select the entire translate Y curve. In the Graph Editor, go to Curves > Weighted Tangents and the handles will change.

Tangent Handles (cont'd)

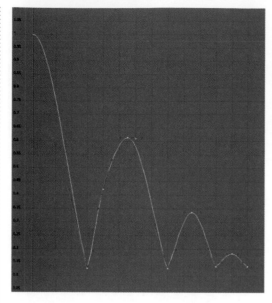

7 Weighted tangents have differing lengths which depend on the distance in value between the keyframes. The longer the distance, the longer the handle, and the more influence it will have along the curve.

8 You can break and manipulate the handles just like with non-weighted, but you have an additional option with weighted tangents. Select a key and click the free tangent weight button.

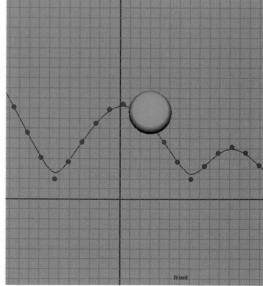

10 You can even break the tangent handles as we did before to create any shape of curve possible.

11 Continue to experiment with the tangent handles and learn how to create the spacing you want using them.

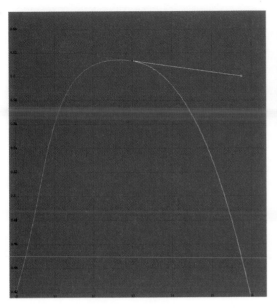

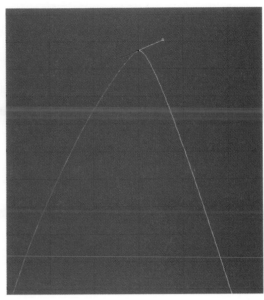

9 The ends will turn into open squares indicating free weights. You can now use the move tool and make the tangents any length you wish, increasing or decreasing the amount of influence they have on the curve.

Handles Pros
- Keeps curves less cluttered with fewer keys
- Powerful curve-shaping options
- Curves scale in time more accurately
- Good for subtle spacing adjustments without adding density
- Create sharp angles with fewer keys

Handles Cons
- Adjusting adjacent keys can affect spacing
- Some shapes not possible without keys
- Too few keys tends to feel floaty
- Can be more difficult for other animators to edit if necessary
- Less control over larger spacing areas

Keys Pros
- Exact, value isn't affected by adjacent keys
- Complete control, any shape possible
- Clearly readable in Graph Editor
- Simple to work with, not complex
- Easy to edit by other animators

Keys Cons
- Curves can get very dense and more difficult to make changes to
- Scaling time can be less accurate if you need to snap keys to frames
- More control usually translates into needing more keys

12 Remember that using handles is just another way to approach animating, not something you need to do or should never do (depending on who you talk to). Some animators never use tangents and only set keys, others use broken weighted handles all the time, but many use both methods when necessary. It's up to you in the end, but here are some factors to consider with the various methods. Ultimately, choosing the best approach for the task at hand will ensure that everything stays as simple as possible.

Spline Technique

Y OU NOW HAVE a good grasp on the capabilities splines have and how you can approach using them, so let's go over some things that can tighten up your spline workflow. We're all about making things easier here, and there are a few tendencies splines have which can sabotage that. Having good spline technique means you have control, and that means you're making the animation look the way you want, not the way the computer happens to do it.

As I've said before, none of these things are really rules and there will be situations where actually doing them may be the best approach. But those are the exceptions and for general guidelines, especially if you're still becoming acclimated with splines, this cheat will go a long way towards helping you get ahead.

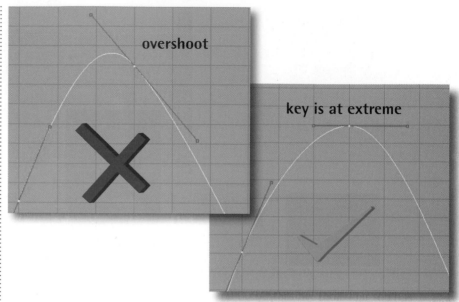

overshoot

key is at extreme

1 Open SplineTechnique.ma and select the ball's move control. Look at the translate Y curve at frame 12. F13 is the extreme key, but the tangents are making f12 a higher value, also known as an overshoot. Use flat or linear tangents at extremes and adjust the eases to what you need.

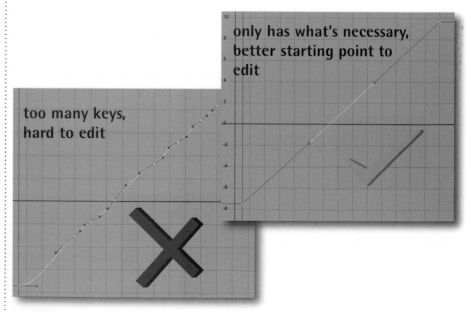

only has what's necessary, better starting point to edit

too many keys, hard to edit

3 Look at the translate X curve. Often when setting keys on all controls, we can get a lot of redundant keys. Splining can turn these curves into a wobbly mess. Only use the number of keys you need and make sure the tangents are the way you want them. Too many keys makes changes very difficult. Since this curve should be a smooth translation, we can delete almost all of these keys.

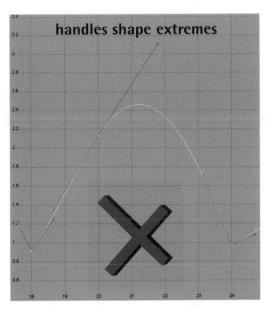

handles shape extremes

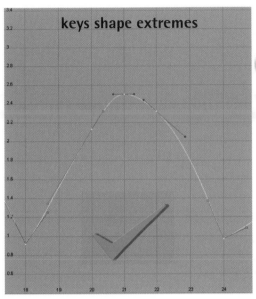

keys shape extremes

SplineTechnique.ma

2 At f21, there's another type of overshoot, where the curve was shaped this way purposely with tangent handles. While this may look fine in the viewport, it's definitely not the best way. When the extremes have keys representing them, it makes things clear, easy to edit, and the values can't be changed without us knowing. With any kind of overshoot, moving an adjacent keyframe or handle can change where your extreme is. As much as we all love Maya, we don't want it making these kinds of decisions for us!

HOT TIP

As awesome as the new AutoTangent functionality is, don't let it make you lazy! In the end it's still spacing and slow ins/ outs generated by a computer algorithm. It will get your curves closer to what you want with less work, but you still need to maintain control of what the computer is doing. Finely calibrated curves are the mark of a great animator.

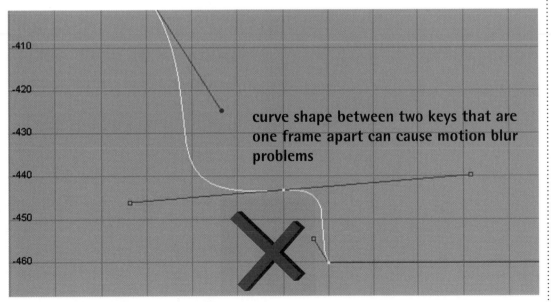

curve shape between two keys that are one frame apart can cause motion blur problems

4 Look at f24-f28 on the Rotate Z curve. Extreme angles are sometimes necessary, but if you need sharp angles, you're better off using keys rather than handles. Handles change when you shift keys around, but keys will always hold their value. It's good to avoid even 1 frame glitches like f27-f28 that aren't seen in the viewport. Some studios use motion blur that look in-between the frames and will give strange results at render time with curves like this. This can actually be used to make motion blur look the way the animator wants, but unless this is intentional, don't do it!

Spline Reference

W E'VE SEEN THAT SPLINES are simple tools, yet capable of describing any movement to pinpoint accuracy. It takes some practice to make looking at them second nature, and as you keep animating, you'll get better at reading them. One thing many beginning animators don't realize at first is that reading splines is just recognizing common shapes. An ease-in will always look pretty much the same as far as the general spline shape goes. The size and angle of the shape will simply determine how big (or small) of an ease-in it is. You know when a circle is a circle regardless of how large or small it is. It's really the same idea.

The file for this cheat, SplineReference.ma, contains six spline shape examples that you can use as a reference for common animation spacings. Every 50 frames has a separate animation and description. Move the time range slider to start at frames 1, 50, 100, 150, 200, and 250 to see each one. The upper arm's Rotate Z curve has the animation. Memorizing these shapes will make looking at the Graph Editor an enlightening experience, rather than a puzzling one. Happy wrangling!

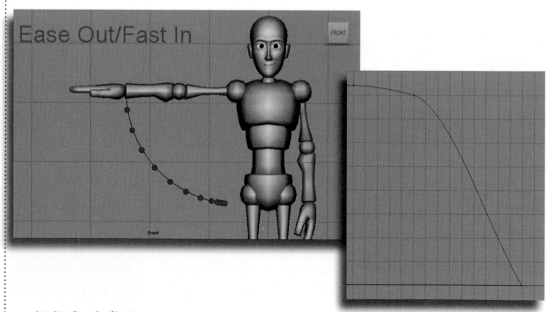

2 f50–f99: Ease Out/Fast In

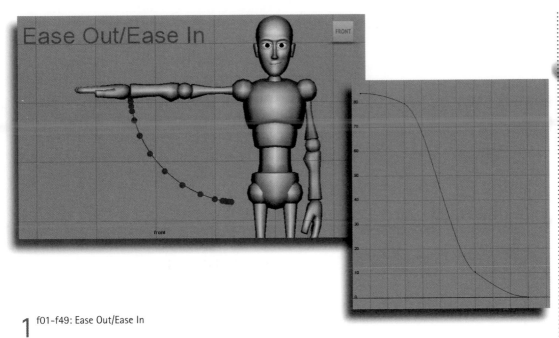

1 f01-f49: Ease Out/Ease In

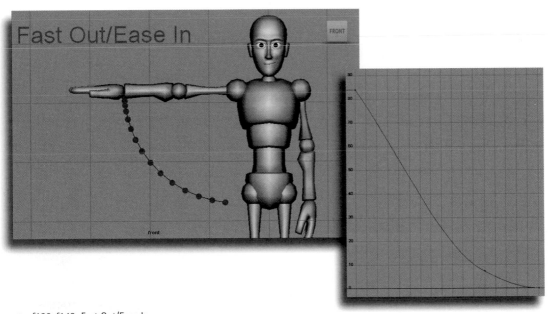

3 f100-f149: Fast Out/Ease In

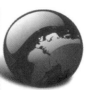

SplineReference.ma

Spline Reference (cont'd)

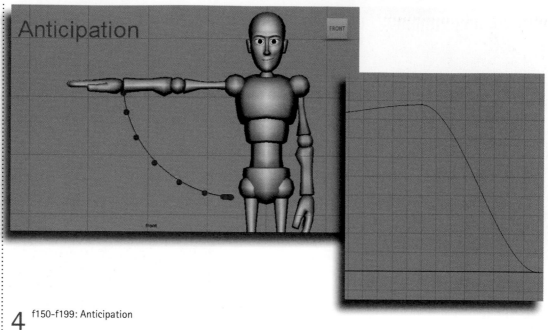

4 f150–f199: Anticipation

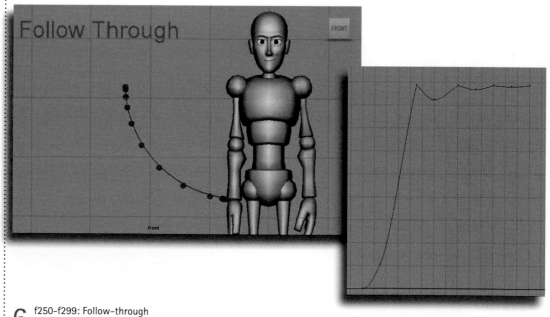

6 f250–f299: Follow-through

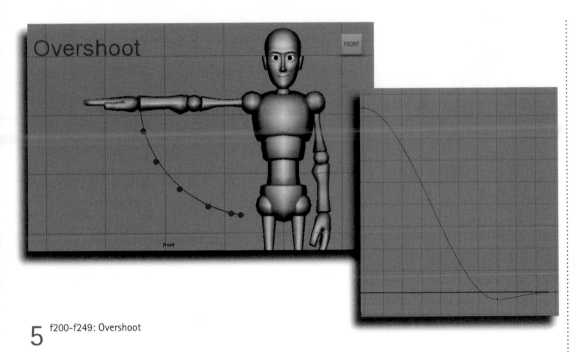

5 f200-f249: Overshoot

Which Field Is Right for Me?

The Many Facets of Animation
by Kenny Roy

SO YOU'VE DONE YOUR RESEARCH and have seen the huge variety of jobs available in animation. It is a great time to be an animator, as more and more content is being created every day that needs an animator's touch. Feature animation continues to gross huge profits in the box office in spite of global economic shifts. Live-action films rely on visual effects and animation to an increasing extent every year. The games industry rose in the late 90s and early 2000s to top all other forms of entertainment in sales. Companies opt for animated spokespersons and commercials loaded with high quality visual effects. Even the web has seen rapid growth in recent years of animated webisodes, animated web sites and banners. Animation is everywhere, but you cannot be. Where do you fit?

How about a career in games? Here's what's in store for you. At major game studios that release AAA titles, animators will work between 6 months to a year. If you think that working on long-term projects is the most important factor for you, a major game studio could be a good fit. You should weigh the pros and cons of long-term work; stability in your career is a major stress-relief, but on the other hand it can become tiresome to animate the same characters or actions for too long. You should not be shy to edit and manipulate motion capture data. Tools to edit mocap have become increasingly artist-friendly in the past few years, so this is not as much of a headache as you may think. You can download trial versions of motion-editing software like MotionBuilder, or even experiment with some motion capture in Maya itself. Find some included motion capture files in the Visor. If you are working on a first-person shooter, the brunt of your animation is going to be physical cycles: walks, runs, jumps, firing, crouching, dying, throwing, reloading, etc. A chance to be more creative and less technical arises on these games in the form of the cinematics, or cutscenes. Though mocap still plays a part in these sections, sometimes they are all hand-keyed. The rule of thumb is if you are working on a project that is more realistic, you should be more comfortable and familiar with motion capture and short, technical, repetitive cycles. A sports game, for instance, is almost entirely motion capture.

As you traverse through the games industry into some more fantasy titles, you will find that the amount of creativity and keyframing increases. Adventure games, scrollers and platformers, strategy and casual games all rely more on hand-keyed animation in general. The drawback of working on smaller titles is the potential to be let go at the end of a project because most of these studios hire artists on as freelance, project-based contractors. It shouldn't be hard to string together enough work to make a living if you are very talented and/or the studio is not in a very metropolitan area (i.e., you are one of only a few animators in the area). Although, living in a city like Montreal, which has half a dozen games studios, is a good idea because the competition between studios to retain talent is very high. Iphone, iPad, and other mobile platforms are another growth market in games as well, and these titles are typically even more creative, and keyframed by hand. The visual quality in mobile gaming is not usually the highest, but that is changing too. If you are a die-hard gamer and are only concerned with working on the most creative, "out-there" projects, then a boutique games studio may be for you. You will be working between 3-6 months on these smaller titles, especially ones intended for mobile platforms, and should be very comfortable marketing yourself and keeping in constant contact with employers in your area to make sure no work drought lasts too long.

Like the rest of the animation industry, the games niche follows the pattern that the smaller a studio you are working for, the more generalized you may have to be. Animators may be asked to rig props for a mid-sized studio, simply because it will be you that animates the prop in the hands of the character and know what will work best. You may also be asked to light your scenes in a cinematic, which could be as simple as adjusting a light rig and configuring presets. At a small studio, and especially for mobile platforms, artists are expected to be very well versed in all aspects of CG. Autodesk makes expanding your skill set as easy as possible, with a very supportive user community and training materials available online. Conversely, and like other areas of the animation field, animators at major studios pretty much only animate day to day. A large part of your decision should be how willing you are to wear "multiple hats".

The games industry is a massive part of the animation field, and a definitely viable path for many artists to pursue. The main questions to consider are if you are totally averse to working with motion capture, how creative you'd like to be in your work, how important job security is to you, and, after all, if you really love games! Think about these as you ponder video games as a possible career choice.

Television visual effects and commercial VFX work is typically done at the same type of studio. The same studio will animate wolves chasing vampires for a popular TV show while also creating dancing soap bubbles for an animated TV commercial. Because of the overlap in pipeline, and the cutthroat nature of VFX in general, this same studio may also take on a few shots of small budget movies as well.

One of the major advantages of working in small film or television visual effects is the variety of the projects. It can be very fulfilling to have such a variety in your career. Your demo reel will be a cornucopia of different visuals, and it is easy to make a move into both games and feature film provided you have the talent. One of the disadvantages is that the projects are generally shorter. Between 1-3 months is typical for this kind of work. You will have to be constantly updating your reel, making contacts, and lining up your next job in the small to mid-sized studios. A related downside to the smaller studios is that every project has about 10-20% of "crunch-time" at the end. This crunch time always seems to be a larger portion of the total schedule, the shorter the project. Successfully stringing together many gigs in a row could actually mean late nights and weekend work every month. Animators with families and other commitments might find the schedule a little taxing on home life. Overtime pay is nice, but you have to have a life outside of work in order to be happy.

The rule is the same in commercial VFX: the smaller the studio, the more hats you wear. If you don't mind the run-and-gun nature of the schedule, and you are looking for a wide variety of experience, then expand your skill set a little bit in preparation. The most advantageous skills besides animating you can learn are rigging, lighting, and modeling, in that order. I've spent most of my career in this area of the industry now that I've opened my own shop. I can tell you from experience that it has been very rewarding to be able to make creative decisions, and work on a wide range of projects.

The crème de la crème, the pinnacle of animation, the ultimate job for most animators, is feature film. Whether it's big budget creature VFX or animated features, this area of the field is indeed occupied by the best and brightest of our kind. It is certainly an achievement to be proud of getting your foot in the door in this part of the industry. The upsides are great: long contracts or staff positions at major studios, working on the highest profile projects in the world, working with the best talent around. These things are all great. There's something to be said about working with a team for a year or longer, and getting the chance to really get to know your colleagues. An immense amount of camaraderie is built in the feature world. In fact, I'll admit to crying during the credits of *King Kong*, seeing all the

names of the people I knew scrolling by. It's a powerful feeling. I would recommend every animator strive to make it into features at some point in their career, if only to get that feeling of seeing your name in the credits.

In features you will be working with the same characters for a long period of time. Some see this as a positive thing, others negative. For my part, I think it can be really nice to get super comfortable with a rig and a character. The result of technical comfort paired with natural performance choices is always just great animation.

In all but a few cases, you will be asked to only animate the characters. No rigging, lighting, modeling, anything other than moving the rigs in your shots. Again, some see this as a good thing, others bad. For animators who are more generalists it can be frustrating to have to wait for a rig to be fixed when you can do it yourself. You cannot break the pipeline at a feature studio so there will actually be some cases where you are forced to work with broken tools, or plates, or tracking, etc. On the other hand, in such a competitive industry I would be surprised if a jack-of-all-trades CG artist would be applying for an animation job at a major studio in the first place. There are exceptions to every rule though.

You can expect to work very steady hours until crunch time, which can get very heavy towards the end of a project--100 hour weeks are normal on major motion pictures for the last few months. Luckily, most of the time production will give the crew a break before the next job arrives, though it sometimes doesn't happen. I still hold that the ebb and flow of work and crunch time is worse in commercials and TV VFX, but it's something to consider with features.

If your animation is top notch, you are interested in working on the highest profile projects, and you are within the area or can move to proximity of a major studio, features might be for you.

You shouldn't think that TV, film, or games are the only outlets for you. There are many other places for your animation to live, including ride films and amusement parks, short films, museums and educational media, medical animation, and more. These other areas might not interest you but you should know that if Pixar doesn't respond to your application, your life is not over!

Give it some serious thought. Where you live makes a big difference in your decision, as does your experience level, generalist skills, willingness to move, family, and financial matters. I wanted to give just a little perspective into the different areas of animation, because many students and novice animators think to themselves it's "features or bust." Considering that the games and commercial industries have the majority of the jobs, it could be time to reconsider that view.

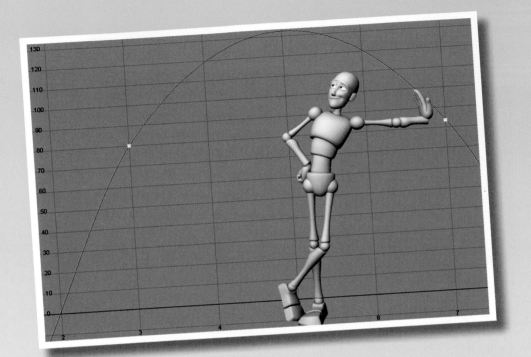

■ As your katana for cutting through a jungle of spline curves, the Graph Editor offers much in power, simplicity, and efficiency.

3
Graph Editor

MAYA'S GRAPH EDITOR is easily its most powerful
and most used tool for animating. It's likely that you
will spend much of your time working with it, so it's
a no-brainer that we learn all the ins and outs of this
fantastic editor. What's more, Maya 2012 has brought a
nice overhaul to the Graph Editor interface and some new
tools to complement it.

We spent the last chapter understanding splines, and now
we'll learn how to use the Graph Editor to interact with,
edit, and manipulate them.

Graph Editor Windup

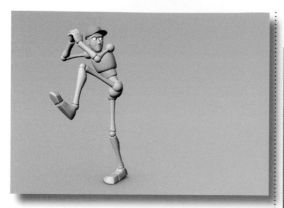

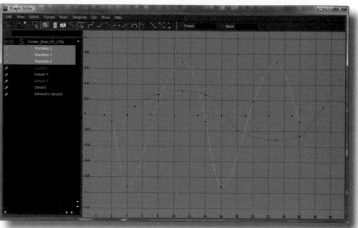

B EFORE WE LAUNCH INTO all the cool stuff the Graph Editor has in store for you, let's go over the basics of using it!

One of the cool features added in Maya 2012 is the unified Graph Editor. This means that the curve editors in other Autodesk products like 3DS Max and MotionBuilder are exactly the same as what's here in Maya. We'll be using this updated editor throughout this chapter, as it's simpler and more streamlined, but you can always go back to the old editor by choosing View > Classic Toolbar.

1 Selecting a control initially displays all curves. Selecting attributes in the left panel displays only those curves. You can drag select or shift select for sequential attributes, or ctrl select for multiple, non-sequential ones.

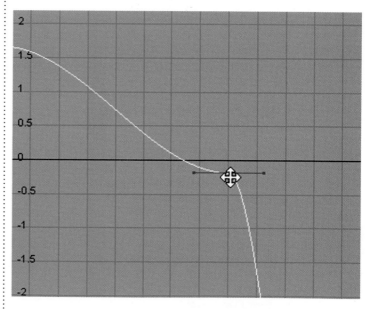

3 The move **W** and scale **R** tools work in the Graph Editor. Once selected, the middle mouse button will drag or edit the curves or keys selected.

2 **Shift alt** and right mouse dragging horizontally expands or contracts the frame range of the graph in view, while dragging vertically contracts/expands the value range.

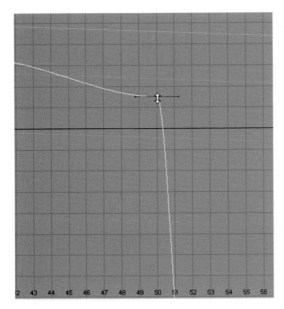

4 **Shift** middle mouse dragging will constrain the movement horizontally or vertically, depending on which way you initially move the mouse.

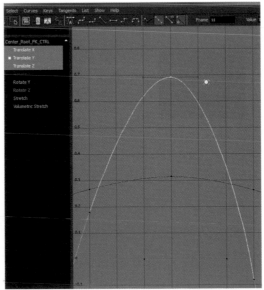

5 If you get a circle when trying to edit, it just means you have the Select tool **Q** active and need to select an edit tool such as the move or scale tool to do an edit.

HOT TIP

Right clicking in the Graph Editor gives you a menu to quickly add keys, change tangent types, swap buffer curves, and more!

67

Visual Tools

THE GRAPH EDITOR IS FULL of goodies, and some of the most important ones let you view the curves in the most efficient way for what you're doing. Whether you need to type exact values, search for keys that may be amiss, compare drastically different curves, or want to isolate specific attributes, the graph editor can accommodate you. In this cheat we'll use a simple bouncing ball animation to test out the options the Graph Editor gives us for oggling curves. We'll be using the new streamlined Graph Editor, which you can enable by going to View > Classic Toolbar and making sure it's unchecked.

1 Open visualTools.ma, switch to the front camera, and open the Graph Editor. Select the ball's move control and its curves appear. Clicking on the attributes in the left panel isolates them, but some of the curves are difficult to see. Enabling View > Auto Frame will automatically focus on any attribute(s) you select.

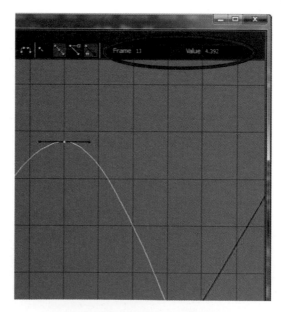

4 The Stats fields show the frame and value of the selected key (or the frame length of a selected curve), which is useful for typing in precise frame numbers or values. You can also use **ctrl C** to copy and **ctrl V** to paste values of one key to the fields for another key or curve.

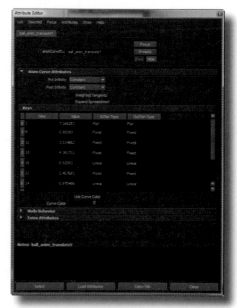

5 If you need to do precise entering of values for multiple keys, you can select curves and choose Curves > Spreadsheet. This gives you values for every key on the curve. You can use copy and paste here, and even change tangent types.

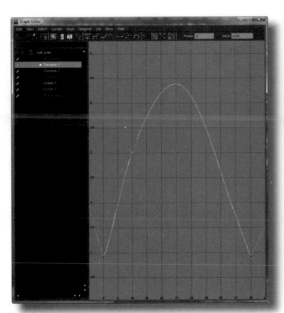

2 Select a few keys and press **F** to focus on them.

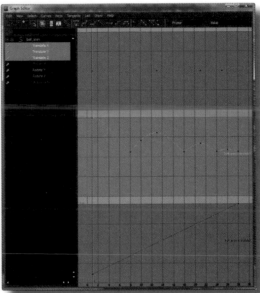

3 Maya 2012 comes with a new way to visualize multiple curves. Select multiple channels and go to View > Stacked Curves. Now all of your channels are displayed in their own stacked panes.

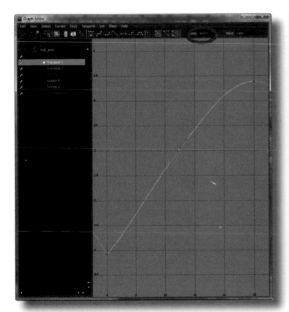

6 On the translate Y curve, select the key at f10. You'll see in the stat field that the current frame is 10.472. In the course of scaling keys or editing them, we can end up with keys that are between frames.

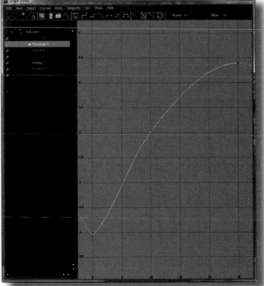

7 Select the Translate Y attribute and go to Edit > Select Unsnapped. All the keys that are not on exact frames will be selected. You can select multiple or all attributes as well. Go to Edit > Snap and the selected keys will be moved onto the nearest frame.

visualTools.ma

HOT TIP

In addition to using the Graph Editor, you can also mute and unmute channels in the channel box by right clicking the attribute and selecting "Mute/Unmute Channel".

69

Visual Tools (cont'd)

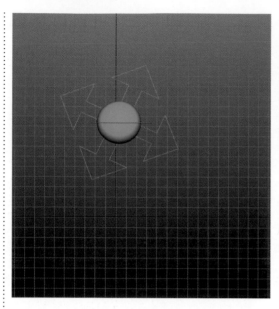

8 The ball is travelling in X as it bounces, but sometimes it's helpful to watch an animation without one of the attributes playing. Select the Translate X channel in the graph editor and go to Curves > Mute Channel.

9 You may have to pan the camera to see it, but now the ball no longer moves in X and simply bounces in place. In the Graph Editor, mute channels have an X next to them. Muting will use the current value as its hold point.

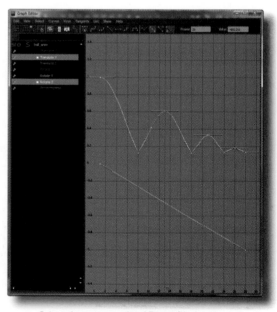

12 Select the Translate Y and Rotate Z channels. Sometimes you'll want to edit curves while comparing to others, but it's difficult because they are in completely different value ranges. Here, we can't see any of the shapes in the Translate Y curve.

13 Select the curves and go View > Display Normalized. Now they are both displayed relatively within a -1 to 1 range and easily comparable and editable. To go back to normal, uncheck View > Display Normalized.

10 To unmute, select the channel, and go to Curves >
Unmute Channel. Everything will go back to normal.

11 To quickly isolate the curves of select attributes,
select them in the Channel Box and press the Isolate
Curve Display button in the Graph Editor. This is great for
quickly showing certain attributes when you have multiple
controls selected.

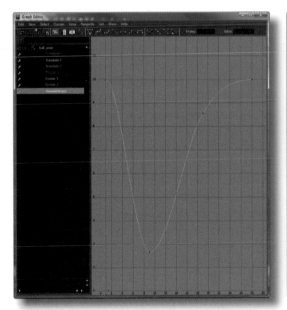

14 Extra attributes beyond the standard Rotate,
Translate, etc. are colored gray, but you can change
that so they stand out better. On the ball is an attribute
called "awesomeness", which doesn't do anything and is just
for example's sake. Select the awesomeness curve!

15 Edit > Change Curve Color lets you pick any color
you like for the curve. Now it will stand out when
looking at multiple curves simultaneously. To remove it, just
select and choose Edit > Remove Curve Color.

HOT TIP

Go to the
Select menu
and enable
Pre-Select
Highlight and
Maya will light
up selectable
objects when
you hover
over them.
Very handy
when selecting
keys amongst
overlapping
curves!

Working with Keys

I N ADDITION TO its visual advantages, the Graph Editor offers some methods of working with keys that you can't get in the timeline or dopesheet. There are often times when we know the general shape of the curve we want to create, but setting keys and then dragging them to create that shape is time consuming. The Add Keys tool allows us to simply click keys where we need them and very quickly create a curve that can be tweaked for the results we want.

There will also be times where you want to add a key into a curve. Simply setting a key works, but the key is created with whatever Maya's default tangent is set to, which can alter the curve more than you want. Setting a key and editing the tangent is a lot of unnecessary work, so Maya offers the Insert Key tool, which can be called upon instantly at any time.

Maya 2012 offers a new Region tool, that is a simple yet powerful upgrade over the Lattice Deform Keys tool. Creating a region of keys and scaling and moving this region allows you to quickly editing multiple keys in an intuitive way. The Lattice Deform Keys tool is still present, but the Region tool has far more potential to become a part of your regular workflow, so we'll show you how to use it here.

We'll be using the new streamlined Graph Editor which you can enable by going to View > Classic Toolbar and making sure it's unchecked.

1 Open workingWithKeys.ma for the start of a bouncing ball animation. Currently we have it translating in X, but no up and down. Select the Add Keys tool in the Graph Editor, then select the Translate Y attribute and select the first key.

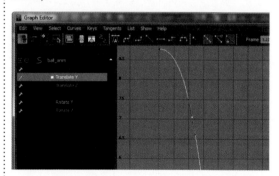

4 Without messing up our Translate Y curve, we need some extra keys at the peaks for a little extra hang time. Select the curve and hold down the **I** key. The pointer will become a crosshair indicating the insert keys tool is active.

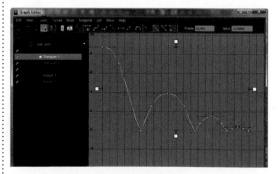

7 New to Maya 2012 is the handy Region tool. Clicking this button will create a region around selected keys with easy to manipulate handles for scaling keys. Clicking anywhere in the center of the region moves the keys.

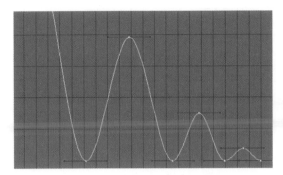

2 Middle click in the graph to add keys. In about 10 seconds I have the general shape of the curve and am ready to refine it.

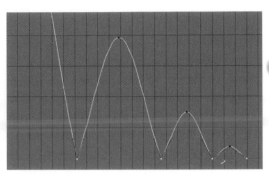

3 Converting the bottom keys to linear tangents gets us most of the way to a bouncing ball.

workingWithKeys.
ma

Maya has a type of keyframe called Breakdown keys, but they're not breakdowns as animators traditionally understand them. They're simply keys that maintain an exact ratio between the previous and following key. This can put them between frames if the other keys get moved. Generally speaking, most animators just use Maya's regular keyframes for everything.

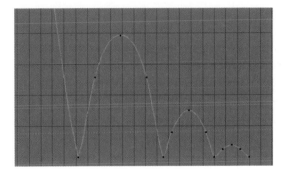

5 Middle clicking on the curve inserts a key without messing up the shape.

6 A few more tweaks and we have all the translation for a bouncing ball in about a minute.

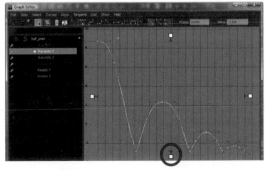

8 Grab the bottom scale handle and drag it downwards. Notice how the keys uniformly scale in value.

9 In the Classic Toolbar mode (View > Classic Toolbar), if you have Time Snap on (see button), then moving the region left or right will automatically snap keys in the region. Turn off Time Snap, select the right scale handle, and scale down the region slightly. Now raise it so that the bottom of the bounce is on the value of 0.

Value Operators

THERE ARE OFTEN TIMES when we need to make specific changes in value to many keys at once. For instance, we might want to see what a walk looks like if we increase the spine's rotate X by 20%. Or we need to quickly scale down a curve's frame range to 33% of its current value. Though you wouldn't know it by looking at them, Maya's stat fields can do calculations that you can use to quickly make precise mass edits on multiple keys. By using a set of value operators, we can get results fast, without clicking on and manipulating tools. Sounds like a great addition to the cheating portfolio, eh?

The value operators are as follows:

+=value Add

-=value Subtract

*=value Multiply

/=value Divide

So if we wanted to add 5 units in value to the selected keys, in the Stat value field we would type +=5 and hit enter. To increase them by 20% type *=1.2 and so on. This cheat will walk you through using value operators in several different situations.

We'll be using the new streamlined Graph Editor, which you can enable by going to View > Classic Toolbar and making sure it's unchecked.

1 Open valueOperators.ma for our familiar bouncing ball animation. There's a ground, but the ball is bouncing too low, about 1 unit or so, and intersecting it.

4 Let's bring the peaks of the Translate Y down 10%. Select the keys when the ball is in the air, and type *=.9 to reduce the value by 10%.

valueOperatros.ma

2 Select the Translate Y curve in the graph editor, and in the value field type +=1 and hit enter. This adds 1 to every key selected.

3 Now every key is 1 unit higher and the ball lines up with the ground.

HOT TIP

Infinity in the Graph Editor refers to what Maya does before a curve starts and after it ends. There are several options, but the default is Constant, which means stay at the first or last keyed value. For Cycles, usually Cycle or Cycle with Offset is used.

5 We can scale the time for keys as well. Select all the curves for the ball and in the frame stat field, enter /=2 to divide by 2 and cut the frame numbers the keys happen on in half. The animation plays twice as fast now.

6 You can also use -=value to subtract. Remember that all the operators work for both frame and value stat fields.

Buffer Curves

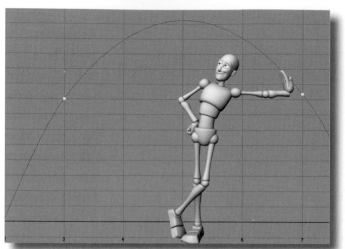

ANIMATION IS RARELY a linear process, and often times we need to compare different ideas to see what works best. Looking at variations saved in different files is a hassle and inefficient, so Maya offers buffer curves in its Graph Editor functionality. We can have two different versions of any curve and switch back and forth between them instantly. For times when we're not sure if we like a certain movement over another, this allows us to experiment without having to redo or lose work.

Buffer curves are best for trying out variations on one or a few attributes. While it's possible to use them on a whole character, there's not a definitive interface for working with them. Switching between many attributes can make it easy to lose track of what you're looking at. Animation Layers are a much better approach for working with variations on a bigger scale, and they're covered in Chapter 11. But when it comes to comparing an attribute or two, buffer curves have a nice efficiency.

1 Open bufferCurves.ma, which has the Goon doing the walk from chapter 8. Select the body control's Translate Y curve.

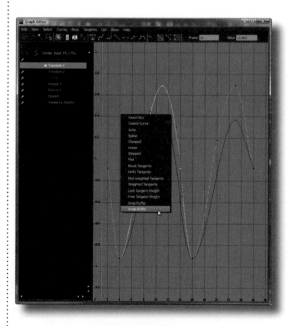

4 Hold the right mouse button and in the pop-up menu choose Swap Buffer to make the buffer curve active. The version you were working on goes into the buffer and you can edit the previous version.

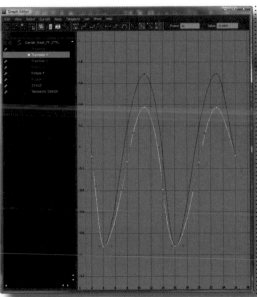

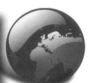

bufferCurves.ma

2 Buffer curves are not visible by default, so go to View > Show Buffer Curves. You won't see anything change yet, as both versions of the curve are currently the same.

3 Move some of the keys around and you will see a gray curve in the background with the shape you locked into the buffer. Now you can edit the curve as normal, keeping the buffer version intact and referencing it if necessary.

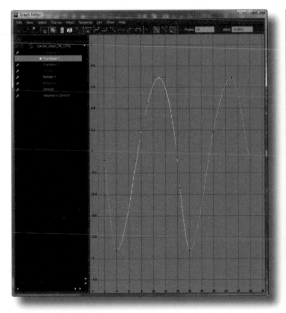

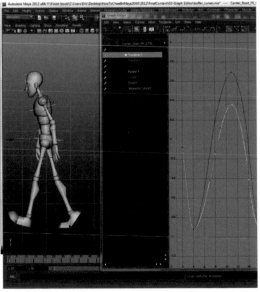

5 In the right click menu, choosing Snap Buffer will snap the buffer to the current version of the curve. This is good for quickly saving the current state of the curve, and then moving on to further experimentation.

6 Use the different curves to compare varying amounts of up/down in the body. If the buffer curves get distracting, or you're finished working with them, just go back to View > Show Buffer Curves to toggle them off.

77

Filming Video Reference

by Eric Luhta

EVERY EXPERIENCED ARTIST USES REFERENCE when creating work, regardless of the medium. From painters to sculptors to draftsmen, all must look at how something truly is in order to interpret, recreate, and make something that a viewer or audience will respond to. As animators, video reference proves an invaluable tool for analyzing physical motion, generating ideas, and crafting a performance.

The reason for reference is simple: either we don't really know how something looks or moves, or we have a compressed idea in our minds that is more efficient than accurate. It's how our brains work and store information, and we can often mistake knowing the essence of something for completely understanding it.

What do I mean by that? Think of a particular car, say a Volkswagen Beetle. Most everyone knows what those look like. Most people could draw something impromptu that represents a Beetle if asked, and be recognized by others as a Beetle. But if you needed to create a 3D model of one for a project, almost nobody (except maybe Beetle engineers) could do it without referencing one. There are so many details: the outlines the doors make, the height of the wheel wells, the angle of the mirrors, how many segments in the hubcap, etc. Our brains are not designed to store extremely detailed information, but rather they store iconic representations that enable us to quickly recall and associate.

Betty Edwards wrote a fantastic book called *Drawing on the Right Side of the Brain* in which she talks about a phenomenon where pretty much everyone who isn't trained in drawing, draws things in a similar way. When asked to draw a house, most drew variants of a square with a triangle on top and squares for windows and a door. A tree was a simple cloud shape with a rectangle on the bottom. Once Edwards instructed people how to use their eyes to draw what they are actually seeing, rather than what their brain is recalling (in its icon-ized efficiency), the difference in their draftsmanship is utterly remarkable.

As animators, video reference provides a basis that we can use to understand how someone really stands up from sitting on the ground, or how their brows furrow when they're upset. If you don't use reference, or only use it occasionally, making it

an essential part of your workflow will dramatically increase your work's quality and authenticity.

Some animators fear that using video reference is "cheating" (yes, I realize the irony in this book, of all things), or that simply copying a video of something isn't being artistic. This can definitely be the case if we're just using reference as a frame-by-frame dictation. In actuality, it's simply a tool, one of many, that we can use in creating something original and unique.

When I use video reference for an acting piece, I'll do dozens of takes acting out the line, trying different approaches and gestures and combinations of ideas. When I go back and study them, never do I end up with a single take that has everything I want in the animation. I'll take bits I like from one and place them with a gesture I like for another, thinking about how these movements are justified in the motivations of the character. Using a composited performance, along with thumbnails, studying other sources like movies, comic books, art, etc, you can come up with something unique that has nuance and detail, and isn't simply a rehash of a clip you made with your webcam.

Most of the larger studios have dedicated rooms for filming reference, but often times smaller ones won't. For these cases I have a cheap, portable HD camcorder with its own screen that I take to work whenever I need reference. I also have a miniature tripod to set it up on. When I need to create some, I can go outside, down the hall, or wherever to get what I need.

When doing an extended acting animation for *Bioshock 2*, there wasn't a dedicated reference filming room. So I, like the other animators, would go in a corner with the video cam, and act out the scene with the line playing on my iPod. It wasn't a state-of-the-art editing suite workflow, but it got the job done.

A colleague of mine told me of how he would film acting reference in an empty conference room that didn't have any playback equipment. He had the audio file looping at his desk, and once he got to the room he'd have a fellow animator call that room's phone from his desk. The other animator would place the phone next to the speaker at his desk, and he'd put it on speaker phone in the meeting room. He would then act out the line in front of a camcorder to film his reference. That's dedication! To go to such lengths to capture video reference states its importance to the animation process. Now get filming!

■ Making changes, tracking arcs, working with multiple pivots, using the timeline, and much more are discussed in depth in this chapter.

4 Techniques

FOR EVERY ANIMATOR there are a variety of techniques that are used throughout the animation process. As you develop your skills, a portfolio of mantras that you call upon regularly will also develop: your kung fu, so to speak.

This chapter contains a wide selection of very useful tools and techniques for animating. While creating a piece of animation, you may call upon some of these techniques dozens of times, others only once, but all of them will make a regular appearance in any animator's workflow. Prepare, grasshopper, for efficiency lies within...

Auto Key

HAVING TO PRESS THE **S** KEY incessantly while animating does two things: gets tedious, and wears out your S key. So in the interest of preventing tedium and extending your keyboard's life, let's look at the different ways we can use Maya's Auto Key. This feature eliminates most of your manual keying, and while it's pretty straightforward, it works great with the Hold Current Keys option, which is easy to overlook.

1 Open AutoKey.ma. The quickest way to turn Auto Key on or off is the button in the bottom right corner. Make sure it's red to indicate Auto Key is on.

4 Looking at the Graph Editor, we see that there are keys on all the hand attributes at f01, but only on Translate Y at f08.

AutoKey.ma

2 There are currently no keys set on the character, he's just posed. Grab the L hand and move it, and you'll notice no key is set. Auto Key only sets keys on controls when you've manually set a key on it first. Undo the move and set a key on it by pressing **S**.

3 Go to f08 and move the hand in Translate Y. Now a key will be set, but only on Translate Y. By default Auto Key only sets a key on the attributes that are changed, not the entire control.

HOT TIP

You can manually key just the Translate, Rotate, or Scale attributes by pressing *Shift* **W**, *Shift* **E**, or *Shift* **R**, respectively.

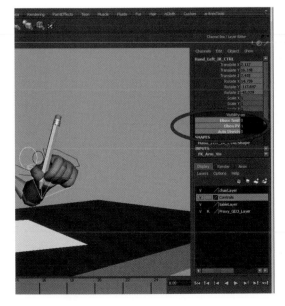

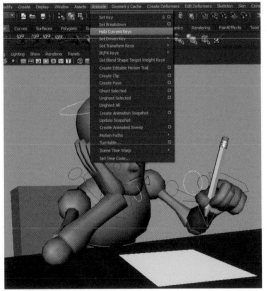

5 In the channel box, select the last of the attributes on the L hand control, right click and choose Delete Selected to erase all keys on this channel.

6 Move to f14 and go to Animate > Hold Current Keys. When using Auto Key, you may want to keep some attributes unkeyed, yet still set a key on all keyed attributes. Using this menu option will set a key on all keyed attributes of a control, but not on unkeyed ones.

Timeline Techniques

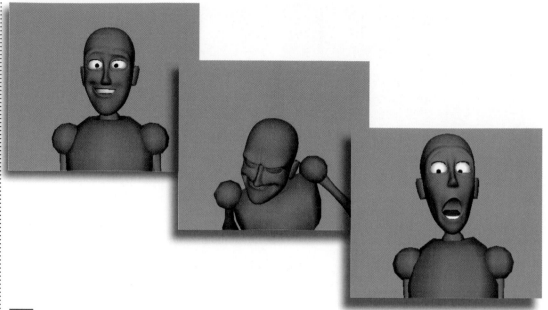

THE TIMELINE is the interface element you will use more than any other when animating in Maya. It has a lot of functionality beyond scrubbing, but its simple appearance can hide how powerful it is. There are lots of edits you can do without ever leaving it, from copy and pasting keys, to reordering them or setting tangent types. Even playblasting is readily available. After working through this cheat, you'll have some timeline chops that will serve you as long as you animate.

We're going to use a simple animation of the Goon doing a take. We have three basic poses and right now that's all they are: poses that interpolate to each other. Let's use some fancy timeline editing to make it less poses and more animation.

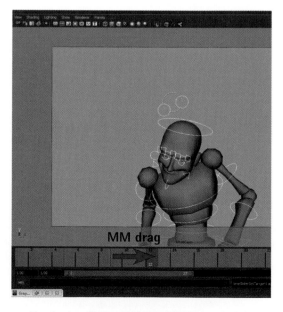

MM drag

3 Now he doesn't move to the anticipation pose until f05, but he needs to hold there also. MM drag from f09 to f12 and set a key to copy that pose also.

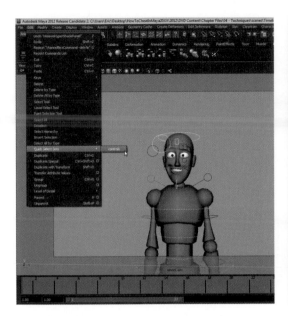

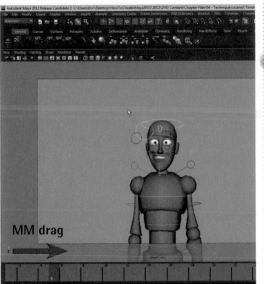

Timeline.ma
Timeline_end.ma

1 Open Timeline.ma. The first pose needs to hold a few
frames longer before the anticipation pose. Go to Edit >
Quick Select Sets > controls to use a predefined set to select
all of the Goon's controls.

2 In the timeline MM drag from f01 to f05. The animation
doesn't change like when you scrub. MM dragging holds
the frame on wherever you started, so it's a quick way to
copy poses. Make sure the tangents are set to Auto, and set
a key at f05.

4 It's looking better, but let's make the transition into the
anticipation a little snappier. *Shift*-click f05 and it will
turn red.

5 Click and drag on the two center arrows to move the key
to f06. Now the transition is only three frames, which
feels better.

85

Timeline Techniques (cont'd)

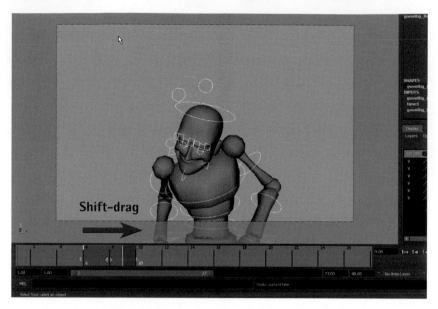

6 He hits the anticipation pose very hard, so let's cushion him hitting that pose. Shift drag from f06 through f09 to highlight them red.

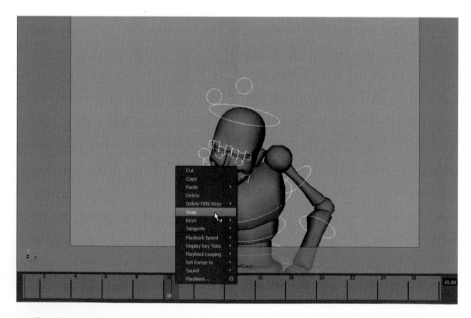

8 That feels much better, but the scaling has put the key between f11 and f12, which can make refining more unpredictable and cause motion blur problems. Right click on f11 and choose Snap to snap the key to the closest frame, which puts it back on f11.

7 Grab the end arrow and drag it through f12 to scale the keys' values out and ease in to the anticipation pose.

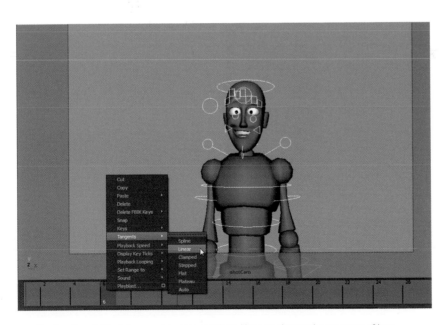

9 The timeline right click menu has many options. You can change the tangents of keys without the Graph Editor, playblast, adjust speed and display options, and more. Use these for speeding up your workflow considerably.

<div style="border:1px solid;">

HOT TIP

The timeline is where you can activate sound for dialogue animations. Import the sound file through the File menu, then right-click on the timeline and select the sound to activate it during scrubbing and playback.

</div>

Figure 8 Motion

'LL ADMIT IT: the first time I needed to do a figure 8 movement for an animation assignment, I was completely stumped. I put my brain into overdrive and came up with elaborate technical solutions involving Maya's motion paths and constraints and probably a dozen mel scripts (OK, slight exaggeration). When someone finally explained the real solution to me, I was dumbfounded at how simple it was. Lesson learned. And to this day there are plenty of times that the figure 8 concept comes in very handy. If it's not for an outright figure 8 movement (such as the hips and hands in walk cycles), I often add it in subtle amounts for texture in head shakes, hand trembles, and much more.

We'll learn this handy concept by doing a simple animation of the Goon Rig doing his best grooving Stevie Wonder head motion. Then the next cheat will show you how to copy the curves onto the body to offset and really get him into the zone.

1 Open Figure8_start.ma and switch to the shotCam camera. The character is already staged, posed, and ready to go. Switch your tangents to flat in the animation preferences.

4 At f12, rotate the head to the opposite side and set a key. He should now have a constant nodding "no" motion.

Figure8_start.ma
Figure8_end.ma

2 The key to easy figure 8's is first doing a simple side to side movement. At f01, rotate the head to screen left and set a key.

3 Go to f24 and set another key to have the same pose at that frame.

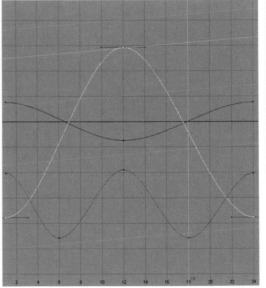

5 Go to f06, halfway through a nod, and rotate the head up in X, and set a key only on that channel. Repeat the same thing at f18, keying only the X channel. His head should now nod back and forth in an arc.

6 In the Graph Editor your curves should look similar to this.

Figure 8 Motion (cont'd)

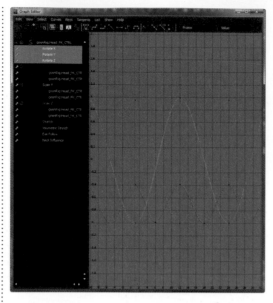

7 Select all the rotate curves and click Curves > Pre Infinity > Cycle, and Curves > Post Infinity > Cycle. If you have View > Infinity enabled, the dotted curves will show you how the curves loop.

8 Reduce the frame range by one frame using the range slider. By looping from frames 1–23, we eliminate the duplicate frame at f24 which would give the animation a slight hitch in its motion.

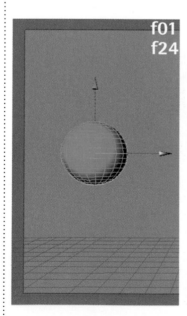

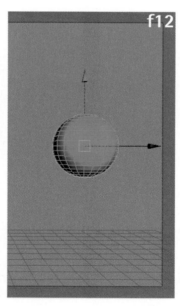

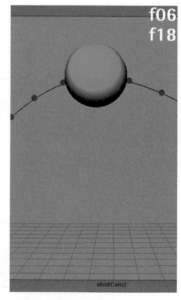

11 Switch to the shotCam2 camera for a ball to translate. With the Translate X, key the ball on the left side on frames 1 and 24.

12 At f12, halfway between, key it on the other side.

13 At frames 6 and 18, halfway through each direction, key the Translate Y upward to create the arc movement.

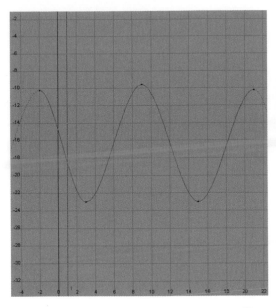

9 Select the rotate X curve and with the move tool **W**, shift it three frames earlier to offset the up and down motion.

10 Play the animation and he will now be moving his head in a figure 8. I tracked the tip of his nose to show the path of the movement. We used rotation in this example but it works the same with translation.

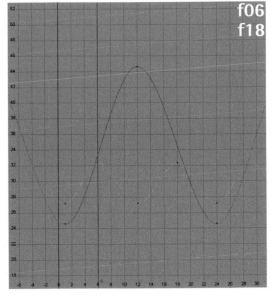

f06
f18

14 Select the curves and make them cycle. Then make sure the frame range is 1-23.

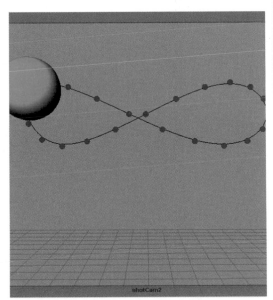

15 Shift the translate Y three frames earlier and you have your figure 8 motion. You can now work with the curves to get the arcs exactly the way you want them.

Copying Curves

OPYING DATA GOES BACK to the earliest functionality of computers, and it is alive and well in computer animation. Maya's curve-copying abilities are rather extensive, and it offers many options for shuffling animation data around to save time and effort. We're going to build on the previous exercise and apply the curves on the character's head to his neck and body to make him much more, well, animated.

As we'll see in this cheat, copying isn't only for putting the same curve on another control. Any attribute's curve can be copied to any other attribute. This is great for taking a curve that is similar in shape to what we want on another control (even if it's a rotate going to a translate, for example) and using it as a starting point. Tweaking a curve can be much faster than positioning the control and setting keys. Faster = good.

1 Open CopyingCurves_start.ma for the completed exercise found in the previous cheat.

4 Select the neck control. Before we paste these curves, go to Edit > Paste > options box. Set the Time range to "clipboard" (to use the curves we just copied) and Paste Method to "replace" and Replace Region to "entire curve". Then press Paste Keys.

2 In the Graph Editor, select the Rotate X Y, and Z attributes for the head control. Be sure to select the attributes in the left panel, not the curves themselves.

3 Go to Edit > Copy in the Graph Editor menu to copy the curves.

CopyingCurves_
start.ma
CopyingCurves_
end.ma

5 The curves will automatically be placed on the same attributes they were copied from if nothing is selected in the Graph Editor. They've been copied to the neck, but now his head is back a bit too far.

6 I moved up the entire Rotate X curve to bring his head forward, then scaled the whole curve down. Now his movement is bigger, but not too much.

HOT TIP

This is a perfectly valid method for blocking in simple animations, but works best with things that are short, or loop, such as a dance or other cycle.

Copying Curves (cont'd)

7 Let's use some of these curves to add side-to-side movement on the chest. The head's rotate Z curve has a similar contour to what we can start with, so select the attribute in the graph editor and Edit > Copy.

8 Select the chest control and set a key at f01. Since we'll be putting the head's Rotate Z on the chest's Rotate Z and Rotate Y, we need to be able to select those attributes in the Graph Editor. Without a key they won't appear.

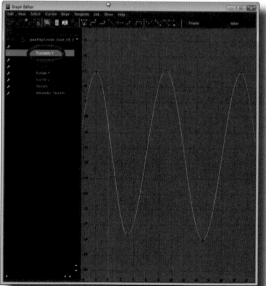

11 Finally, let's add some bounce on his body. The curve most similar to what we want is the head's rotate X, so select that attribute on the head and copy the curve.

12 Select the main body control and set a key at f01. Select its Translate Y attribute and paste the curve onto it. He'll move out of frame because of the values, so let's quickly tweak this curve.

9 In the Graph Editor, select the chest's Rotate Y and Z attributes and go to Edit > Paste. The curve will be put on both attributes.

10 I shifted both curves one frame earlier for a little offset, and scaled them up. Now his movement is much more energetic.

13 I edited the curve so it starts on f01 and his bounces stay in frame. There are also some differences in the values so everything doesn't feel exactly the same.

14 The animation can be refined a lot from here, including adding some bounce in the shoulders, but now you see how we can quickly get a smooth starting point simply by copying curves and not doing any character positioning.

HOT TIP

Copying curves is a great technique, but it's almost always best for quickly giving you a curve to start refining, rather than a finished result. It can also work well for starting overlapping action on things like tails and floppy ears.

Editable Motion Trails

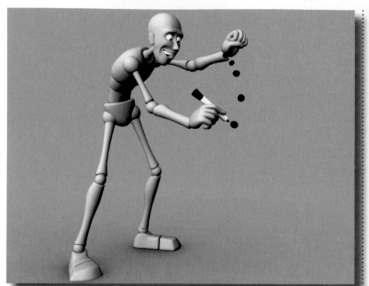

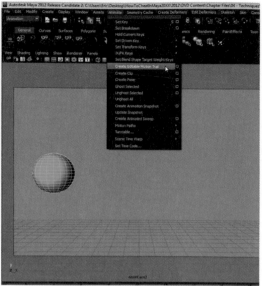

I N ORDER TO GET APPEALING, polished animation, it's a good idea for the motion to travel in pleasing arcs. After all, it is one of the 12 animation principles! There have been plenty of tools made for Maya to track arcs, but what about fixing them directly in the viewport? Wouldn't that be nice? Or even adjusting your spacing without having to go into the Graph Editor? If only there was a way...

There is. One of the best new features in Maya 2012 for tracking and editing arcs (and other things) is the Editable Motion Trail. Not only does it show you the path an object is taking through 3D space, but it also allows you to edit that path directly in the viewport. Needless to say, this has been a feature animators have desired for quite some time, and Maya 2012 finally makes it a reality.

Editable Motion Trails give you lots of power. They work in conjunction with the other keyframe tools (Graph Editor, Dope Sheet) so anything you edit on them will be reflected everywhere else. You can adjust the path of action, timing, and spacing, as well as add, delete, and move keyframes right on the path. This cheat will give you all the ins and outs of this most welcome addition to Maya's animation toolset.

1 In the project file, double check that your tangents are Weighted, and that the tangent type is set to Auto. (See Ch. 2 for more info) The motion trail's behavior is dictated by what tangent settings are present on the curves. Select the ball and go to Animate > Create Editable Motion Trail.

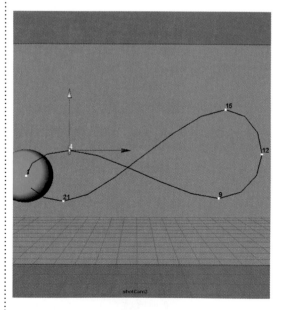

4 Select the move tool **W** and select the key at f04. Just like moving an animation control, you can move the key in 3D space and adjust the path instantly.

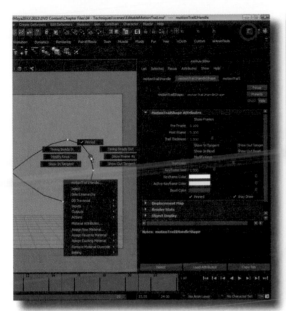

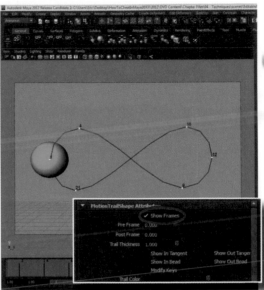

EditableMotionTrail.
ma

2 Open the Attribute Editor if it isn't already and click on the motion trail to bring up its options. You can also right click directly on the trail to quickly access the settings most commonly toggled on/off.

3 The trail shows the path the object takes in 3D space. The white beads show where keyframes exist along the trail. Click the Show Frames box in the Attribute Editor to display the frame number for each key.

HOT TIP

The Trail Color slider is very handy for when you have multiple motion trails happening. Keeping the colors different makes it easier to remember what is what.

After

Before

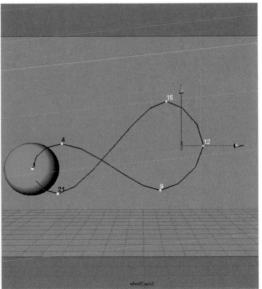

5 Notice the Translate Y curve before and after the change I made in the previous step. Adjusting keys in the motion trail is really just another more visual and natural way of editing the curves.

6 You can select multiple keys and move them just as easily. *ctrl*-dragging will move the selected keys perpendicular to the viewport (i.e., backwards/forwards), which is great for not having to change cameras to make an edit.

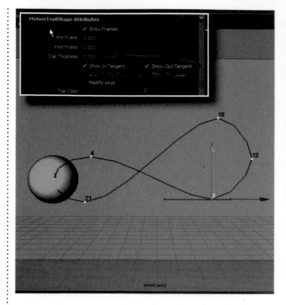

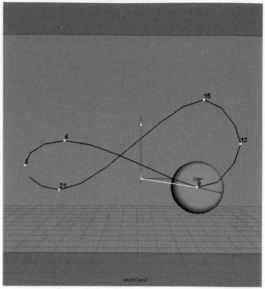

7 Select the key at f09 and in the Attribute Editor (or right click menu) turn on Show In Tangent and Show Out Tangent to show handles for the key. Remember that the way these handles will behave depends on the settings for the curves they are found on.

8 Marquee select the handle and you can use it to edit the spacing in the motion path, just like in the graph editor. Editing handles is easiest when you only use one axis on the manipulator at a time, rather than grabbing them in the middle and dragging all axes freely.

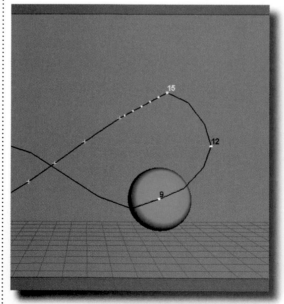

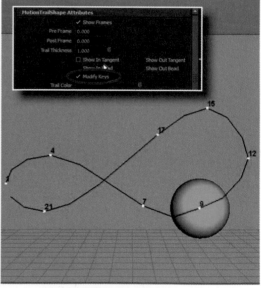

11 Simply clicking and dragging on the beads lets you adjust the spacing. Remember, if you don't see any beads, it's because your tangents on this key are not weighted.

12 Click the Modify Keys box in the Attribute Editor or right click menu. When this is turned on, simply clicking on the trail will add keys, which will use whatever tangents are currently set to default.

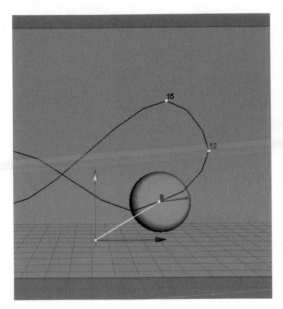

9 If you break the tangent handles (select the curves/keys in the graph editor and click the break tangents button), you can edit them independently in the viewport as well.

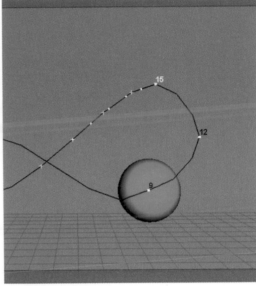

10 Select the key at f15 and click Show Out Bead in the Attribute Editor or right click menu. Beads representing the in-between keys appear on the trail. Notice that you cannot show both tangents and beads at the same time, as they're really just different representations of the same thing--spacing of the in-betweens.

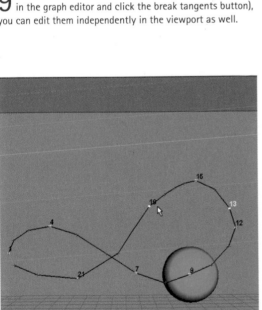

13 For making quick timing changes with Modify Keys, simply hold S and MM drag keys. You'll see the frame number adjust, as well as marks indicating the current position of the in-between frames. Very nice!

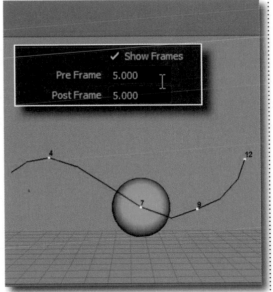

14 In the Attributes, you can enter Pre and Post Frame values. This controls how many frames before and after the current frame to display. This helps if the path crosses over itself multiple times in a small space, which makes the trail hard to read. Setting 0 shows all frames.

HOT TIP

The "Pinned" option means that the trail will stay present all the time. If you turn it off, it will only appear when the object with the trail is selected.

IK and FK

ALMOST ANY RIG that is intended for character animation will have the arms and legs available in two modes, IK (inverse kinematics) and FK (forward kinematics). Many animators have a mode they prefer to use when either is viable, but there will often be times when you have to use a specific mode, at least for part of the animation. If your character is going to plant his hand on something to support his weight or push or pull it, you will have no choice but to use IK arms if you want acceptable results. Switching between the modes can seem tedious at first, but when you understand how switching works, it's really quite simple.

For a quick refresher, FK (forward kinematics) means that the position of the hand (or foot) is dependent upon the joints leading up to it. This is how our bodies work in the real world. To reach up and grab something with your hand, your shoulder must rotate, taking your upper arm with it, which takes your forearm with that, which takes your hand up to the object. You can't raise your hand without at least raising your elbow, and so on. With FK, if you move the character's body, it will move the arm as well. This works well for things like walks and gesturing, but not for pulling or pushing things.

IK (inverse kinematics) is the opposite. The hand is positioned on its own, and Maya figures out where the rest of the arm would be angled based on that. You can think of the hand almost as a separate object that's tethered to the body. If you move the body the hand will stay where it is, making it ideal for pushing or pulling. This way we can work on the body animation without losing the positioning of the hand.

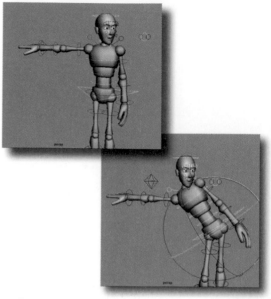

1 Open IK_FK.ma. The left arm is currently in FK. Rotating any of the body controls brings the arm along with it.

4 When Chest Influence is 0, the FK arm will follow with translation of the body, but not rotation. Some animators prefer this because you need to do much less correction on the arms if you change the body.

IK_FK.ma

2 Undo the body rotation and put the L arm in any pose you wish. Again, the arm will follow along with anything we move in the body and spine.

3 Undo everything and select the hand control. In the channel box is the chest influence attribute. Change it to 0. The arm may jump slightly when you do this, which is normal.

5 Undo everything. Select the hand control and set the IK weight to 1 (100%). The arm will move to the IK control and is now an IK arm. Move the body and the hand will stay in place no matter what you do.

6 On the IK control if you set Auto Stretch to 1, the geometry will stretch between the hand and body, rather than separating at the wrist.

IK/FK Switching

WHEN PLANNING AN ANIMATION, an important step is determining if it's best to use IK, FK, or both at different times. When we need to use both, switching between them in a way that's smooth and seamless is the key to quality work. While some animators may dread this element of animating, when you keep in mind how switching works under the hood, it's very straightforward.

The thing to realize is that there are actually two different arms as far as the joints underneath the geometry are concerned. One arm isn't switching between IK and FK modes, we're actually moving the geometry to another joint skeleton. So when you switch to from, say, FK to IK, keep in mind that the frame where IK takes over, the FK arm is still in its last position, following along (albeit invisibly). Remembering that there are two arms at work will make switching more clear in your mind.

While it's possible to blend into the other arm over several frames, I believe it's almost always best to do the switch over a single frame. When you blend, there are frames where the geometry is partially attached to both arms, so both controls affect the geometry to varying degrees. This makes it difficult to be precise in both posing and timing. It can work, of course, but I always prefer complete control at every frame.

Some rigs do have IK/FK snapping, which makes life much easier by automatically lining either arm to the other. Many rigs don't, however, and you just have to pose the switching frame manually, which is how we'll do it here.

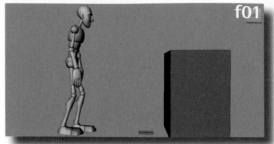

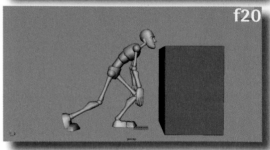

1 Open IKFKswitching_start.ma. There's a simple blocking animation of the character standing, then stepping to push the box. The arms aren't animated yet and they start in FK.

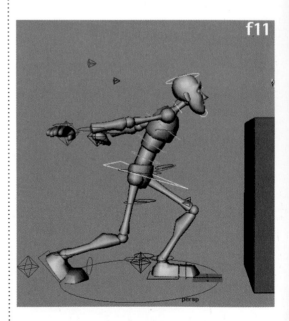

4 At f11, key the IK weight attribute at 1 (for 100% IK). The arms will snap back to where the IK arm skeletons are located.

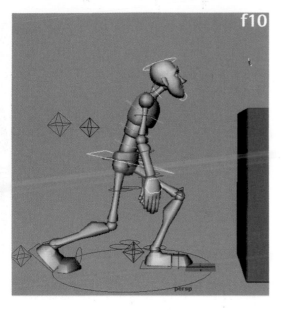

IKFKswitching_
start.ma
IKFKswitching_end.
ma

HOT TIP

For any kind of IK/FK switching, don't sweat the small stuff until the transition is working. Focus on just the hands and hide or ignore the fingers until the foundation is set.

2 First we'll do the switch manually without the snapping tool. F11 is where the switch to IK will happen, so select the hand controls and move to f10.

3 At f10, in the channel box right click and choose Key Selected on the IK weight attribute. This keys it again at 0 so we hold in FK up to f10.

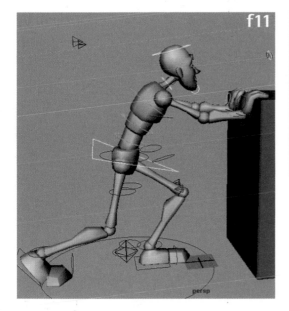

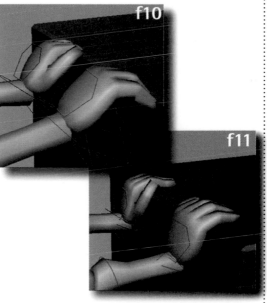

5 At f11, pose the IK hands and fingers on the box. Use the shoulders to help you get a good pose. When doing a switch, it's helpful to first establish the pose you're switching to, rather than basing it off of the transition into the pose.

6 At f10, key the FK arms and pose them going into the IK pose. Try to ignore the fingers and just focus on the palm since we'll need to edit them again anyway. It won't be perfect yet, since we'll also have to adjust the IK pose again in a moment, so just get it in the ballpark.

103

IK/FK Switching (cont'd)

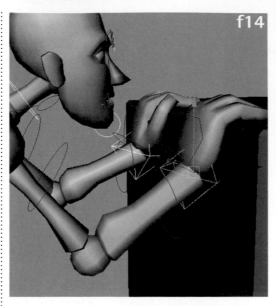

7 Now that the transition is better, we can improve the contact point. Right now his hand just kind of sticks to the box and we don't feel it compress into it. Select the IK controls and set a key at f14 to set the same pose a little later.

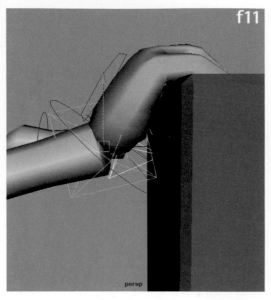

8 Go back to f11 and pull the IK controls away a bit and rotate them down slightly. Again, focus only on the palm and don't worry about the fingers yet. Make the palms ease in nicely to f14 to give a feeling of the palms pressing.

10 You probably noticed that once you get the switch frame, the rest is just normal animating except you're switching between two different types of controls.

11 You may or may not have the problem of his arms going crazy during the transition. If so, it's because of gimbal lock (see Chapter 7 for details), which can happen from time to time.

9 With the press working better, now is a good time to rough in some finger poses and have them trail the palms pressing for some overlap.

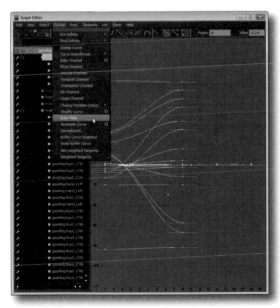

12 To fix it, select all the FK arm curves in the graph editor and use Curves > Euler Filter.

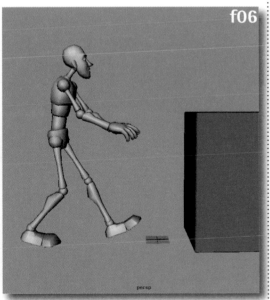

13 Now his arms interpolate to the push pose the way we'd expect and we can continue to refine the animation from there. Chapter 7 is all about gimbal lock if you want more info.

Character Sets

D URING PART OR ALL of their animation process, some animators like to use Character Sets, which are basically selection sets you don't need to select to key. They're kind of a legacy feature, as they've been around since the earlier versions of Maya, but a number of animators still find them useful. Personally, I think they work best in situations where you have to do a lot of keyframing on specific channels of a control, such as the fingers, and for that they can be handy. In this cheat we'll look at how to create and edit character sets.

1 Open CharacterSets.ma. The Character Set selection menu is at the bottom right, next to the Auto Key button. Click the arrow next to it and select "spine".

2 Without selecting anything, press **S** to set a key. This set contains all the spine controls, so they will automatically be keyed with any key. Notice their channels are yellow, indicating they are connected to a set.

5 With the arms set selected, setting a key will now key all the controls. Open the Animation Preferences and turn on Auto Key if it isn't already. On character sets, set to Key all attributes.

6 Now adjusting any of the arm controls will set a key on all the other arm controls automatically. This can be handy for blocking if you make a set for all controls.

3 Let's create a set for the arms. Select all the arm controls and in the animation menu set f2 go to Character > Create Character Set > Options box.

4 In the options, name the set "arms" and select "From Channel Box". Highlight the rotate XYZ channels in the channel box, and click Create Character Set.

CharacterSets.ma

HOT TIP

It's best to create character sets before you start animating. If you need to create a set with controls that are already animated, create a new set with nothing selected. Then add the controls/ attributes to the set using Add to Character Set.

7 To remove attributes, go to Window > Outliner and select the set you want to edit. The attributes will appear in the channel box. Select the attributes you want to remove and go to Character > Remove From Character Set.

8 To add to a character set, have it selected in the list at the bottom, select the objects/attributes you wish to add, and go to Character > Add to Character Set.

Multiple Pivot Points

ONE ISSUE THAT CAN ARISE when animating props is needing different pivot points at different frames. Being able to rotate an object from other pivot points when you need to makes animating much easier. While it is possible to key the pivot point of an object to different spots during the animation, this method is difficult to make changes to and keep track of. It also does not give a clear indicator, such as a channel box attribute, that the pivot point is being animated. Instead, we're going to use grouping to achieve the control we need and make animating multiple pivots more straightforward.

Grouping is basically parenting your object to an invisible object that can be moved, rotated, and translated just like any other object. You might think of it as a container for an object or objects. We can define the pivot point of the group wherever we like, and we can nest groups as many times as we need to get the number of pivots we require.

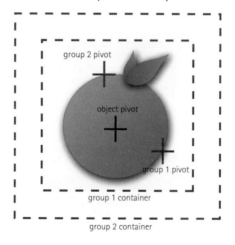

The important thing to remember is, once the groups are created, always animate from the top group down. In other words, the last group we create (the highest in the hierarchy, group 2 in the above diagram) is the first one we animate. Also, once you "leave" one group and move to the next one down for the next pivot point, you cannot go back to the previous one at a later frame. You must plan ahead beforehand so you don't animate yourself into a corner.

It may sound a bit precarious, but this cheat will give you all the info you need to have as many pivots as your heart desires. Always be sure to plan your animation first, determine how many pivots you need, where you need them, and the order in which they happen. For this animation, the shuriken will be flying through the air, so we will need to first animate it from its center, meaning that's the last group we will create for it. It will then stick into a wall with one of the tips. The shaking from hitting the wall will resonate from that tip, so that's where the other pivot will be, within the first group.

So in a nutshell, create the groups working backwards from the end of the animation. Animate them starting at the top group (the last one you create).

MultiplePivots_
start.ma
MultiplePivots_end.
ma

1 Open MultiplePivots_start.ma and go to Window > Hypergraph:Hierarchy to open the hypergraph. This editor displays objects' hierarchies (what they are parented to). Currently the shuriken is by itself.

2 Select the shuriken and press *ctrl* *G* to create a group node and put it inside. You can see in the hypergraph it now appears underneath the group object, meaning it's the child and the group is the parent.

109

Multiple Pivot Points (cont'd)

3 Rename the group to reflect what pivot you're animating by *ctrl* double clicking the name. Again, we're creating them backwards from how we'll animate them, so this is the tip.

4 With the tipPivot group still selected in the hypergraph, select the Move tool and press the insert key. This goes into pivot mode (the arrowheads disappear). Move the pivot to a tip and press insert again to exit pivot mode.

6 Open MultiplePivots_end.ma to see how the animation works. The centerPivot group is animated from f01 to f19. As stated before, the last group that's created is the first one that's animated. As the frames progress and the pivots change, you simply work your way down that list, and never go back to a pivot after the following one has been keyed.

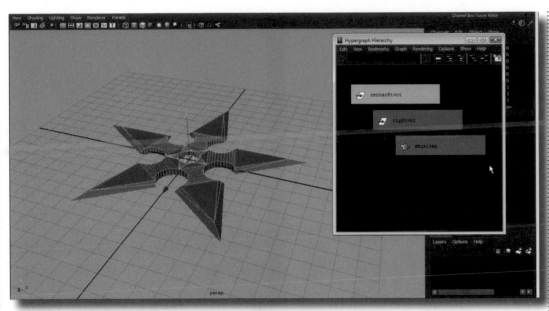

5 Making sure that the tipPivot group is selected, press *ctrl* G again to create another group at the top of the hierarchy and rename it to centerPivot. This is the center of the object which we will animate first, flying through the air. We won't change the pivot on this one since it's already where we need it to be.

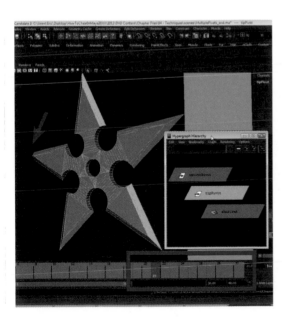

7 From f19 to the end the tipPivot group is animated for the residual energy from hitting the wall.

8 When animating multiple pivots, it's easiest to use the Hypergraph to quickly select the group you want to animate. You can also select the object and use the up\down arrow keys to move through the hierarchy.

111

Reblocking

I T IS INEVITABLE, IT IS YOUR DESTINY... as an animator the time will come (and regularly at that) where you'll need to make changes to work you already started refining. It can be frustrating when it happens, but it's one of the tiny cons to the major pro of doing the coolest thing in the universe. Doing a reblock in the middle of an animation is just a fact of life for an animator. The key to making changes smoothly is knowing how to save what you can, when to shuffle around poses that can be salvaged for other spots, and not allowing the new stuff to derail what's already working.

We're going to look at a sort of test case where we take something that's already in the refining stages of animation, and insert another acting beat into it. We'll start with a simple take animation, and imagine we've been given the direction to have him see a spider first, which then makes him do the take.

As we expand this animation, we'll also use it in the polishing chapter to learn other techniques, such as texture and moving holds.

1 Open MakingChanges_start.ma. We have a simple animation of the Goon doing a take, and we need to add a spider coming down screen left, which he sees and does the take from there.

f40

4 He'll be looking at the spider when he starts the anticipation, so that's a good spot to begin. Select the spider, move it into position at f40, and set a key.

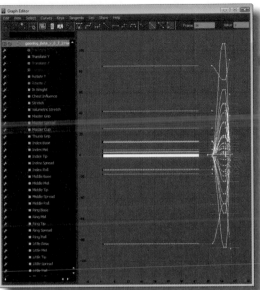

MakingChanges_
start.ma
MakingChanges_
end.ma

2 The first thing we need to do is expand the frame range. Click in the Display End field and enter 70. Typing a number greater than the whole range here automatically expands the entire range.

3 Go to Edit > Quick Select Sets > controls to use the predefined selection set to select all his controls. Select all the keys from f06 on, and move them to start on f50.

f50

f01

5 At f50 alter his pose to make him calmly looking at the spider.

6 Let's keep his eyelids low until he does the actual take, so select the two eye controls. MM drag to f01 and set a key to copy the eye pose.

113

Reblocking (cont'd)

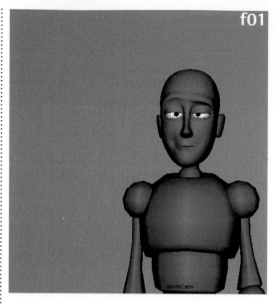

f01

7 Alter his mouth pose to give him a smug, vacant expression. This will add some variety when he changes to the smile when looking at the spider, and hopefully make it funnier.

f40

8 We'll have him hold while looking at the spider for 10 frames for a delayed reaction. Select all controls, and in the timeline MM drag from f50 to f40. Set a key to copy the pose.

f17

11 On the spider, MM drag from f30 to f17 so he has a 7 frame drop down.

f17 f19

12 Rekey the spider at f19 with the same pose as f17. Then go back to f17 and lower him a bit more. This will give him a little overshoot when he hits the bottom.

f30

f10

9 MM drag from f01 to f30 and key all to hold the first pose for 30 frames.

10 Select the spider and at f10, translate it up out of frame and key it.

Here's a good trick when you need to insert new material into an already refined animation: isolate the sections that won't change by inserting keys (hold **I** and middle click) in the Graph Editor on all curves before and after where the change happens. Then delete all keys in between the sections to give yourself some working space. Inserting the keys makes sure any new poses you'll add won't affect the animation you don't want to change.

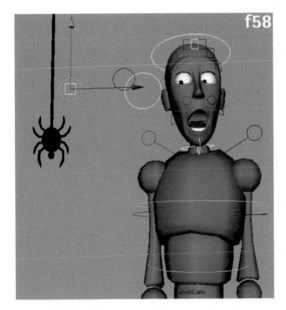

f58

13 To finish this reblocking, we just need to make him looking at the spider at the end. At f58, move the eyes to a better position.

14 With a minimum amount of work, we are able to make this animation much more interesting than its previous version. It's now ready for some more detailed refining with the face and overlap. See the other cheats listed in the intro to keep working on it.

Office Etiquette

by Kenny Roy

IF YOUR GOAL IS TO WORK in a production setting there are some things you should know about the studio environment that may help you avoid problems in the workplace. The following guidelines ensure a copasetic working environment for all:

It is always a good idea to sit silently in a few dailies sessions to observe the culture before offering any feedback to another animator. This not only changes from studio to studio, but from project to project; different clients, different supervisors, budget and schedule constraints all have an effect on how "town-hall" the dailies are going to be. See if the supervisor or director gets all his/her comments out before opening up the floor for discussion. If you are encouraged to give feedback, ALWAYS phrase your feedback positively. In fact, I'd only offer ideas when a supervisor asks for it, at least until I get to know my coworkers very well.

Always listen to your music or your dialogue tracks through headphones. Always use headphones that have good sound insulation. Heavy metal has a way of being even more annoying when you can hear the sound escaping someone else's headphones. The rule of thumb is your ideal working conditions cannot disturb other artists.

I feel this should go without saying, but you have to bathe regularly and manage your body odors. Animators' desks are commonly placed end-to-end and you will be working in close proximity to others for at least 8 hours a day. It is unfair to put others in the uncomfortable position of having to ask you to remedy rogue aromas. Animation is hard enough to create even without an awkward air in the room (pun intended). I am not above sending an animator home to shower if it is necessary.

Pipeline is more than just a suggestion; it's a rule. And in relation to office politics, adhering to pipeline will keep you out of a lot of trouble. For instance, it is common that your animation will be handled by a few different departments before it finally goes on screen. However, if for some reason your work goes against the studio pipeline, you may have created more work for someone else down the line. You can quickly alienate other artists if you are constantly straying from the established pipeline.

Equipment can be a point of contention. Hopefully the studio has a bit of standardization; everyone gets dual monitors and the same speed workstation, etc. It's not always best to be the squeaky wheel when it comes to equipment, including desks and chairs. The more senior artists may become upset if you get the brand-new chair, widescreen LED monitors and a screaming fast workstation on your first day after complaining. Wait to bring up your equipment woes to your supervisor until you have established yourself, or worst-case scenario you cannot get your work done with the equipment you've been given. And never steal someone else's chair!

Another thing that should go without saying, wash your hands every single time you use the restroom. Colds and the flu can travel around studios at light speed because of the close proximity. If you are sick, always cover your mouth (preferably with your sleeve and not your hands) when you cough or sneeze.

Never go over anybody's head. If you have a lead, bring your questions and concerns to him/her. If the problem is big enough, it will be elevated to the supervisor or director. The established hierarchy is set up to make it so that the amount of work that needs to be completed is done so in an orderly fashion. Breaking the pecking order not only hurts your relationship with your higher-ups, it's bad pipeline.

Finally, make an effort to be courteous and generous to your coworkers. The animation industry is an exciting business, but that doesn't mean every day is a picnic. There's overtime, challenging work, computer crashes, schedule delays, and nightmare clients. You're all on the same team, so always be cheerful and helpful and the whole team will brave the difficulties together.

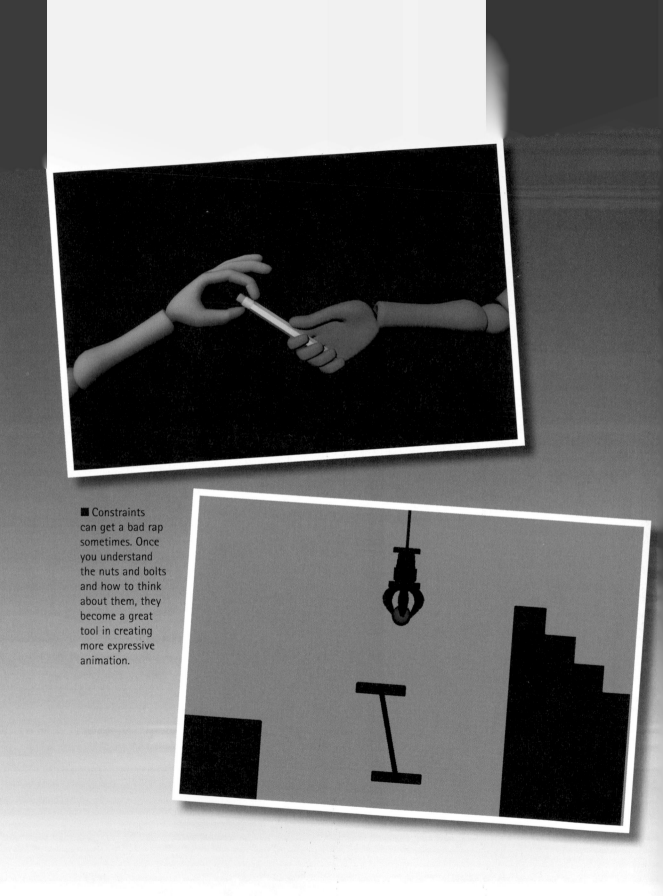

■ Constraints can get a bad rap sometimes. Once you understand the nuts and bolts and how to think about them, they become a great tool in creating more expressive animation.

5
Constraints

SOONER OR LATER every animator must have a character interact with a prop, and that means we need to work with constraints. They can seem a tad complicated at first, but once you understand how they work, you can design a constraint system that is simple and flexible. The next few cheats will tell you what you need to know about constraints as an animator. Then we'll look at some tools that will make constraining a breeze.

Parenting

NOVICE ANIMATORS SOMETIMES confuse parenting and constraining. These two processes behave somewhat similarly, but are quite different under the hood. First let's look at how parenting works.

Parenting is essentially indicating the center of an object's universe. By default, an object created in Maya exists in 3D space, and the infinite area inside the viewport is its central universe.

When we parent an object to another object (referred to as the child and parent), we are making the child object's central universe the parent object, instead of the 3D space. The child can still be moved independently, but its location is defined by where it is in relation to its parent, not where it is in space.

Think of it like this: you are currently parented to the earth. If you are sitting at your computer reading this book, as far as you're concerned, you're not moving. If you get up to get a soda from the fridge, you would say you've moved to a new location. Now think beyond earth and consider your position in the galaxy. When you're at your computer thinking you're not moving, you actually are moving through space (at 65,000 mph!) because the earth is moving through space and you are on it. It's your own perspective that you're not moving, but in relation to the entire universe, you are. This relationship of you to the earth to the galaxy is respectively the same as a child parented to its object in Maya's 3D space. Let's observe this in Maya.

1 Open parenting.ma. Here I've created two spheres, and right now they're independent of each other. We can see in the hypergraph (Window > Hypergraph: Hierarchy) that they're side by side, indicating two separate objects.

4 This is also indicated in the channel box, where we see that, although nothing has changed in the viewport, the little sphere coordinates are different to reflect the new relationship.

7 Use the move tool again to translate the little sphere.

2 Notice the coordinates for the little sphere in the channel box, indicating their position in world space. Move the little sphere and you will see these coordinates update accordingly.

parenting.ma

3 First select the little sphere (the child), then shift select the big sphere (the parent) and press **P** to parent them. We can see in the hypergraph that they are now connected. We've created a hierarchy. The little sphere now uses the big sphere as its reference point.

5 Move the big sphere using the move tool **W**, and the little sphere follows accordingly, maintaining its position.

6 If we look at the little sphere's coordinates in the channel box they're still the same. Its reference point of moving is only in relation to the big sphere, just like our intro example: our perception of moving is related to the earth, rather than the universe.

HOT TIP

When parenting, the order you select the objects in determines what is parented to what. Think "child runs to the parent" to help you remember to select the child first. To unparent, use **Shift P** with the child selected.

8 Now the translate channels for the little sphere change, because it's in a different position relative to the parent.

9 What's this have to do with animating? Knowing the difference between parenting and constraining will help you make a flexible system when using props with your characters. Next we'll look at how constraints work, and then how to use these methods together.

Parent Constraints

Constraints

Parent Constraint

Character's Hand Prop

CONSTRAINED OBJECTS are fundamentally different from parented ones in that they still ultimately reference their position from the origin. They simply get their translate, rotate, and/or scale information told to them by their master object. Think of it as a direct line from the master object's attributes into whichever attributes are constrained (which can be any or all of them) into the target object. When we have constrained a prop to a character's hand, it isn't actually "stuck" there; it just receives the same location information which makes it follow along.

Because of this direct line, we can't move constrained objects because they're "hardwired" to the master object. We can turn the constraint off (using what's called the weight), but if it's on, the constrained attributes cannot be altered independently of the master object.

We can see that there is sort of a yin/yang balance with parenting and constraints. Parenting cannot be turned off or on over the course of an animation, but you can move the child object independently. Constraints can be turned on or off yet are locked to their master object while on. In setting up effective constraint systems, we can use the strengths of each to get the results we need.

1 Open parentConstraint.ma. There are many types of constraints but as an animator, you'll probably use parent constraints most of the time. Parent constraints connect the translate and rotate attributes, and the constrained object behaves as if it were parented, except for not being able to move it independently.

4 In the hypergraph, notice that the objects stay disconnected, and we see a constraint node appear. This is connected to the box, because it looks at the translate and rotate data of the cone, and "tells" the box to do the same.

parentConstraint.
ma

2 In this scene we have two independent objects, a cone and a box. Go to Window > Hypergraph: Hierarchy. Notice how they are not connected like in the previous parenting example.

3 Constraint selection order is the opposite of parenting, where the master object is selected first. Select the cone, then shift select the box, and in the Animation menu set go to Constrain > Parent. The names can make things confusing, but keep in mind this is a constraint, so you are not actually parenting these objects.

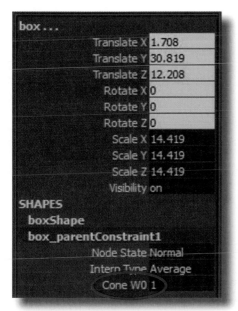

5 In the channel box the box's translate and rotate channels are blue, indicating they're constrained to something. If you click on the box_parentConstraint1 node, you'll see "Cone W0". This is the weight, or how much the constraint is affecting the object. 1 = 100% influence.

6 Translate and rotate the cone and the box follows. Notice how it maintains its position relative to the cone. This is why it's a parent constraint, because it assumes the pivot point of its master object, just like in a parent–child relationship.

Constraining a Prop

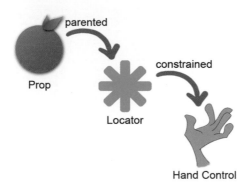

parented

Prop

constrained

Locator

Hand Control

W E'RE GOING TO USE both parenting and constraining to get the most flexibility in animating our props. Instead of just constraining the prop itself, we're going to constrain a locator that has the pencil parented to it. A locator is simply a blank object that you can translate, rotate, and scale. Not only does this create insulation between the rig and prop, but it also gives us the flexibility to reposition the prop and animate it. We're using the benefits of parenting and constraining in conjunction to make animating flexible and easier.

This approach can be very handy if you want to make some adjustments to a prop after you've already constrained and animated with it. Then we'll see how this can allow us to animate the writing movement of the pencil while keeping it in sync with the moving hand.

In a nutshell, the pencil is parented to the locator, which is constrained to the hand. Parenting the pencil lets it follow the locator, but still allow us to keyframe it. Since the locator is constrained to the hand, it follows how we want it to, while still giving us control to animate the pencil movement and keeping it isolated from the rig.

1 Open propConstraint_start.ma. Go to Create > Locator and move it in the area of the prop. If you can't see it, make sure Show > Locators is enabled in your viewport menu. Use the scale tool **R** to make it larger.

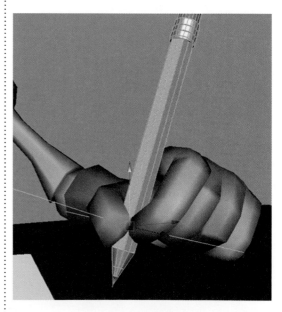

4 Select the pencil, then the locator, and press the **P** key to parent them. Moving the locator will now move the pencil. Using the locator, position the pencil in the character's hand. Keep in mind where it will pivot from between the fingers.

2 In the perspective view, position the locator at the pivot point where the character will hold the prop and where the fulcrum of movement will be. It doesn't have to be mathematically exact, but get it as close as you can, being sure to check the position from all angles.

3 Select the pencil and press **W** for the move tool. Then press the insert key on the keyboard to go into pivot mode. Hold down the **V** key and middle click the center of the locator to snap the pencil pivot to it. It may help to press **4** to go into wireframe mode to do this. Press Insert again to return to the normal move tool.

HOT TIP

When creating any constraint system, it helps to diagram it on paper first. Just diving into Maya and parenting and constraining with reckless abandon can make things very confusing very quickly. Think about what you need to accomplish, where you need control, diagram it, and name your props and locators appropriately. Remember, disorganized constraining will make animating more difficult and ultimately affect your work negatively.

5 Select the hand control, then the locator, and go to Constrain > Parent. The channels on the locator will turn blue indicating a constraint.

6 Now when we translate or rotate the hand, the pencil follows along. We can now easily animate the hand and arm writing. For the subtle movement of the pencil, we can simply key the pencil itself (perhaps with some subtle animation on the fingers as well).

Constraint Weights

1 Open constraintWeights_start.ma. In a viewport menu, go to Panels > Perspective > shotCam to see the camera for the animation. If you like, press the viewport's Film Gate button to frame the animation more accurately.

WHEN WE'RE USING PROPS and objects in our animations, there will be times when things need to be constrained to multiple characters. If a prop is passed between two or more things, it will have to be constrained to all of them at some point in the animation. To tell Maya which constraint we want active at a specific time, we need to use the constraint's weight attribute.

It may be helpful to think of the weight as an on/off switch. Every time we constrain an object to something else, a weight attribute for that particular object is automatically created in the constraint's node in the channel box. Then we simply need to key it at 1 (on) and 0 (off) at the appropriate times.

In this simple animation of one hand giving another a pencil, we're going to see how to switch the constraint weights over one frame to get a seamless transition.

f32

4 Go to frame 32. We want to constrain the pencil to the hand on this pose, as the blue hand will take control of it from this point on. Select the blue hand IK control, then the pencil control, and go to Constrain > Parent Constraint.

7 Go to frame 33, then switch the weights values to the opposite, turning off the pink hand constraint and turning on the blue hand's. Select both weights, right click and "Key Selected".

f50

constraintWeights_
start.ma
constraintWeights_
end.ma

2 Scrubbing through the animation, we can see that the hands go through the motion of giving the pencil, but the blue hand doesn't actually take it. Right now there is only a parent constraint on the pencil for the pink hand.

3 In the layer panel, turn on the Controls layer to see the rig controls. Select the control on the pencil and click on pencil_anim_parentConstraint1 in the channel box. Here we can see the weight attribute for the right hand since it's constrained to it.

Constraint
weights don't
have to be
switched over
one frame. They
can blend over
however many
frames you want
by simply setting
the weight
keys further
apart. Then
the constraint
will gradually
drift into the
next one. You
can even edit
the blend's
curve in the
Graph Editor.
For animations
like this one,
that obviously
wouldn't
work, but for
situations
without obvious
contact changes
it can be handy.

f12

5 You'll see the new weight for the Left hand created in the channel box, but now the pencil floats between both hands. This is because both weights are on, therefore pulling the object equally to keep it exactly between them.

6 Select the pencil control. At frame 32, set the Hand Left weight to 0 (off). Then select both weights, right click and choose "Key Selected" to set a key on both weights. If you scrub through now, the pencil stays with the pink hand the entire animation again.

f46

f37

8 The pencil should now get taken by the blue hand after frame 33. On your own projects, remember to design your animation so you have the right pose to pick up a prop and make the switch look natural.

9 You'll notice that the pencil goes through the pink hand's fingers after it is taken. Once we have the constraint working properly, its much easier to animate the fingers following the pencil as they let go. Open constraintWeightsEND.mb to see the final result.

Animating with Constraints

THERE WILL INEVITABLY be situations where the easiest way to animate something is to keyframe it at certain places, and constrain it in others. Maya makes this simple with an attribute called "Blend Parent," which we can key on and off depending on what we need at a given moment. When Blend Parent is set to off (0), Maya will ignore any constraints on an object and follow the keyframe data. When Blend Parent is on (1), it will ignore keyframes and conform to any constraints currently active. The best part about Blend Parent is it's created automatically whenever you set a key on a constrained object, or constrain something that already has keyframes set on it. When either of these situations happens, Maya creates a pairBlend node that allows us to switch between the two modes (or even blend somewhere in between, hence the name...).

Many times, I find animations that need this approach are simplest when done in a rather straight-ahead fashion. That isn't to say the animation isn't planned out, it most certainly is, but I've always found keeping track of things easiest if the constraints are done during the blocking process. We're going to take that approach here, where we'll start by animating an object (a bouncing ball: the cornerstone of animation education), constrain it to a platform, then keyframe it again, constrain it to a claw, and finally keyframe it through the end. Sounds complicated in theory, but this exercise with a living ball as our character will show you how simple it really is.

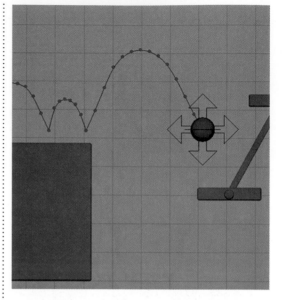

1 Open ballCourse_constraints1.ma and switch to the front view. I've done some preliminary animation of a ball hopping over to a platform, which is also animated. Scrub through and you'll see that the ball doesn't follow the platform after frame 41.

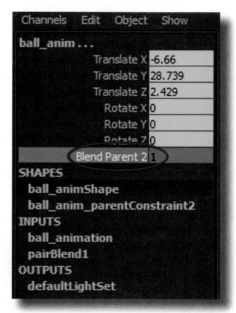

4 At frame 41, right click on the Blend Parent attribute and do Key Selected to set a key on it. This ensures that we will be at 1 (on) at the frame where we want the ball to start following the platform. The channel will turn orange once you set the key.

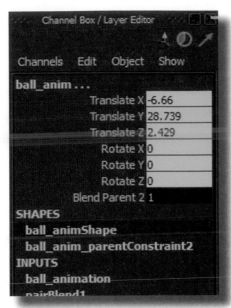

2 Select the platform the ball is on, then the ball move control, and in the animation menu set go to Constrain > Parent. Notice that our channels turn green, indicating both keyframe and constraint data, and the Blend Parent attribute automatically appears.

3 Scrubbing through the animation, we see that the ball now follows the platform, but stays there the entire time. Because Blend Parent is on (1), Maya ignores the keys and follows the constraint. We need to key it on at frame 41, but have it off up until then to see the animation.

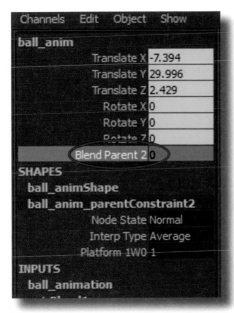

5 Go to the frame before, frame 40, and set Blend Parent to 0 (off). Right click it and key selected again. Since this will be the first key for Blend Parent, all the frames up to it will be off as well.

6 Scrub again and you'll now see that the ball is once again animated until frame 41, where it follows the platform perfectly.

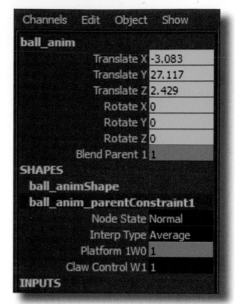

7 Open ballCourse_constraints2.mb. This file has everything we've just done, as well as the blocking animation to get the ball up to where the claw grabs it. Scrub through to frame 88.

8 Select the claw control, then the ball control and go to Constrain > Parent. Notice in the channel box that we get a Claw Control W1 attribute. Remember that these weight attributes tell Maya which constraint is currently active.

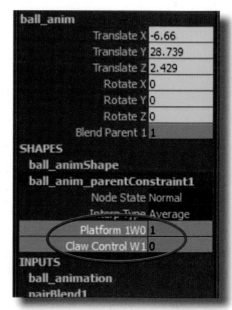

11 At frame 88, key the Blend Parent to 1. This makes it switch on over one frame, making our transition seamless. The ball still doesn't follow the constraints properly though, as we need to set keys on the weights to tell Maya which constraint we want active.

12 At frame 41, RMB > Key Selected the Platform weight to 1, and the Claw Control to 0. The ball will snap back to the platform. However, it should follow the claw at frame 88, so the weights need to change there.

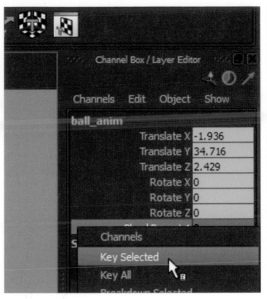

9 If you scrub, you'll notice the ball acting strangely at the constrained parts of the animation. This is because since both constraint weights are on, they both pull at the ball equally.

10 Let's key the Blend Parent so the ball starts to follow the claw's constraint at frame 88. Go to frame 87, enter 0 in the Blend Parent attribute and RMB > Key Selected. At f75, key the Blend Parent at 0 as well. This will make the ball follow its keyed animation from frames 75-87.

HOT TIP

The reason we use 0 and 1 for turning constraints on or off is that it's like binary: 0 = off, 1 = on. Or you can think of 1 being 100% and 0 being 0%., whatever is clearer to you.

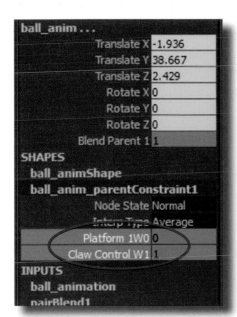

13 Set a key on both weights at frame 87 so this value holds through there. Then at frame 88, key the weights at the opposite values, the platform to 0 and the claw control to 1. Also key the Blend Parent back to 1 so it switches to following the constraint.

14 Now the ball stays with the platform when it's supposed to, jumps on its own from f75-f87, and follows the claw after frame 88.

Animating w/ Constraints (cont'd 2)

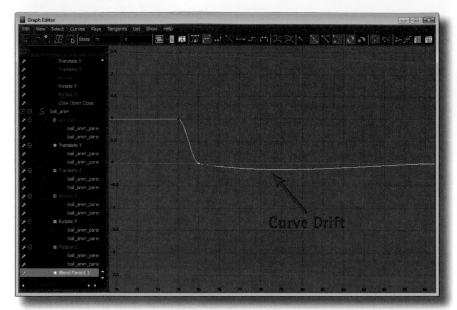

Curve Drift

15 If you notice the ball behaving strangely during the constrained sections, check the Graph Editor. If the curves for the Blend Parent or weight attributes have any drift in them, they will mess up the constraints. Be sure to zoom in and check the curves closely, as they can look flat zoomed out.

FRONT

17 Open ballCourse_constraints3.mb and it will have everything we've done, along with the final blocking animation of the ball being released and bouncing down the stairs. We can't see it, however, because we need to key Blend Parent off once more to tell Maya to once again use the keyframe data on the ball.

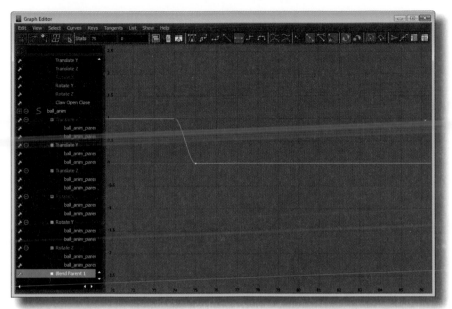

16 If you find this happening, simply select the curves and set them to flat, linear, or stepped tangents using the buttons at the top of the Graph Editor. Any of these tangent types will work for this purpose. See the Spline chapter for more details on how the different tangent types work.

HOT TIP

You can set the options for a parent constraint in Constrain > Parent > options. Here you can tell Maya to only constrain specific axes, if you only need certain ones for your animation.

18 At frame 112, key Blend Parent to 1 to hold it through that frame, then key it to 0 at frame 113. Scrubbing through you should see the ending blocking animation. We now have blocking of all the animation, including the constraints. If you have more constraints in an animation, remember to always have the active one's weight keyed at 1, and all others at 0. Always set a redundant key at the frame before the weights and Blend Parent change to hold the current state up to that point. Remembering those two steps will get you through any number of constraints, no matter how many there are!

Doing Personal Work

by Eric Luhta

AS YOU GROW AS AN ANIMATOR, you will likely develop a laundry list of things you want to animate. Perhaps a particular dialog clip inspires you, or you always wanted to animate a giant spider destroying a city. Even if you are working on projects that you totally love, there will be things in completely different styles or veins that intrigue you. This is good, as it gives you plenty of fodder for personal work; that is to say, things you can work on in your spare time.

Work when you're not working? Of course! After all, if you don't love what you're doing, then you wouldn't be an artist. Naturally, I'm talking about doing this with a balanced perspective. Finding a happy medium between hard work and relaxation are key to enjoying what you do. But spending just a few hours a week on something you work on just for you can be a tremendous benefit to your skill and knowledge.

Personal work can be done in a variety of forms, and it's important to mix it up enough to give yourself a broad range of self-education and growth. Some projects should be short, simple tests of a concept. These are things you could finish in a day or few days. They're generally not finished works you would show, but just things to try something new. This could be anything from challenging yourself to come up with 10 different blinks, to animating pieces of a wall breaking open, to a slick camera move you saw in a film, to any small idea that you will find useful in the context of a larger project. If you're working on a short film, these can be tests of stylistic ideas or pieces of shots you know will be challenging to animate. We all know that our first attempts at something are never our best.

Another idea for doing personal work is recreation of another animation. While not something you want to do all the time, this exercise can be a phenomenal learning tool. It doesn't have to be extensive either. Take one or two seconds of a character animation from an animated movie, and using your own rig, do your best to recreate it exactly. I'm not talking rotoscoping, but having the clip next to you, constantly checking it and analyzing what each body part is doing. You will be amazed at how this makes you look at something in-depth and in a completely different way. All of the master artists learned partially from imitation, and animators

should be no different. Or if you want to practice staging and composition, take a clip from a movie you like, set up the characters, and copy a sequence of shots using simple geometry and placing the characters. A simple layout pass emulating great directors and editors will teach you multitudes.

Finally, there is the personal work that is full animation tests. Dialog clips for acting shots, physical animation tests, anything that requires a lot of work and can potentially go on your reel falls under this category. Rare is the animator who feels like they get enough of the types of shots they love to do at work, so this is where you can have total freedom to do what you love.

Make sure your tests are varied, and not all of the same type. Variety will keep your mind engaged and prevent you from falling into a rut.

Doing personal work will help you grow and develop your own style of workflow and technique. And if you're not working as an animator yet, this is the only way to get there! We're at the point where enough people do animation well that studios aren't impressed by the standard animation tests everyone does in school. To stand out from the reels filled with bouncing balls, a character lifting something heavy, and walk cycles, you need to have a portfolio that shows the same concepts that these tests do, but with things that excite you and show your unique vision as an artist. Keep working, and those little tests and experiments will quickly add up into some serious knowledge and experience.

■ If you've experienced the pain of gimbal lock in the past, put those dark days behind you. We'll not only learn exactly what gimbal lock is, but also how to never let it possess (as in a poltergeist-ey kinda way) your rigs again.

6

Gimbal Lock

EVEN A BRIGHT STAR in the creative universe like animation has its dark nemeses, things that conspire to rob you of your inspiration and turn your artistic endeavour into a hair reduction session. One of the most common technical gremlins an animator has to deal with from time to time is gimbal lock. It's derailed many animations, and it just may have its sights set on yours next...

But so what! You've got this book, and in this chapter all the secrets of gimbal lock and how to combat it (and better yet avoid) lie within. Put the following tools in your shed and leave behind a life of keyframing in fear.

What Is Gimbal Lock?

EVERY ANIMATOR CAN TELL YOU what gimbal lock does to their animations: during playback arms suddenly go crazy, wrists can spin like a top, heads can go exorcist on you. You check your keys and everything appears to be in order. The poses look fine, but between them the animation you knew and loved has become something else entirely. Something....evil? What's going on?

Gimbal lock can happen on anything that can rotate on all three axis: X, Y, and Z. It's not a bug in Maya; it happens in all 3D software, and in real life with things such as robotics. It's a result of mathematical calculations when using Euler (pronounced "oiler") interpolations. We don't need to know what those are, save for the fact that they're why we can use splines and the Graph Editor and why they visually represent what we see in the viewport. Maya has other rotation solutions available that don't gimbal lock (called Quaternion) but it works differently and therefore the Graph Editor no longer makes visual sense in regards to animation. So as animators, we must use Euler rotations if we want to use splines in any capacity whatsoever.

For rotation in the three axes to be mathematically possible with a manipulator, there must be a hierarchal order to them. Anything you can rotate in X, Y, and Z in Maya has a rotation order. It can be set to any combination of the three axes, but it always works the same way. The last axis is the top of the hierarchy:

Rotation Order: XYZ
hierarchy starts with last axis

You can think of it as X being the child of Y, and Y being the child of Z. The last axis will always rotate the other two with it as if they were one piece:

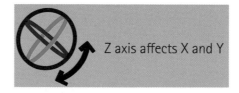

Z axis affects X and Y

Rotating the middle axis will bring the first axis along with it, as if they were a single piece:

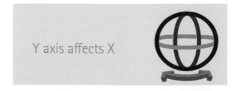

Y axis affects X

Rotating the first axis moves only that one:

X axis affects none

If the rotation order were different, say ZXY, it would work the same way starting with the last axis, which is Y. Rotating Y would also affect X and Z, and rotating X would affect Z. Let's see these two rotation orders in Maya.

1 Open WhatIsGimbalLock.ma. There are two cubes, the first has its rotation order set to XYZ, the second to ZXY.

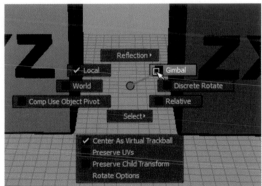

2 We'll go over why in the next cheat, but for now we need to set the rotation mode to Gimbal. Hold down the **E** key, then click and hold in the viewport. When the marking menu comes up, drag over to Gimbal and release the buttons.

3 Select the XYZ box and rotate the Z axis. You can see how X and Y come along for the ride.

4 Undo the rotations to 0, then rotate Y. The Z axis stays put, but X follows along.

What Is Gimbal Lock? (cont'd)

5 Undo to 0 again and now rotate X. Both the Y and Z axis stay put.

6 Undo to 0 and go back to the Y axis. Rotate it 90 degrees and notice that it now lines up with Z. That's gimbal lock. The X axis is gone and the cube can only rotate on two axes now.

f06

9 Between the poses, however, the arms literally flip out. Instead of simply moving into the f11 pose, they flip upward almost over his head, and the L wrist twists into a broken pose.

10 Select the R upper arm control at f11 (make sure you're in gimbal mode as in step 2) and you'll see that the axis is pretty much locked. When this happens, Maya has to twist the arm all around to work through the lost axis and land at the keyed pose.

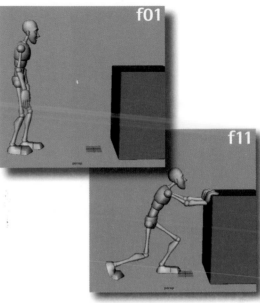

7 Whatever the rotation order is, the middle axis is the one that can cause gimbal lock. We can see here that rotating X about 90 degrees on the other cube causes it to lock. Experiment with the rotation of the two boxes until you fully understand how rotation order hierarchy works.

8 To see the effects gimbal lock can cause, open GimbalLockedArms.ma. The arms have only two keys on them, the starting pose and pushing pose.

11 It may seem a little strange that setting as few as two keys can cause such ridiculous behavior, but we'll see how this is all based on the rotation order. Next we'll talk about why we changed the rotation mode and why you may have never seen gimbal lock happen on your rotation axes (but possibly seen the effects of it).

HOT TIP

It's possible for character rigs to be designed to easily negate gimbal lock (or give additional controls to switch to when it happens), but it must be designed into the rig and therefore is generally found only on production quality rigs.

141

Gimbal Lock

Rotation Modes

WE KNOW NOW WHAT gimbal lock is, but you may have been animating in Maya for awhile now and never seen an axis disappear like in the previous example. It's possible to have experienced the joint flipping gimbal lock causes, yet your rotate manipulator had all three axes readily available. This is because Maya offers several different rotation modes to help make working simpler (visually): Local, World, and Gimbal.

Gimbal mode is the only "real" mode, in that it's showing how the rotations are actually happening. Local and World modes can be thought of as "skins" for gimbal mode. They appear to keep all three axes available to make them easier to work with, but underneath the hood they're actually rotating in gimbal mode. So it can appear to you that you're only rotating one axis, but Maya may be rotating two or all three behind the scenes to give you what you're asking for. And remember that no matter what mode you're in, the Graph Editor's curves will always show rotation in Gimbal mode.

Local mode rotates all three axes together, so it appears that your rotation always stays lined up. This is the default mode and it's very useful once you understand what it's doing and when it's a good time to use it.

World mode always keeps the axes oriented to world space. It's not usually used for animating unless there is no other easy way to get what you need.

Switching back and forth between the modes can really help with your workflow, as long as you're always aware what the modes are actually doing. This cheat gets you up to speed.

1 Open RotationModes.ma. Press **E** for the rotate manipulator. In the upper right corner, press the tool settings button to open the tool settings panel.

2 Under Rotate Settings, select Local.

5 To switch rotate modes on the fly, hold down **E**, click and hold in the viewport, and select the mode you want. Switch to World mode and set the box rotate XYZ attributes to 0.

6 In World mode the axes will never change no matter how you rotate the object. Just like Local mode, Maya is using all three axes underneath to get the results.

RotationModes.ma

3 Select the XYZ box. Remember from the previous cheat that the middle axis in the order is the one that will lock. Rotate in Y -90 degrees, and you will see that this doesn't happen in Local mode.

4 With the Y axis rotated a bit, rotate in Z and watch the attributes. Even though we're only moving one axis, Maya is changing all three. Underneath local mode, Maya is rotating the axes it needs to orient the object how you're telling it to.

HOT TIP

When using Local rotation mode, don't rotate freely on all three axes simultaneously (which isn't possible in gimbal mode). Rotate on only one axis at a time to minimize the additional rotations Maya has to do.

7 Set the rotate mode to Gimbal. Select the R upper arm on the Goon character and rotate in Y 90 degrees. If we started with a pose where his arms are in front like this, we've already gimbal locked. This is how we can get gimbal lock with only two poses.

8 Switch to Local mode. Maya is now allowing you to rotate in Z, but is doing a lot of crazy rotations underneath. Notice I've only rotated up in Z a few degrees, but both X and Z in the channel box have moved -90 degrees.

143

Setting Rotation Order

WE NOW UNDERSTAND rotation in Maya, so let's see how to put it to work for us. One of the most effective things you can do to combat gimbal lock is set your rotation orders when you're doing technical preparation for an animation. So the phase where you're deciding IK/FK, how you're setting up constraints, etc. is also the time to think about rotation orders of any three axis control. It's important to do it here because you can't really change it once you've started animating without using scripts or redoing the animation.

Figuring out the rotation order to use really depends on the actions you need to do in the animation. When you're planning and analyzing the movement you're going to animate, you can look at the movement and see which axis is rotated the furthest, which is the least, and base the order you choose off of that.

This cheat will walk you through doing that with our pushing example, but here's how it works: figure out which axis you're going to move the furthest. Usually anything that you need to rotate at least 90 degrees to start with will be something to consider. For this example, let's arbitrarily say it's X.

Then figure out which rotation will move the least. It may seem a little esoteric to think about this, but it will pay dividends later. If you've planned your animation properly, it should be fairly straightforward. Let's say we find that's it's Z.

Remember that the middle axis is what will gimbal lock, so that's where the least rotated axis should be. The main axis is the last one, so that's where the most rotated will go. To recap this example:

Most rotated = X
Least rotated = Z

We should set our rotation order to **YZX**.

A couple times practicing and it will be second nature. This example is obviously a simple one, but its principles hold true for any animation.

1 Open RotationOrder.ma. This is our familiar push example with the arms zeroed out to default position. Thinking about the poses we need for this animation, rotate the arms down in Z around 90 degrees.

4 Select the upper arm control and press **ctrl A** to bring up the attribute editor. Select the UpperArm_Right_FK_ CTRL tab, find the Rotate Order menu, and select YXZ.

most rotated

Y X Z

least rotated

RotationOrder.ma

2 Set your rotate manipulator to Gimbal. Testing it out before I key the arms, the second pose has Z still about 90 degrees, and Y will be about 65 degrees. X has not been rotated at all.

3 Since Z is our most rotated axis and X is our least, YXZ is a good rotation order for the arms in this animation.

HOT TIP

Even if all 3 axes move a lot, rank them from greatest to least rotated. Setting the rotation order based on that will still help. Some rigs may not let you do this, but this trick should work on many of the free character rigs available.

5 When I rotate the arm down almost 90 degrees in Z, we still have all our axes intact.

6 Better yet, when I go to the second pose, I still have all of my axes, and no gimbal lock whatsoever.

145

6 Gimbal Lock
Zeroing Out Poses

ONE OF THE BEST HABITS to really make instances of gimbal lock minimal is zeroing out your poses when blocking. When the rotations keep picking up from the previous ones when posing, the values will accumulate inefficiently over time. If there are quite a few poses, odds are by the end things will have been rotated significantly more than necessary. More rotations = more chances of gimbal lock. This is just due to the visual nature of how animators work. We should be concerned with how things look, not how values are accumulating. Nevertheless, we've seen that this technical side can have a great impact on our work.

When you zero out poses, you simply start every new pose by setting the three-axis controllers' Rotate XYZ back to zero. By doing this, you aren't stacking rotations on top of each other, and Maya can interpolate between keys much more efficiently. It might seem like a bit of a hassle if you're not used to it, but after blocking with it a few times, it will become second nature and save you an amazing amount of unnecessary work overall. Sounds like good cheating to me. Best of all, if you don't much care for working in Gimbal mode, you can do this in Local mode and simply work in that the whole time.

If you're a bit skeptical on the impact this trick can have, check out this cheat. We're going to fix gimbal locked arms completely with it. No setting rotation orders, no euler filters, nothing except your zero key. Enjoy this classic home remedy for gimbalis lockitis.

1 Open ZeroingOutPoses.ma and put the rotation manipulator in Local mode. We have our earlier example of gimbal locked arms and wrist going crazy in the transition.

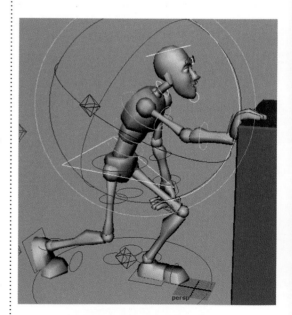

4 At f11 rotate the R upper arm into the pose and set a key. Even though you're in Local mode, always rotate only one axis at a time to maintain efficiency.

ZeroingOutPoses.ma

2 Go to f11 and select both upper arm controls and the L wrist control. Delete the keys on them by shift clicking f11 in the timeline so it turns red. Then right click and choose Delete.

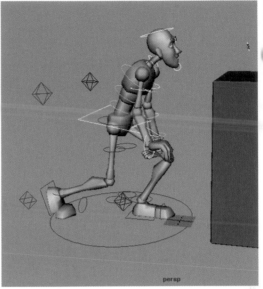

3 The arms will drop down into their f01 pose, although the fingers and elbows still have their keys, which is fine since they're not three-axis controllers.

5 Do the same for the L upper arm and wrist. Again, rotate only one axis at a time. Make this a rule in your workflow.

f06

6 Check the transition and notice that the arms now move like we expect them to into the f11 pose. There's no flipping or strange movement. Remember, we didn't change the rotation order. Zeroing out poses is probably the most powerful prevention of gimbal lock!

6 Gimbal Lock
Euler Filter

MAYA IS EQUIPPED WITH A GREAT TOOL for dealing with gimbal lock called the Euler Filter. While its use is so simple that making a cheat about it is borderline insulting, we can expand upon "choose this option in the Graph Editor" and learn a bit more about what's happening when we animate. And, there will be times where the Euler Filter doesn't work. If it's your first and only line of defense (which the previous cheats have now prevented), you can end up having to deal with a lot of unnecessary frustration.

If you've used any of the other gimbal preventing techniques we've learned, then the Euler Filter will almost surely work if a control locks up anyway. Without those other methods, there's a distant possibility that it won't do anything. At that point, the usual options are frame-by-framing keys to work through it brute force, or starting over if you're not too far along. Take care when frame by framing animations that will be rendered, though, as the extreme rotation flips that will happen between frames (which you won't see in playblasts) can mess up the motion blur. As we'll see in this cheat, you can also attempt to manually work the curves out of gimbal lock, provided things aren't too complicated.

This chapter contains quite a few approaches to working through gimbal lock, and doing all of them would definitely be overkill. Truth be told, zeroing out poses and the Euler Filter are probably all you'll ever need to never lock again. But everyone works differently and you may find occasional situations where the other methods are better suited. When we have plenty of tools to choose from, it makes all of our work easier. Live lock-free and prosper!

1 Open GimbalLocked.ma. Select both upper arm controls and the left wrist control.

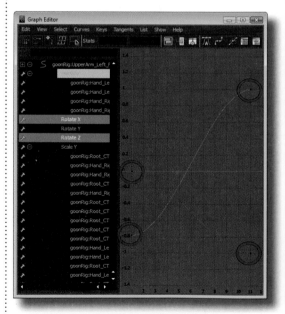

4 Undo back to where the arms flip, and select the R upper arm control. Look at the Rotate X and Z curves and notice that they're moving to almost the opposite values, even though we don't want that in the animation. Gimbal lock often has this 180 flipping of values in the curves.

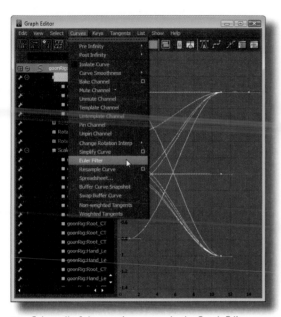

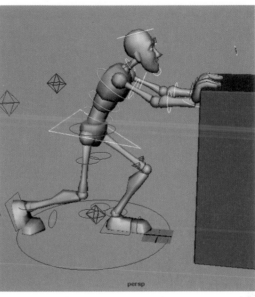

GimbalLocked.ma

2 Select all of the rotation curves. In the Graph Editor use Curves > Euler Filter.

3 The curves will be rearranged into a more efficient order and the arms no longer flip.

HOT TIP

If you happen to be using Maya 2008, the Euler Filter had a bug that rendered it useless. There's an update if you google it or search Autodesk's Area website.

5 Repeat the Euler Filter and notice that it pretty much just eliminated this reversing of values in the curves. Values like 100 and -100 can look identical in position in the viewport, which is why it's hard to notice gimbal lock during stepped blocking.

6 If the Euler Filter doesn't work, search out 180-degree flips and manually drag them (while watching the viewport) to the same value range. If the animation isn't too far along, you can often fix the locking. Practice with this simple example to get the feel for it.

Keeping Perspective

by Eric Luhta

THE JOURNEY OF AN ARTIST is never an easy one. Throughout everyone's career there are high and low points, successes and failures, lessons gifted and lessons learned in the aftermath of a storm. These things are unavoidable, but it's our perspective that can allow us to rise above them, or let them chip away at our love of creating until we're that animator who spends every day complaining about making cartoons for a living.

Perspective is everything, because it's the lens through which we interpret our experiences, and on which we base our responses to them. If you're in the early footsteps of your artistic journey, then the perspective you choose will determine how quickly you learn, how soon you find success, and most importantly, how much you enjoy doing what you're doing. If you've been on this journey for a long time, perspective will create how much you hunger to keep pushing yourself, your graciousness for your success, and most importantly...how much you enjoy doing what you're doing.

I've been a musician for longer than I've been an animator, but I've found you only need to find one artistic philosophy that works for you, and it will apply to any art form you partake of. Allow me to share some ideas that continue to stick with me in the hopes that maybe a morsel of them will resonate with you.

"Process is King"

Nothing changed my outlook more than choosing to enjoy the process of animating, rather than focusing on the goal of having a nice shot at the end. If we animate because animating is fun, and not because we want a test everyone will ooh and ahh at, I think the chances of ending up with both increase dramatically. Why animate characters at all, if it's not fun to actually do it? If you focus on a list of goals you want, you can end up reducing your art to keeping score and tracking statistics of success versus failure. When I focus on the process of creating, enjoying it, and seeing where it leads me with no expectations, I end up looking back at all the goals I passed without even realizing it.

"Art is a Triangle"

Understand that there is a triangular relationship with any piece of art. There is the work, the artist, and the audience. As an artist, you can never have the relationship with your work that the audience does. You know what the idea started as, what was difficult to achieve, what was cut out, what was changed, and every minute detail of the process of creating it. Because of this, your view is somewhat skewed. It may feel like the audience sees the things you do, but they don't. How could they? When you've finished a piece, take feedback, compliments, and criticism, learn from them, and move on. Realize that you will never see your work the way everyone else does. There's no sense in dwelling on what you could have or should have done. Improve your work by carrying these ideas into the next piece, not cringing or rolling your eyes about what's over with. The audience has seen your work and moved on; shouldn't you do the same?

"Many animators, but just one you"

There are a lot of animators these days, and more coming all the time. The competition for work can be intense, and being a skilled computer animator is becoming commonplace, rather than the rare commodity it was even just ten years ago. There will always be animators who are more skilled than you, no matter how good you are. How do you keep from getting discouraged? By realizing that this isn't a race, and measuring artistic skill is pointless. Your value comes not from your knowledge of technique, but from being you. No other animator will have your unique experiences, your life, or your knowledge. In your individuality, you have something nobody else can compete with, ever. Focus on becoming the artist that is yourself, with your own ideas and sensibilites, and you will find contentment and success.

"Keep it real"

You will undoubtedly run into bitter artists from time to time, the ones who complain about everything. They have every right to choose to do this, but that doesn't mean you have to. If you find yourself getting stressed out when working, put things into perspective. Nobody will die based on your animation choices, nobody will get hurt. The fate of millions is not dictated by an acting choice and not nailing your blocking on the first or second try does nothing to disrupt the space time continuum. If the biggest problem you face during the day is getting a cartoon character to look a certain way, you are most certainly blessed. Even if you're the intern at a studio, remember how many would give their left arm to be where you are. The happy artist doesn't get what they want, they want what they have.

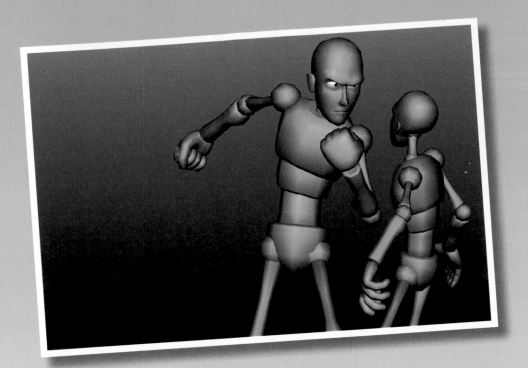

A brilliant animation doesn't look like one if it's not filmed effectively. This chapter contains everything from animating cameras to composition to the new camera tools in Maya 2012.

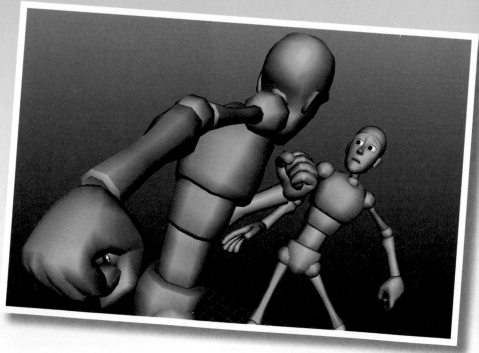

152

7 Cameras & Layout

AT ITS HEART, animation is about storytelling. And not too long after the camera was invented did master storytellers start using them to craft films. As animators, our primary job is to create performances within a scene. However, as the craft becomes more widespread and animators need to be more well-rounded, knowing how to manipulate cameras in Maya will become required for the job. Animators wishing to create short films or test animations for their demo reels also have to familiarize themselves with camera work to be able to compete for the top positions at major studios. Finally, knowing a little about film directing, editing, and composition will only help you integrate your performance choices better within the scenes you are given. Let's look at new tools in Maya 2012 that give you true filmmaking power in creating animated performances.

Framing and Lenses

ANIMATORS WORKING WITH MAYA 2012 will find that the camera tools are second to none. They have to be! Maya is the de-facto standard of visual effects studios around the world. Visual effects supervisors need to work closely with cinematographers and be able to use the same terminology. If you are planning on a career in visual effects, it will behoove you to understand the fundamentals of camera work, and know how to frame your shot for the greatest impact.

Don't forget your staging! In all scenes it is imperative to make sure your action is staged nicely in order to allow for dynamic camera angles and lenses. Take the time to really practice interesting staging, with dynamic poses and compositions. A lot of times, experimentation will lead to the best choice; time spent "feeling around" the scene will pay dividends when your animation starts coming to life.

When your staging is complete, it's time to pick angles and lenses. Remember that a low angle can make a character seem formidable and aggressive. A high angle can make a character seem small and unassuming. Wide angle lenses distort perspective to an extreme degree, and are good for establishing the scene layout, moving through the scene, and for when you want perspective to play a role in composition. Narrow or "long" lenses remove the effect of perspective on your composition, are great for flattening the scene layout, and are generally not used for moving cameras because of the lack of depth.

Let's apply these principles in a scene that has been staged for us. It is a scene where a bully is about to clobber a smaller student at school. The poses have been set, and now it's time for us to create some cameras to get the right feeling in this scene.

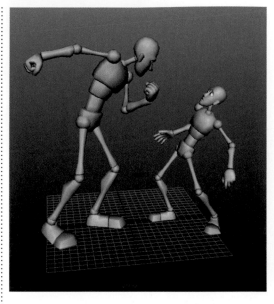

1 Open framing_start.ma. Our characters have been posed, and it's time to set up this shot to get some dynamic camera angles.

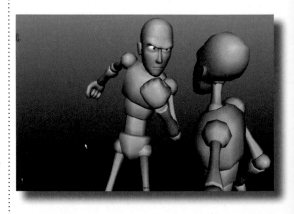

4 This is a good start. We've recognized that the bully should be seen from a low angle so that he looks very foreboding, and the little kid is being pushed close to the frame edge so he feels cornered. However, since the little kid is in between the camera and the bully, he's actually almost as big as the bully in composition.

framing_start.ma
framing_finish.ma

2 Create a camera by going to the Create menu, and selecting Cameras > Camera. A camera will appear at the world origin. Let's switch to this camera by going to the Panels menu, and choosing Look Through Selected.

3 Our view changes to the new camera's perspective, and we're staring right into the bully's foot. Charming. Now let's move this camera to an angle facing the bully, and try to make it so that it shows off how big he is.

HOT TIP

When working with multiple cameras in a scene, choosing with the Outliner and using Look Through Selected is the fastest way to move between them.

5 Open up the camera's attributes by clicking the small "Camera Attributes" button in the top left of the panel. In the Focal Length attribute, put in 200. This makes the camera a 200mm lens, far more telephoto and zoomed in than Maya's default: 35mm.

6 Now dolly the camera backwards by *alt* RMB dragging. Notice how the bully is bigger in composition, even though he's farther away? With this nice zoomed lens, the effect of perspective has been diminished and we've flattened the scene to keep the bully larger in composition.

Framing and Lenses (cont'd)

7 But we're still not ready to animate; we have to check what the scene is going to look like once rendered. Hit the Resolution Gate button in the camera panel. The box that appears is our render area, and I'm not happy with the bottom being cut off. Adjust the camera to get their hands in frame.

8 Now let's frame the "reverse" (a camera facing the other character in a scene). Switch back to the Persp view and create another camera but this time create a "Camera, Aim, and Up". This camera type has handles that allow us to keep its orientation well under our control.

11 In reality ALL cameras have aims, and ups. When you dolly a camera around in Maya, you are actually moving that camera's aim. In fact, it's possible to get this aim so far away from where it needs to be it causes trouble. In the Persp panel, select and Look Through "crazyCam".

12 It's almost the same angle as our other camera, so what's wrong? Orbit the camera and watch as it behaves totally unpredictably. Its Center of Interest is very far away, which can happen without you knowing it. The fastest way to get a camera to return to normal is to hit **F** to Frame Selected, and then reframe the shot.

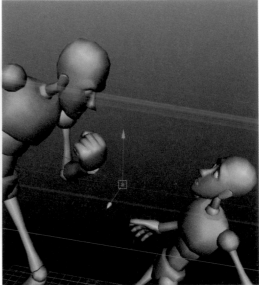

9 Look through the new camera, and use the normal camera tools to frame the shot as above. You'll notice that the aim moves with your camera when you dolly, and that the camera rotates around it when you orbit, (**alt** + LMB).

10 As I said before, the nice thing about a Camera, Aim, and Up, is that you are given controls to precisely control the orientation of your camera. Fine tune the framing of the shot by switching to a two-panel layout and moving the new camera's aim in a Persp panel.

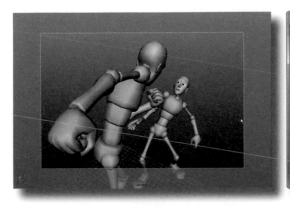

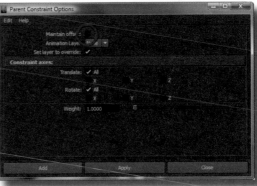

13 Switch back to camera2, and let's make the shot a little bit wider, to emphasize the bully's fist in composition. Set camera2's focal length to 25 and then dolly and pan to frame the shot like above. Don't forget that your cameras have their own Undo buffer. **[** and **]** undo and redo camera movements.

14 Every once in a while we'll happen upon a framing that we love, but "Oh no!" we're looking through the Persp camera! No problem! Create a new camera, then Parent Constrain the new camera to the Persp camera with "Maintain Offset" unchecked. Voila, camera saved!

HOT TIP

Pros can spot a default 35mm camera from a mile away. Using a default camera homogenizes student work. In your personal work, distinguish yourself right away by choosing a new lens for your shots. It might even be a good idea to open the Create > Camera > Camera Options box and set your default focal length to 50 or 60 just to be sure you won't accidentally follow the crowd!

Camera Sequencer

N EW SINCE THE LAST *How to Cheat in Maya* book is the Camera Sequencer tool. Introduced in Maya 2011, this tool has received some very nice updates in 2012. The idea behind this tool is to make it so that complex scenes with multiple cameras can be visualized all within a Maya panel. In production, it is quite common for a sequence with very complex "hookups" (the animation that continues across an edit from one shot to the next) to be blocked in a single Maya scene and then sliced up into component shots. Certainly at the previz stage, when the director has to make camera placement and editorial choices with very little to go on, this tool will be extremely helpful. Now, animators can create an entire sequence within a single scene file, and even do some basic editing with the director to get a better "feel" for a sequence as early in the film as possible.

We are going to see how powerful the camera sequencer can be by setting up a sequence using a shot we've already blocked. Let's add some drama and story to this scene by using creative composition and camera work.

1 Open up sequencer_start.ma. This scene looks familiar! I've extended the timeline just a little bit to give us more frames to work with.

3 Let's now add all of the cameras to the sequence. Click on the "Create Shot" button in the top left corner of the Camera Sequencer. A shot will appear and its length will match the time slider.

sequencer_start.ma
sequencer_finish.
ma

2 Set your panel layout by going to Panels > Layout > Two Panes Stacked in the viewport menu. Now in the bottom
panel, choose Panels > Panel > Camera Sequencer. The Camera Sequencer will load in the bottom panel.

HOT TIP

You can export the edits you do in the camera sequencer as XML files to use in other software packages, like Final Cut. Just go to File > Export Editorial.

4 Now right click on the added shot and click on Change
Camera > Camera1. This will designate Camera1 as the
camera for this shot in the Sequencer.

5 Create two more shots using the "Create Shot" button,
and change their cameras the same way we just did, to
Camera2 and Camera3, respectively. Your Camera Sequencer
should look like this. Note that the traditional panel zoom
and move tools work the same in this panel.

Camera Sequencer (cont'd)

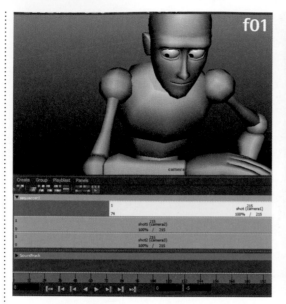

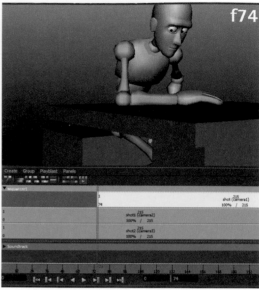

6 So, what exactly is going on? Just like layers in Photoshop, the shot that is on top of the Camera Sequencer will display. Move the top shot to the right by LMB clicking in the middle of it and dragging it to the right. Hit play on the bottom of the Camera Sequencer.

7 You may notice that Camera2 is displaying up until the timeline gets to the beginning of Shot 1 in the Camera Sequencer, at which point it goes to camera1. BUT! Also notice that it goes back to Frame 1 as well! We'll fix this now.

9 Unless you want to render multiple angles and takes of the same motion (called "coverage" in filmmaking) you are most likely going to want to keep linear time in your sequences. Manipulate the shots by grabbing the top row of numbers instead. Drag the top right number to 52 and hit play. The camera switches from Camera 1 at frame 52 and Camera 2 picks up the action.

8 There are four numbers on a shot in the Camera Sequencer. The top row corresponds to the start and end frame in the scene file itself. If you move or scale a shot in the Sequencer, you are effectively editing non-linearly in time. The bottom row of numbers corresponds to the Sequence you are creating. Hence in our shot right now, at f163 in our Sequence, Maya is switching to camera 1 and playing all of frames 1-215 at fast speed until the end of the sequence.

10 We're going to layout this sequence cinematically, but first let's split shot1 so that we can go back to our "master" shot at the end of the sequence. Drag the timeline in the Camera Sequencer to frame 26. Right click on shot1 and choose Split Shot.

HOT TIP

When working on the lengths of shots within a cut, you can use the Edit > Ripple Edit option to automatically adjust other clips affected by the edit. For example, if you lengthen a shot in the middle, the following shots are moved over automatically to compensate for the middle shot's new length.

161

Camera Sequencer (cont'd 2)

11 Layout the scene like I have here. We go from Camera 1 to Camera 2 when Goon notices the person off-screen. Then we cut to the close-up of his eyes as he watches them pass. Finally back to the wide shot, Camera 1, to finish the scene. Make sure your shot and sequence frame numbers line up.

13 If we want to submit this edit choice as its own movie file, it's simple and easy with Maya 2012. Click on "Playblast" in the Camera Sequencer Panel, and choose "Playblast Sequence". Notice how Maya can now playblast "Offscreen", meaning program windows that get in the way of the Main Maya window will not interrupt the playblasting. Convenient!

12 We need to get a feel for how the shot is going to render, so let's apply the resolution gate. Select Camera1 in the outliner and open up the attribute editor. Change Fit Resolution Gate to "Vertical". In the Display Options tab, check both "Display Resolution" and "Display Gate Mask". Change the Gate Mask Opacity to 1, and Gate Mask color to Black, and change Overscan to 1.0.

14 A final update to this tool comes in the area of audio. You can add multiple tracks of audio in the Camera Sequencer itself. Just click on File > Import Sequencer Audio and choose a file. Another nice feature is the ability to link audio to a shot. Select a piece of audio and shift+select a shot. Right click on the audio and choose Link Audio. Now the audio will match the edit of that shot.

HOT TIP

When you are working in the Sequencer, you can not only time your sequence, but strengthen the framing and composition of your shot by adjusting the camera live. Work with the attribute editor open, and manipulate the camera as it is loaded by the Sequencer. You could even create multiple cameras to start and then wait to frame them until after they're in sequence.

UberCam

THE UBERCAM IS A BRAND-NEW addition to the Camera Sequencer that allows you to create a single camera that follows all of the edits of your sequence. This has a lot of potential for production purposes. Firstly, having an animated camera means that you can watch your sequence without having to use the play controls in the Camera Sequencer; you can simply have the Ubercam loaded as one of your panels and work this way. Secondly, rather than render multiple sequences at rendertime, the single UberCam can be chosen as your renderable Camera, saving you time when it comes time to composite a sequence. The last benefit is scene overhead and manageability. In a very long sequence you may have a dozen cameras and 20 to 30 edits. With the ability to use this new tool to bake all of this data onto a single camera you can unclutter the outliner and get back to creating compelling performances with your characters.

We'll use the sequence we just finished to practice creating and manipulating Ubercams.

1 Open ubercam_start.ma. Change a panel to the Camera Sequencer and hit the "Frame All" button in the top left corner of the panel. Remember, the normal Maya zoom and move controls work in the Camera Sequencer too.

4 The Ubercam is not updated live, however. Change your panel layout to Four Panes in Panels > Layouts. Make the top left Panel your Ubercam, the top right panel camera3, and the Outliner in one of the bottom panels.

ubercam_start.ma
ubercam_finish.ma

2 Creating the Ubercam itself is very simple. In the Camera Sequencer Panel, click on Create > UberCam. Maya will create the camera and it will show up in the Outliner.

3 Change the bottom pane from Camera Sequencer to Ubercam. You can either select the Ubercam in the outliner and click on Panels > Look Through Selected, or simply click on Panels > Perspective > ubercam. Now you can watch the sequence playback in this panel while making changes to the animation.

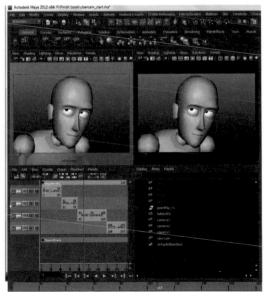

HOT TIP

Rename your Ubercams to represent edit versions, (e.g., edit_v1_cam, edit_v2_cam). You can then load your Ubercams BACK into the Camera Sequencer to compare your current camera sequence against older versions, and really experiment to find the best result.

5 Select camera3 and open the attribute editor. Change the focal length attribute to 120. Camera3's focal length changes, but the Ubercam's does not. Since it is not a live connection, we have to recreate it.

6 Whenever you make a change to a camera position, focal length, or any animatable attribute, you must recreate the Ubercam. Select and delete the Ubercam from the outliner. Change the bottom panel back to the Camera Sequencer and do Create > Ubercam. Back in business.

Animating Cameras

NOW THAT YOU ARE FAMILIAR with static cameras, it's time to learn some cheats on animated cameras. You will quickly discover that animated cameras really are a totally different animal.

For starters, audiences have become very savvy and you can't get away with unrealistic movement in your camera work. It stands out badly, and for potential employers demonstrates a lack of understanding of filmmaking. So we'll take a look at animating a camera in a realistic way, as if a person is holding it.

In live-action filmmaking, camera movement has been taken to some extremes; from helicopter cameras, underwater cameras, Steadicam, motion-controlled cameras, huge cranes and boom shots, directors have never stopped searching for new ways to move the camera. Our second scene is going to deal with animating a camera moving in an extreme way.

Within both these scenes, and all of your animation, you should bear a few rules in mind. First, know what kind of camera movement you are trying to recreate. Second, key the camera as little as possible. No matter what kind of effect you are trying to achieve, camera animation looks very choppy, very quickly. Last, only move the camera with a purpose. Staging, composition, and story dictate whether or not the camera should be moving.

1 Open anim_hand_start.ma. Our familiar bouncing ball animation is going to benefit from an animated camera, as if the camera is hand-held. Prepare the scene by opening three panels (renderCam, Persp view, and the Graph Editor), and the renderCam's attributes.

4 Another thing that really makes a camera feel hand-held is it lagging behind the action a little bit. Key the camera again on frame 61 and 68, and make sure the ball is leading the frame.

anim_hand_start.
ma
anim_hand_finish.
ma
anim_motion_start.
ma
anim_motion_
finish.ma

2 One of the quickest cheats to make a camera look hand-held is to make it look like the camera operator "notices" the action. Let's achieve this with an animated zoom. Key the Focal Length at 35 on frame 1, and then key it at 60 on frame 36. Flat the tangents in the Graph Editor.

3 Now let's key a little bit of pan and tilt in the camera. Hit **S** to key the camera on frame 1. Then on frame 24, frame the ball in the center of the camera by rotating the camera in the Persp window. Set a key again on frame 36, 43, and 52, with a VERY small amount of random rotation.

HOT TIP

We flattened the tangent on keys set on Focal Length because on a real camera, the zoom ring doesn't move unless it's being touched. We are creating the illusion that the camera operator is letting go of the zoom ring when we flat the tangent.

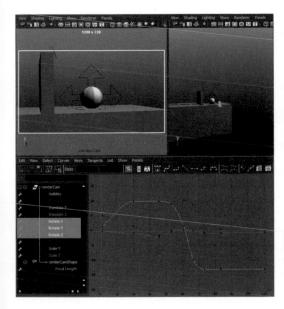

5 Set two more keys on 76 and 88, and settle the camera. Then one more key frame on 120. Do not flat this last tangent; animated cameras should never come to a complete stop, and certainly not right at the last frame.

6 Let's key one more quick zoom in. Key the Focal Length on frame 95. Now on Frame 105, key the focal length at a value of 80. Flat this tangent.

167

Animating Cameras (cont'd)

7 Open anim_motion_start.ma. We're going to animate a dramatic camera move that is seemingly created by a camera on dolly tracks. First we need to set up a camera made for this kind of movement.

8 We'll need a camera with an aim to keep everything easy to control. Go to the Create menu, and choose Cameras > Camera, Aim and Up.

10 Next switch to the Top panel, and select the EP Curve tool in the Curves Shelf. We are creating our camera's path, so create a nice half circle curve like the one here by clicking points in the view. Finish your curve by hitting *Enter*.

9 Our camera needs to move with its Up control, so let's group them together. Select the Camera, Up control, and press **ctrl** **G** to group them. Rename the group camMain_GRP, and center the pivot by selecting Modify > Center Pivot.

11 Now we attach the camera to the motion path. Select the camMain_GRP in the Outliner and then **ctrl** click the newly created curve1. Now click Animate > Motion Paths > Attach to Motion Path.

Animating Cameras (cont'd 2)

12 Let's frame up the bouncing ball. Select curve1 and translate it upwards in Y to 3.0. Also select the camera Aim and center it on the ball on frame 1.

14 We were wise to group the camera before; now we can add a bit of camera shake on top of the path animation. Select the camera and, starting on f69, animate some camera shake, straight-ahead, by moving the camera Up control upwards and then downwards subtly for a few frames.

13 Now let's follow the motion of the ball. Just like in the hand-held scene, we want to key the aim a little bit behind the ball. I have a key on frame 1, 51, 63, 73, 99, and 120. The fewer the better.

15 Here is a closer look at the curves for the main camera movement.

INTERLUDE

Finding Inspiration
by Eric Luhta

EVERY ANIMATOR KNOWS WHAT IT'S LIKE to get that "fire in your belly" feeling. After seeing something that you found so cool and awesome, you want nothing more than to run to your computer and create something just like it. Whether it's a film, book, TV show, piece of art, whatever, inspiration can come from many sources. As an artist, we can fall into a rut where we forget what made us want to animate in the first place. Experience is a catalyst for growth, but it can also erode the wide-eyed wonderment you had when you first saw that special film or show that made you say "I want to do THAT!". But staying inspired isn't difficult; it's just something that needs some attention every once in awhile. If creating is starting to feel commonplace and uninspired (and it happens to everyone at some point), then perhaps seeking out some of the following will help rekindle the flame.

Inspiration by:

Top 10
Everyone has a top ten list of their favorite animated films. When's the last time you watched one? What was it about them that made you so excited to animate? The films and TV shows that define the art form for you should never be more than an arm's length away from your desk.

Films
Any film, from animated to live action to everything in between can serve to inspire your creative flow. It's true that many animated films are made for a specific audience range, but many animators fantasize about creating work outside the typical "family scope." Documentaries, art films, sci-fi epics, slasher movies, anything outside the box for animation can give you new ideas and things to try. Looking beyond genre, perhaps it's the way a film was shot that inspires new staging and composition ideas, or how it uses a soundtrack. Leave no film-related discipline unturned when searching for something unique.

Other Art Forms

Move away from the time-based visual element we work in. Books, music, museums, graphic design, theater, any creative discipline can give you ideas that can make for refreshing animation work. Different mediums engage your brain in different ways. If you haven't been reading much, you may find that a book opens some new doors for you, or that listening to some music you're unfamiliar with gives you visual ideas you wouldn't have had otherwise.

Process

You can be inspired by a particular artistic process or challenge. Never did stop motion? Set up your digital camera, grab some action figures and give it a try! Create interesting limitations and see if you can meet their challenges...can you make a simple ball rig emote? Make a cool animated gif with photographs from your family reunion? Animate only characters in the wingding font and tell a story? Anything that pushes you out of your comfort zone or initially seems unreasonable is great process fodder.

Other Artists

With the multitude of blogs, websites, artist sketchbooks, "Art of" books, interviews, DVD extras, and more, we have more information and inspiration available to us than any past society. Make use of it! Having an hour set aside each week to seek out new things you haven't heard of is a wise idea. You can watch shorts on YouTube, read blogs, look through artist websites and communities, view photographs, watch other reels, anything that shows you what everybody else is doing. Keep a folder or hard drive that functions as your personal inspiration library, and archive anything you find that you like. When you're not feeling your work, start browsing through your library and see where it leads you.

These are just a few of the ways you can keep your creative desire fresh and always hungry for more. Maintain a steady flow of inspiration, and you'll never tire of challenging yourself and becoming a better artist. And who knows, you just may come up with the thing that inspires everyone else to keep on going. Best of luck, and happy animating!

■ Creating a solid foundation for your animation is probably the most important element of making a successful piece.

174

Blocking

8

CREATING THE FOUNDATION of your animation, or blocking, is arguably the most important phase of animating. Since almost everything we do is affected by it, from the performance ideas we incorporate, to the appropriate technical approach, to the ease of refining and polishing, it's a great idea to define a solid blocking workflow. We're going to look at some common, yet very powerful, techniques to make blocking enjoyable and efficient.

This chapter is based around a short ninja animation, as the main reason to become an animator is to animate awesome things like ninjas. We'll go from conception to splining, all while looking at a myriad of handy techniques to make your animation kung fu very powerful. Like, super powerful. Like, Neo fighting off thousands of Agent Smiths powerful. Hiii-ya!!

Thumbnails and Reference

AH, THE GOOD OLD DAYS. The days we used to have an idea, jump to the computer, start Maya, and animate away! Many hours later, we'd look at our finished work and say..."I thought this was going to look so much better than it does." Sigh, to be young again.

But life moves forward and so must we. In order to do quality work, we must plan what we're going to do. A general idea isn't enough, and some extra planning at the beginning will save you many hours later, fighting to get curves under control in the Graph Editor. There are different approaches to planning, but two of the most common are thumbnailing and reference.

You don't have to be a great traditional artist (and I'm certainly not) to do effective thumbnails. Anyone can draw basic shapes and lines, and that's all you need. Think about the line of action in each pose and sketch it out. Experiment and try different things until you get something you like.

The second part is reference. Every great artist studies what their work is about. Video reference and motion studies are invaluable. Whether you film it yourself or find it online, study the movement of what you're going to do until you understand it thoroughly.

Everyone has their preference for detail, so feel free to add more in your planning if it helps you.

1 I want to do a short, physical animation test of a ninja where he enters in a cool way, then does some acrobatics. To motivate the movement, I decided to have him attacked by an off-screen foe who throws some shuriken at him, and he must avoid them.

For inspiration, I looked at ninja artwork on the internet, and Spiderman comic books to study the poses of an agile, nimble character.

Good websites for inspiration include deviantart.com and cgtalk.com, as well as blogs by artists and animators. Watch movies, television shows, read comic books, listen to music, anything to get ideas and visualize.

2 I broke down the animation into four parts:

1. Lands into camera in cool pose, looks around suspiciously.

2. Sees off-screen attack coming (does a take to anticipate).

3. Jumps out of the way doing a hand spring.

4. Ends in a different cool pose.

Having a list or outline helps clarify what you're going to do, and picture each moment in your mind. I also use it to make sure I have a reason for the actions, which makes for a better animation test. If the ninja just did the flips for no reason, it would be confusing to the viewer. Yet I wanted to keep it as simple as possible. Having him notice an offscreen threat creates an anticipation so the viewer knows something is about to happen.

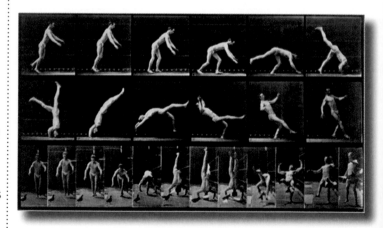

5 Reference like the photography of Eadweard Muybridge is required material for any animator's library. Since most of his work is in the public domain now, you can also find a lot of it online. I also studied his handspring breakdown.

3 For the physical movement, particularly the handspring, I searched YouTube and found tons of gymnastics and breakdancing videos with that movement. There were also plenty of step by step tutorials on handsprings, which is invaluable to understanding how to animate it.

4 If you want to frame through the video to study it (always a great idea), there are some great free options available. You can download a video from YouTube or other streaming video sites using www.keepvid.com. Then convert the .flv file into Quicktime format (also free from www.apple.com) using Quick Media Converter, a fantastic free program (from www.cocoonsoftware.com) and frame-by-frame away.

The BBC Motion Gallery (www.bbcmotiongallery.com) is also an excellent reference source, as you can download free Quicktime movies of any footage they have available. They're particularly good for animal reference.

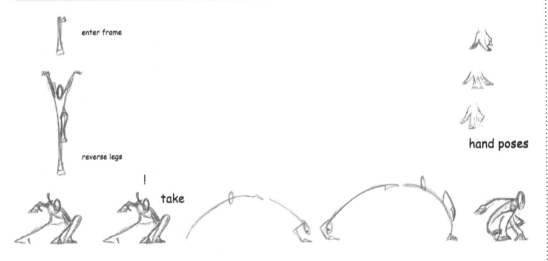

enter frame

reverse legs

take

hand poses

7 Finally, I sketched out the progression of the animation, focusing on the main poses and lines of action. I also made some notes to myself where needed. Your planning doesn't need to make sense to anyone but you, so do whatever it takes to create a clear picture of what you're going to do.

Setting Up the Scene

WITH A CLEAR IDEA of what we're going to animate, let's get our scene ready. This is the part of the process where I map out how I'm going to approach any technical aspects, such as constraints, animated cameras, using IK or FK, etc. I also create the shot camera, reference the character rigs, get their settings in order, put the props in place, and set up the environment.

This is also the time where I decide my approach to blocking. We're going to be doing a stepped keys blocking of the main poses, then add breakdowns, then convert the keys into spline mode and refine from there. It's a very common and effective method, but it's not the only way to block. There are cases where stepped keys make things less clear. Short, continuous actions that are part of a group of shots and not started or ended in the current shot are a good example of where I would block with splined keys. It's easier to ensure the timing works between all the shots if I'm not looking at it in stepped mode. Every shot is different and it's a mix of preference, experience, and what's the most clear in how you approach blocking.

1 Open blocking_start.ma. The back wall and three shuriken are already created for you. Go to File > Create Reference and select the goonNinja_ rig to reference the character into the scene.

2 Since his hands need to be planted on the ground, I'll use IK arms and I won't worry about switching to FK since they're rarely off the ground. Select each hand control and set IK Weight to 1 in the channel box.

5 I also like to turn on a gate to see exactly what the framing is when rendered by pressing the viewport button (second one indicated). You can adjust the gate's color and opacity to taste in the Display Options tab by pressing the camera attributes button (first indicated).

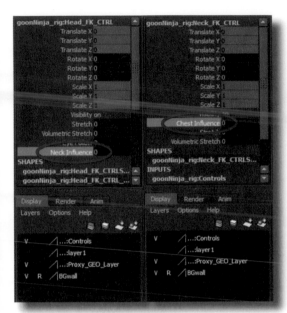

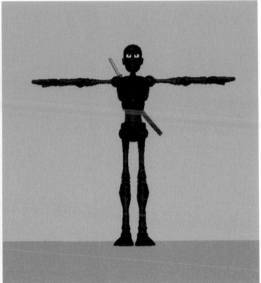

blocking_start.ma

3 I prefer to almost always use the head in world space so I'll also set Neck Influence on the head to 0 and Chest Influence on the neck control to 0 also. This means that rotating the chest or neck won't rotate the head also.

4 Go to Create > Camera and name the new camera shotCam. Position it angled slightly up with the ninja in the center. We'll no doubt have to adjust it later, and possibly even animate it, but just get it roughed in for now.

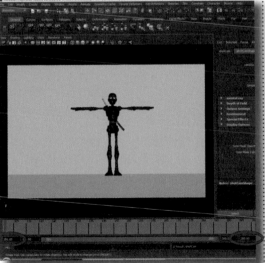

6 There are quick select sets with the ninja rig, and here's a quick way to add them (or any menu command) to the shelf. First hold down *ctrl* *alt* *Shift*, then go to Edit > Quick Select Sets > the set you want. A shelf button will automatically be created for whatever you choose.

7 Set the timeline to start at 101 and end at 200 (for now). This is common practice in production so no frame number starts with 0, which can potentially confuse the computer's ordering of frames when rendering and compositing.

Key Poses 1

Now THAT WE'RE ALL SET UP (finally!) we're ready to create the framework of our animation with the key poses. We'll start with the storytelling poses, or golden poses as they're sometimes called, and add more detail from there.

It might help to think of storytelling poses as what you would need if you were doing a comic strip with only two or three panels. Reduce the idea down to where you could convey the fundamental events in your animation with only two or three poses. That's a good rule of thumb to what the storytelling poses are. My thumbnails were pretty basic, but I could communicate the animation's events with these:

I even left out the last pose, as it's not essential to understanding the fundamental actions: he lands, then he jumps away. It's a matter of preference, but the point is to distill the animation to its most basic level.

I'm also going to put these poses on consecutive frames and not worry about timing when they happen yet. This keeps me from being distracted by any timing issues and helps me focus on the poses themselves and making them read as clear as possible. Let's start animating!

1 In the animation preferences, set the default out tangent type to stepped. Then shrink the timeline range down to 101–107 to make for easy scrubbing through the poses.

4 While it's true we animate to camera and the pose only has to look good there, you don't want to cheat things if you don't absolutely have to. In the perspective view, I make sure the pose looks as natural as possible to prevent problems later.

7 It looks weird for a moment, but now the foot lands exactly where it was headed in the previous pose, and I can move the body and other foot in relation to it.

blocking_start.ma

2 Select all the controls using the quick select set, and set a key at frame 101. Using the thumbnail as a guide, I pose the ninja above the ground in his descending pose. I adjusted the gate opacity so you could see outside the frame.

3 I like to work in with 2 viewports, one perspective and the shotCam. I select controls and position in the perspective window while always making sure the pose looks good in the shotCam.

HOT TIP

Always rotate the FK spine joints together and get the pose as close as you can. Only after you can't get it any better should you rotate the individual spine joints. This helps prevent the strange independent ribcage movement so common in beginning animators' work.

5 Select all controls and set a key on f102. Setting the key on everything first lets Auto Key do the work of updating the key's data as you adjust the manipulators, and lets you concentrate on posing.

6 Using the channel box is a good shortcut for things like putting the feet on the ground. Instead of moving it back manually, select the left foot and in the channel box enter 0 for translate Y and rotate XYZ. The foot will move to the ground.

8 The second pose isn't exactly like my thumbnails. There are times the rig and/or character design won't work with the poses exactly the way you planned. Putting his foot underneath more made him feel more dynamic from the diagonal line from his right toe to left knee.

9 Select all controls and set a key at f103.

Key Poses 1 (cont'd)

10 Since he must push off from his left foot for the leap to be physically possible, keep that in place and pose the body and arms based on its position.

11 To rotate the planted left foot, use the pivot attribute instead of the rotate Y on the left foot to make it a smooth transition. This rotates his foot from the ball instead of the ankle.

13 It's especially important to watch the perspective view for poses that are profiled, like pose three. It can look fine in the shotCam but be way off at other angles.

14 Poses being off like this have the potential to cause extra work and headaches once you switch the curves to spline mode, so fix inaccuracies as you find them. Many technical problems in animation are cumulative, meaning they rear their ugly head long after they appeared.

12 Get the third pose blocked in, keeping the line of action his body makes strong and dynamic. This character doesn't have controls to add a bend through his legs, so just get it as close as possible to an arc.

15 With the last storytelling pose in, you can see we're running out of room quickly. In the next cheat, we'll continue adding key poses, and also block in the camera panning along with his handspring. While camera movements are usually planned beforehand, this will offer us an opportunity to experiment with the staging and make the animation even more dynamic.

8 Blocking

Key Poses 2

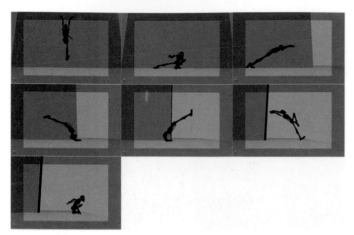

f102

1 We're going to need to make camera adjustments, so press the select camera button. Go to f102 and press **S** to set a key on the camera. This will lock it in position up until this frame.

THE STORYTELLING POSES ARE DONE, so now let's add the next pass of key poses. We'll do four more poses: the hands planting in the handspring, the flip, landing, and the end pose. These describe the parts of the animation where the movement changes. Once he does his leap (the third pose from the previous cheat), he's going to continue that movement until something changes the momentum, which is landing on his hands. The new motion that happens next is his feet leading his body in the second jump. He'll continue through that jump until he lands, at the last pose.

f104

4 Use the **Shift alt** middle mouse drag to continue the camera pan with this pose, and set a key on the camera.

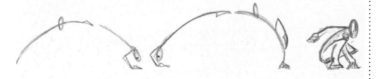

Working in passes, which means starting as broad as possible and adding detail each time through subsequently, is a good approach to computer animation. It makes it easy to refine things as you work, and making changes is simpler because you're not bogged down in detail. We'll also block some camera positioning, since it became clear we need to track the camera with the character as he does his acrobatics.

f106

7 For the next pose at f106, I'll do the camera pan first to give myself some room. Use the same method as in previous steps.

f103

f104

02_keyposes.ma

2 With the camera still selected, go to f103. For now let's just pan with each successive pose; we'll refine later. Hold **alt Shift** and middle mouse drag to constrain the camera movement sideways. Pan right and set a key on the camera.

3 Go to frame 104 and key all the character controls. Block in the next pose, keeping in mind the arc his body is going to continue from the previous frame. Position the main body control, get it lined up along the arc, and then do the rest of the body.

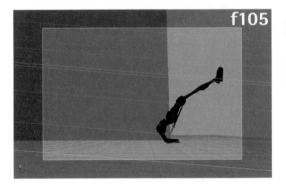

f105

f105

HOT TIP

Don't block each pose in a vacuum. Use the **< >** **hotkeys to keep flipping between the current and previous poses to compare. Look at the line of action, and make sure the body is transitioning smoothly. You can also hold down** **K** **and drag in the viewport to scrub without moving to the timeline.**

5 Go to f105, key all controls, and block the next pose. From the reference, we can see that the body does almost a mirror image flip, so keep that in mind when you line up the body with the previous pose.

6 Using the same **Shift alt** middle mouse drag method as before, continue the camera pan and set a key on it.

f106

f107

8 Key all controls, then block in the landing pose, flipping back and forth to the previous pose to ensure they are making an arced path of action.

9 Go to f107, key all, and do the final pose. Keep the left foot in the same location as f106. Remember that zeroing out your rotations can help make posing easier and cleaner. Flip through the frames, and you'll have a smooth sequence of poses. Feel free to refine them as you see fit.

Rough Timing

OUR KEY POSES ARE SET, so let's create the rough timing of when they happen. These will likely be adjusted when we add more poses, so for now we just want to get everything in the ballpark. Since we blocked our key poses in sequentially, we can now focus solely on timing. This approach helps us make each individual element of the animation as strong as possible. This is the main advantage of animating with a computer: the ability to separate and focus on specific things. Use it to your advantage!

We'll use the Dope Sheet editor for quickly moving around all of the keys in our scene, including the camera's keys, without having to select any controls. The Dope Sheet does a few other things, but its main function is managing large numbers of keys quickly and easily (two words you should never tire of hearing).

1 First we need to give our timeline some more room to work in. Expand the time slider to frame 165.

4 Starting at f101, there are blocks indicating keys present. In the scene summary row, if there is a key on anything in the scene file on a frame, a block is present. This saves having to select anything since we blocked all our controls and camera on each frame.

7 In the Dope Sheet, select the keys from f107 on, and with the move tool **W**, MM drag them over three frames to give some space between the descending and landing poses.

03_roughTiming.ma

2 Go to Window > Animation Editors > Dope Sheet to open the editor. Currently it only displays keys when something is selected, so let's change that.

3 In the Dope Sheet's View menu, click on Scene Summary to turn it on.

The way we're approaching the camera isn't the most common method for animating it, but I find it works well for moving cameras in simple animation tests. Bland staging always takes effort to overcome, and blocking it in with key poses helps to avoid the generic look of keeping everything in one big open frame.

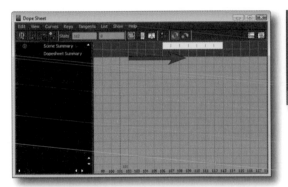

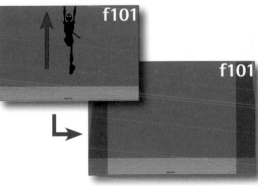

5 Press **W** for the move tool, then marquee select all of the keys. MM drag them over to f106. This will give us time at the beginning to drop down from off-screen.

6 Let's do a pose with him off-screen to better gauge the timing. At f101, key all controls. Select the body, IK arms, feet, and knee PV controls, and move him up out of frame.

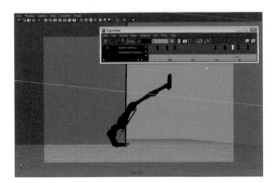

8 Continue adjusting the timing to get a rough flow between the poses. Keep playblasting the animation and flipping through the poses to get something that feels good to you.

9 I placed them sequentially on f101, 106, 110, 131, 136, 140, 143, and 147 for now. Things will still feel a bit choppy because of the camera still being on step keys, so in the next cheat we'll get it moving smoothly.

Camera Animation

BEFORE WE GO ANY FURTHER, we need to get the camera in a good place to finish the blocking process. A stepped key camera works for storytelling poses, but to refine things any more, it needs to be smooth. We'll keep things simple by only keeping two positions for the camera and simply following the character's actions to keep him in frame. At the end, we'll add a few extra frames to the camera's movement so it doesn't stop exactly with the character, giving the feel of a cameraman following an actor (or stuntman!).

1 In the shotCam's viewport, click the Select Camera button to select it.

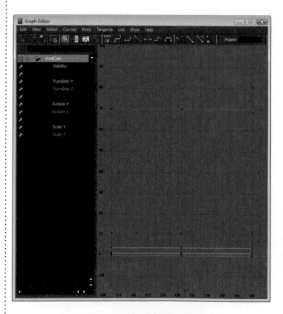

4 Once the camera starts moving, it should go at a fairly constant rate, so we really only need the starting and ending keys of the movement. Select all keys between f128 and f148 and delete them.

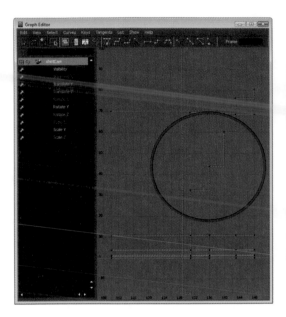

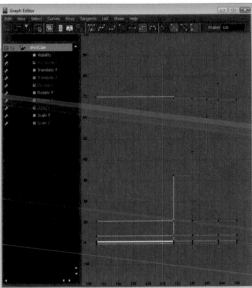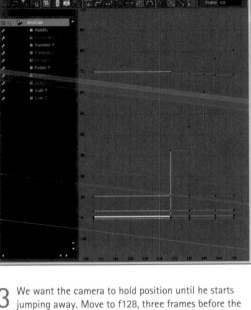

04_cameraAnim.ma

2 In the Graph Editor you can see the camera's keys. Notice how they're a bit uneven in the translate X, which even when splined will make for jerky movement.

3 We want the camera to hold position until he starts jumping away. Move to f128, three frames before the jumping away pose, and set a key.

HOT TIP

Camera animation is best kept simple, particularly for animation tests. We want nice staging, but we also want the focus to stay on the animation and not have the camera distract. It's a good rule of thumb to use the simplest camera movement (or no movement if possible) in many cases.

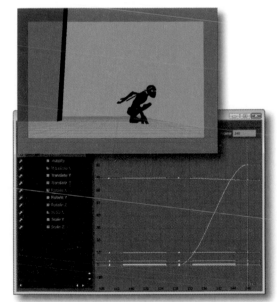

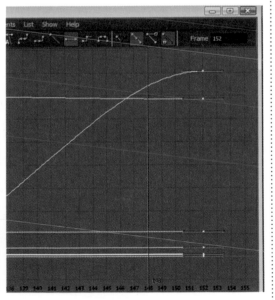

5 Select all the curves and press the flat tangents button to make a smooth transition between positions. Play the animation and you'll see the movement is much nicer through the flips, but it still stops abruptly with the last pose at f148.

6 Select the camera's keys at f148 and drag them over four frames to f152. Now there's a slight lag behind the character, which feels better. In the final polishing of this animation, we'd most likely tweak the timing a bit more, but now the camera will work great with the next blocking step: adding breakdowns.

189

Blocking

TweenMachine

W E'RE GOING TO CREATE BREAKDOWN POSES to add more detail and clarity to our animation. Breakdowns are the poses that happen between the key poses. They show how we get from one key to another, as well as define anticipations, overlap, arcs, and the other animation principles. There aren't any rules for how many breakdowns need to be added; some keys will have one breakdown between them, others more. Time and experience will give you the knowledge to know what's right for you.

But first let's look at a tool that makes doing breakdown poses super efficient. It's called TweenMachine, created by animator Justin Barrett, and is freely available on his website www.justinanimator.com. It's a fantastic tool used in many animation studios. This cheat will give the basics on how TweenMachine works, and then we'll put it to good use as we create the breakdown poses for our ninja animation.

TweenMachine lets you set the position of selected controls relative to the keys on each side by simply using a slider or buttons, instead of manually positioning it. Generally speaking, Maya's curves will always lean towards making things in motion feel even, as that is what computers are good at. To fix this, we tend to have breakdowns "favor" either the pose before or after to create ease outs and ease ins. In other words, it's safe to say that, in many cases, a breakdown pose in the middle of two keys will be closer in position to one of them, rather than perfectly between. TweenMachine lets you quickly experiment with different amounts with your entire character, or just parts of it, rather than doing all the positioning yourself or by copying positions from other frames.

1 Open tweenMachine.ma and go to the shotCam. We have a sphere travelling from one end of the grid to the other evenly. Run the tweenMachine script (see included readme) to bring up the interface.

4 Now press the fifth button and the sphere will jump closer to the end position by 33%. Each side of the zero will favor the closer keys by increasing amounts. Play the animation and the ball will slow down as it gets to the end, as the middle point is already closer to that side.

tweenMachine.ma

HOT TIP

If you enable the Overshoot option in TweenMachine's options, you can adjust the slider to 150% in either direction. This allows you to set breakdowns either before or past the keyframe positions, which is very handy for doing overshoots. We'll look at overshoots more as we refine the ninja animation.

2 At f11, we can see that the sphere is perfectly in the middle of the two key poses at frames 1 and 21.

3 Select the ball and click the fourth button in tweenMachine. You should see *absolutely nothing* happen. This is because the middle button is 0, or perfectly between the two keys, which the ball already is.

5 Experiment with different amounts at f11 to get a feel for the favoring percentages. Here we're at -60, or favoring the previous frame by 60%. You can also use the slider if you like, or type in amounts in the field. Play the animation each time to see how the favoring affects the timing.

6 TweenMachine has a lot of additional functionality, but this is the essence of how it works. On a full character, the speed of getting the breakdowns to their general position and tweaking them makes working very efficient. We'll see this in action in the next cheat as we employ TweenMachine with our ninja animation.

8 Blocking
Breakdown Poses

W ITH THE TRUSTY TWEEN MACHINE by our side and the camera locked down, we can shape our animation to communicate the timing and movement much more accurately. I'm going to use a simple workflow that is efficient and still leaves room for experimentation. At each frame that needs a breakdown, we'll set a key on all the controls. Then TweenMachine will help us quickly get the character in the general position we want at that frame. Finally, we'll tweak the individual body parts to get the pose looking good. By the end of the breakdown phase, it should be pretty clear what this animation will look like when it's finished.

1 As a warmup, let's add a breakdown between f101 and 106, as it currently looks like he's just appearing out of thin air. Select all controls and set a key at f104. Then start TweenMachine.

4 Scrubbing through, we now have a huge spacing gap between f104 and f106, and a small one between f106 and f108. This will make him appear to slow down before he hits the ground, so let's make his fall more constant.

7 Continue adjusting this pose, thinking about the hands dragging, and a clean path of action through the hips, spine, and head into the next pose. Keep flipping and comparing, focusing on one body section at a time. The right leg stays in because it will swing out later.

05_breakdowns.ma

2 With all controls still selected, click the middle button in TweenMachine (0.0). The ninja will move to halfway between the two poses.

3 Go to f108, and set a key on all controls. We need a contact pose of the foot touching the ground. Because the pose is still the same and not changing, I'll just select the body, arms, knees, and feet, and move them down, rather than use TweenMachine.

Remember that you can use TweenMachine on individual and groups of controls. You'll need different amounts of travel depending on the action and things like drag and follow-through. It also has capabilities for putting controls and groups right in the interface for working quickly, so check out the tool's readme!

5 At f106, with the body, arms, knees and feet selected, press the 0.0 button on TweenMachine to make the spacing even. Animating is a constant back and forth, so it's necessary to alter the key pose in this situation to make the motion work.

6 Key all at f109. I selected the body and used TweenMachine at 0 to position halfway again. Then I used it at 100 on the left foot to lock it down where it landed. I then adjusted the ball roll to 0 so the heel comes up in the next pose. Bring down the right leg and arms also.

8 Be sure to check the pose in the perspective view to make sure nothing strange is happening that can't be seen in the shotCam angle.

9 We'll need some more breakdowns here, so select the keys at f110 and move them to f113 however you prefer. I used the Dope Sheet, but you can also use the Graph Editor or timeline.

Breakdown Poses (cont'd)

f111

10 There are times where it's easier to do a later breakdown first. Let's do the overshoot of his body when he lands before we do f110. Select all, go to f113, and MM drag in the timeline to f111 and set a key.

f111

11 Work backwards from the landed pose, thinking about the compression in the body happening as he hits the ground. I lowered the body, compressed the spine/head in rotate X, and lowered the R arm. You can rotate the hips in Z to counter the knee moving when you adjust the body.

f110

14 At f110, the body, spine, head and arms are dragging, creating an arced path into the next pose. The R leg is easing out to the extended position. Dragging the R foot in an exaggerated way helps the expanding feel as well.

f122

15 I'll do the take when he sees the offscreen attack coming next. This is really a key pose, but I'm doing it in this phase since it's so close to the landing pose. Again, it's a matter of preference. Go to f122 and key all.

f119

18 At f119, I did an anticipation into the take pose. A slight body and shoulder compression, with the brows scrunching and the eyes narrowing works well to set up his surprise.

f127

19 At f127, key all and add a small anticipation pose right before he starts to jump away.

f111

12 The R leg is in the middle of pushing out into the last pose, and the L arm is compressing into the ground to balance. Scrub through and his weight should feel much better when he lands.

f110

13 Go to f110, select all and set a key. Use TweenMachine to interpolate the pose at 33% to get a starting point.

16 For the face, I pulled up the brows and pulled down the cheeks to widen the eyes. This will help his surprise read more clearly. I also rotated the jaw down to give more of a change in the face shape since the face has limited detail.

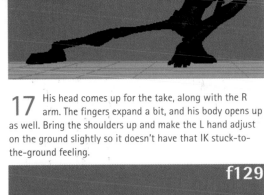

f122

17 His head comes up for the take, along with the R arm. The fingers expand a bit, and his body opens up as well. Bring the shoulders up and make the L hand adjust on the ground slightly so it doesn't have that IK stuck-to-the-ground feeling.

f129

20 Go to f129 and key all. Run TweenMachine at -60 to start off the pose.

f129

21 Adjust the body to have a good path of action into the next pose. The chest and head are still turning while the arms drag. The L heel is pushed down from his body weight, and the R foot is lifting off.

HOT TIP

When doing breakdown poses with TweenMachine, don't get stuck going in a linear order. If another pose is closer to what the breakdown is than the current one, copy it and work from there.

195

Breakdown Poses (cont'd 2)

22 The next breakdown I'll do is at f134. So we can feel his weight as he lands at f136, this breakdown will be him arcing through the air. Key all and TweenMachine 100% to copy the following pose.

23 The pose needs to be manually positioned from this point. Since this rig doesn't have bends to put in the legs, just get the body arc as nice as you can. The three jumping poses should make a nice shape throughout.

26 At f139 I'll put a continuation of the crunch, pushing the body down a bit more. The feet continue through to lead into the next foot forward pose.

27 For f142 I'll do another pose that's the same idea as f134. His body will "trace" along the arc of the leap. I found it easier to start with f143's pose.

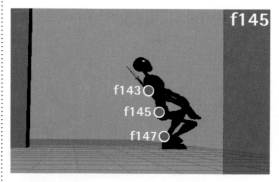

30 Adjust the pose so the spine continues through the arc of the motion. Make sure the spacing in the body control is in the middle of the surrounding frames. This will make it feel like he's dropping, and not slowing into the landing.

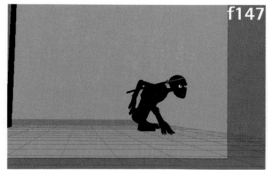

31 Select all and set a key at f150 to duplicate the pose at f147. At f147, compress the body and the planting hand as his momentum carries through.

f138

24 Let's do a body compressing pose at f138 to give him some better weight. I keyed all and ran TweenMachine at 33%.

f138

25 Get a nice crunch in the body and separate the feet. Since this is an FK spine, rotate the spine into the shape you want first, then reposition with the body control to put it in the right spot.

f144

28 With the breakdown in place, the key pose at f144 needs adjusting. It doesn't make sense now for his R foot to travel upward, so adjust it down without making the feet too even.

f145

29 At f145 we'll add another breakdown into the landing. Key all and set tween machine at 33%. The head may interpolate strangely depending on your rotations, so just fix it manually.

f142

32 Make another pass through the animation and refine the breakdowns. Make the lines of action as nice as possible and adjust timings if necessary. We're almost done blocking!

HOT TIP

Don't let anything remain in stone. If you need to go back and change your key poses, timings, etc. when you add breakdowns, do it! The end result is what matters, rather than sticking to the original plan at all costs.

Adding the Shuriken

WHILE BEING ABLE TO WRITE a section titled "Adding the Shuriken" is justification alone for doing this entire book, it is nonetheless an important part of our animation. After all, the ninja must have some motivation for jumping that's clear to the viewer. We'll block in the basic choreography of the throwing stars narrowly missing his evasive jumps.

Things like this are often better to do once the character is blocked in, which is why we've waited until then. Three simple objects are much easier to manage than an entire character. As long as their action is readable, they can go pretty much anywhere and work, unlike the ninja.

1 In the perspective view are three shuriken positioned out of the shotcam's view. Select one and set a key at f123.

4 To make it easier to position the star from an angle, you can hold down **W** and then hold down the LMB in the viewport. In the marking menu that pops up, select Object. Now the move tool is based on the object's position, rather than the world.

f129

2 At f129 position the shuriken in the wall somewhere close to where his head just was. I also angled it to the side a little so it reads better as a star.

3 In the Graph Editor, select the curves for the star and change them to linear splines. The star will now move to the target in a straight line.

f133

f130

5 I positioned the other two stars at f132 and f133. Change their curves to linear and adjust their paths and timing as you see fit.

6 You can add spin on the stars if you like, but I usually save details like this for polishing. It's a good approach to only do what is necessary in the blocking process.

Refining the Timing

W E'RE AT A GREAT SPOT to do another pass on the timing and tighten everything up a bit. Timing can be subjective and very dependent on the poses you came up with, so I'll show you what I ended up with. Feel free to make the animation your own if you're inclined.

Before shifting around lots of keys, I usually go through and make sure I've keyed everything on each frame with a pose as a precaution. It's easy to miss a few controls here and there and have the knees go crazy if you forgot a pole vector control or something. So I make sure every control is selected and quickly go through resetting keys on everything using hotkeys.

1 Double check all controls are selected. Then use the **>** hotkey to step through each keyframe and press **S** to set a key.

f106

f108

f111

f113

2 Once this is done, make another pass on the timing, shifting keys around whichever way you prefer. I used the timeline, but the Dope Sheet and Graph Editor work just as well. See the Techniques chapter for more on using the timeline.

f109

f110

f119

f122

HOT TIP

Don't forget to playblast, especially when working on timing. You may have a machine that plays back the viewport very well, but there will always be slight, noticeable inaccuracies. Playblasts are the only way to be completely sure of what the animation will look like.

Refining the Timing (cont'd)

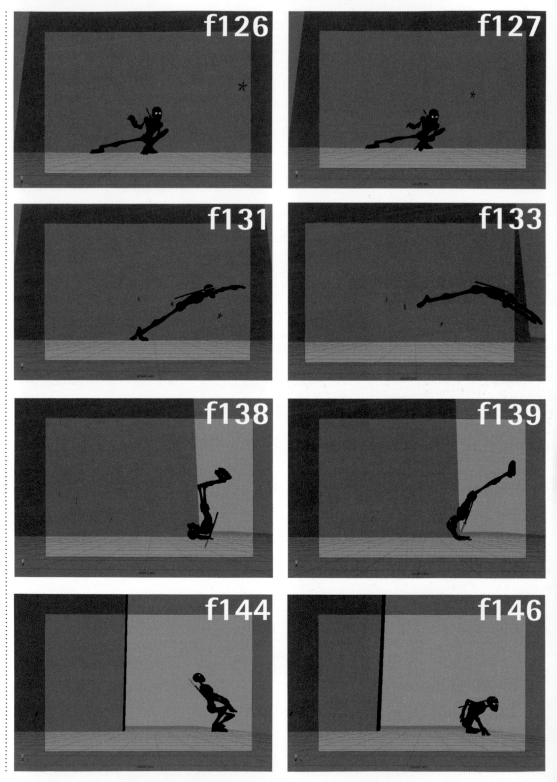

f128

f129

f134

f136

f141

f142

f149

HOT TIP

A good guideline for the number of poses to have before splining is at least one in every four frames. This keeps Maya from needing to do too much inbetweening and looking floaty.

Copied Pairs

W ITH OUR BLOCKING NEARLY COMPLETE, we are almost
ready to spline the animation to begin refining it.
Before we do that, however, we're going to use a very powerful
technique called copied pairs. By copying held poses over several
frames, we can keep better control over the inbetweens when we
convert from stepped keys.

Normally when we spline, Maya figures out the transitions
into a pose, then immediately starts transitioning to the next
pose on the next frame.

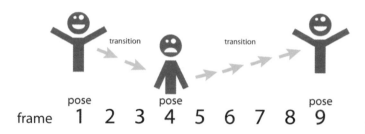

Copied pairs is simply rekeying a pose that you want to hold
several frames later. Since it's the same pose, there won't be any
inbetweens, because it's already there.

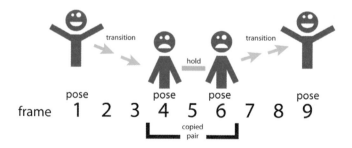

This works well for spots like the pose where the ninja lands.
We want him to hold that pose for a bit, not immediately start
moving into the anticipation pose. Once we've splined, we can
add some subtle animation on these holds to keep the character
alive (moving holds, overlap, eye darts, etc.).

A simple concept, but extremely powerful. Perfect for cheating!

f117

1 The first pose we need to hold is the landed pose at f113.
Select all and set a key at f117 to duplicate the pose and
hold through that frame.

4 Select all the curves in the Graph Editor and spline them
by pressing the plateau or automatic tangents button.

f125

2 Next I want a hold on his surprise pose at f122 so it can read clearly. Go to f125 and set a key on all.

3 The rest of the animation is continuous action, so we don't need any holds on those. Next, select all controls.

5 The animation is in good shape to start refining, but let's fix a spacing issue right away. Because his starting frame is at 101, it makes the drop uneven. At f101, MM drag in the timeline to f105 and key all. This is how we can create a copied pair in splined mode.

6 Congratulations! We've taken an idea from conception through blocking and now are ready to refine and finish it. The idea for the animation reads clearly and gives us a solid foundation on which to continue working. Enjoy!

Making a Short Film

by Eric Luhta

ANIMATION TESTS CAN TEACH YOU A LOT about animating, but they often come up a bit short on the side of filmmaking. There's nothing wrong with that, but tests have their purpose and place, and they can only go so far in terms of thinking of the bigger picture. If you want to work as an animator in feature film (and games too--there are plenty of cinematics in them these days), there is probably nothing that prepares you better than creating your own short film.

Making a short film, by yourself or with others, is a tremendous undertaking. It's one that will test all of your animation skills, and demand others that you didn't know you needed. The spectrum of what you do throughout the process is great, and you will find it trying at times, but the rewards are most certainly worth it. You will have something that is uniquely yours, that people can watch and be entertained by, and which you can use to illustrate your understanding of the filmmaking process.

Why do a short instead of more tests? Because it will require you to think of the broad picture: from story, to shot composition and flow, to animation, to sound and music, and more. Doing tests exclusively can box you into a mindset that can be difficult to break out of. Cycles, as valuable as they can be for body mechanics, will not force you to think of the shots before and after your animation and how it connects within them. With lip sync tests it's difficult to create situations where your acting choices need to be truly dependent on an established context. They're too short, and you can make up any justifications you want for why a character is acting the way they are in a 10-second clip. Presenting a story clearly, so anyone can watch it and understand it, is a tremendous challenge, and one that will strengthen your animation in ways that technique simply can't.

Of course, there can be widely varying connotations of what constitutes a short film, and everyone is at different levels of skill. Knowledge of other disciplines, such as rigging, texturing, lighting, etc. may or may not be realistic at this point. Some people are able to do many of these things well enough to make a finished product but many others are not. So let me clarify by saying that you don't need to do anything well besides animation to make a short film that can entertain and teach

you volumes about filmmaking.

Use the skills you have to make something that has a little story (intro, conflict, and resolution), multiple shots, and character acting, and you'll get the benefits the short film endeavor has to offer. "Short film" may conjure up visions of elaborate sets, particle effects, and beautifully textured characters, but those are not necessary for the experience to benefit you greatly as an artist.

You can challenge yourself to make your tests into mini short films. You want to work on your physical animation by doing a heavy lift test? Come up with a simple story of why this character needs to lift it and give it an interesting twist. Create storyboards, experiment with using different shots to tell the story and communicate the weight, and animate it. It can be 15, 20, 30 seconds max and at the end of it you will have grown tremendously.

Of course, you must actually finish a short for it to really give you a higher understanding. Make it something you will really enjoy doing and that you will finish. A 20-second ditty that's entertaining is 10 times better than the quarter finished epic sitting on your hard drive. Make a schedule and stick to it! I promise that things will look different on the other side.

It's easy to forget that the true reason to be an animator is to tell stories and entertain. Everything we do should be in service of that. The best animators I've ever seen all had a thorough understanding of story, character arcs and development, and a love for filmmaking that shined through their animation.

■ Having skill
in efficient cycle
creation is a
requirement of
every professional
animator.

9
Cycles

CYCLES, or animation meant to loop or repeat, are a mainstay of the animation industry. From games to film, to TV, cycles will most certainly be a part of your career in animation to a varied extent. The ability to quickly create realistic and appealing cycles is the hallmark of the experienced animator. To do this you must be familiar with all of the tools that Maya 2012 has to offer. In production it is common for an entire animation team to share cycles, and so having cheats to avoid little technical problems can have a large impact on a project.

We're going to look at the technical aspects of creating a cycle with Pre- and Post-Infinity curves. Then we'll manipulate a walk cycle and create a flying cycle from scratch. With both of these cycles the plan is to use the simplest method to get the best results; with cycles, that cheat is called *offsets*.

9 Cycles

Cycle Basics

WHEN WE TALK ABOUT cycling in animation, there are a few terms and technical rules you should be aware of. We'll run through them here in this chapter.

First of all, when dealing with cycles where a character moves "forward", the Z axis is the axis that is used to show forward movement.

Next, you will be dealing extensively with Maya's Pre- and Post-Infinity curve types. Maya uses these settings to determine how to cycle animation before your first, and after your last keyframe. We'll test out all of the different types here.

Another rule is that all of the controls of your animation need to have the same duration of frames between the first and last frame of the cycle. They don't have to necessarily be the same frames, however. For instance, as long as you have set your animation to cycle correctly, your head could be animated between frame 1 and 24, and your arms could be animated from frame 18 to 41.

Also, it is typical to counter-animate a master control against the Translate Z to make it so that the cycling animation stays centered over the world origin, as if it's on a treadmill. This is extremely handy when you are working with a cycle that covers a lot of distance, like a run cycle. It is easy to create this treadmill; simply cycle the master controller backwards the same stride length and frame range as the character cycle (we'll talk all about stride length soon).

Finally, cycling is a lot more manageable when you are familiar with the idea of "offsetting" your keyframes in the Graph Editor. The basic idea is to create animation on controllers within your set frame range, (1-24 for example), and then move the keyframes backwards or forwards in time. These new offset keys are the same total duration of the cycle, but you don't have to worry about getting some hard-to-create curves cycling on the same frames as your base animation. An example of this is if there is an extremely wobbly antenna on your character; it's hard to imagine exactly at what point in the overall motion that antenna should be started at on frame 1, whereas it's easy to key the entire flopping motion and then offset it.

210

1 Open cycle_basics_start.ma. In this scene we're going to have this ball move up and down, and tilt left and right. You'll see two keys are already created for you. Our cycle length is 24 frames, and there is a key on frame 1 and 12.

4 Expand the timeline to 48 frames and watch how nicely the animation loops. Now let's key the antenna flopping over from the left to the right. On frame 1, key the antenna over to the right, and on frame 12 key the antenna bent over to the left.

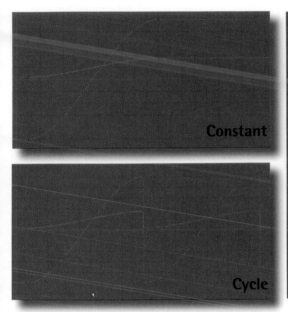

Constant

Cycle

cycle_basics_start.
ma
cycle_basics_finish.
ma

2 Let's look at the different cycle types. Select the ball_
anim control, and open the Graph Editor. Click on View
> Infinity. As you can see, the value is constant before the
first and after the last keyframe by default. Select the Ty
and Rz curves and go to Curves > Post Infinity > Cycle.

3 "Cycle" means that when it gets to the last keyframe,
Maya will loop the animation by going back to the first
keyframe. In order for the cycle to work, the first and last
keyframes need to be identical! In the timeline, MMB drag
frame 1 to frame 24 and hit **S** to paste the key at the end
of the animation. Flat all tangents.

5 In the Graph Editor, select the antenna control's rotation
channels. Go to Curves > Post Infinity > Oscillate. Also
go to Curves > Pre Infinity > Oscillate. This infinity curve
type tells maya to "bounce" backwards and forwards through
the animation when it gets to the first and last key.

6 Now let's make the character move forward. Set a key
in Translate Z on the ball_anim control at frame 1. On
Frame 24, move him forward in Z about 10 units.

Cycle Basics (cont'd)

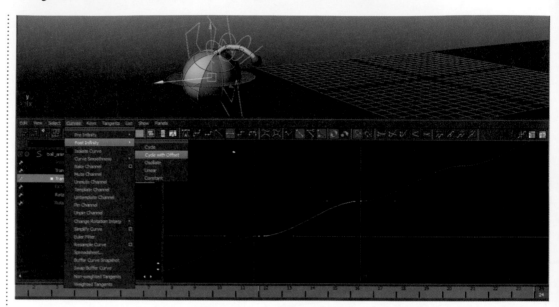

7 The rule of thumb is Translate Z channels on your MAIN character controls (body, feet, etc.) should be "Cycle With Offset". Set the Translate Z curve to this type in the Graph Editor. Flat the tangents on the Z channel and notice that Maya takes the last frame as the "new" start frame and "goes from there."

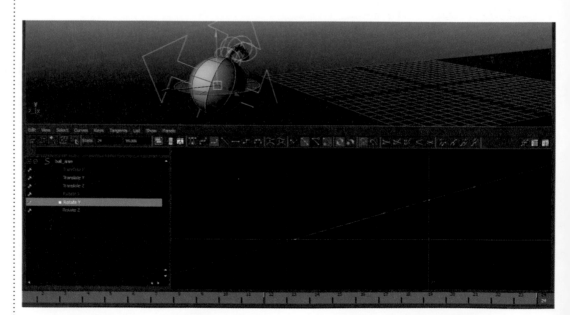

9 Now set the Rotate Y curve Pre- and Post-Infinity type to linear and see the resulting curve. The rotation continues linearly forwards and backwards for infinity. Let's do our first offset. Remember, offsetting animation is a great way to build layers in a cycle.

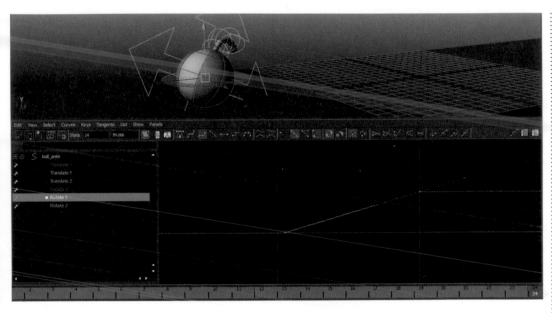

8 The Linear infinity type extends the animation as if a linear tangent were applied to the keys. Select the ball_anim control and hit S on frame 24 to make sure there is a key on the Rotate Y there. In the Graph Editor, select the key on frame 24 on the Rotate Y channel, and move it up to a value of 100.

HOT TIP

Now that you know all the cycle types, be aware of the simplest way to get the motion you need. Pros are always using offset animation curves to build complex motion that would be immensely difficult to create working only within a set frame range.

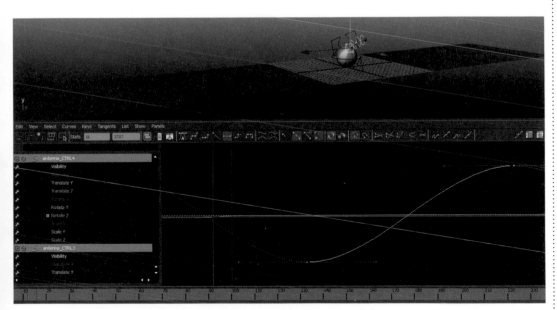

10 Select the controls of the antenna. In the Graph Editor, select the rotation curves and move them forward four frames to make the motion more overlapped. Notice how the curve retains its shape, but also how hard it would be to create the curve shape that exists between frames 1 and 24 from scratch.

Stride Length

Wʜᴇɴ CREATING ANIMATED CYCLES, we'll first want to quickly sort out a few decisions, namely cycle length (frame count) and stride length (how far one complete cycle "travels" in space). These two decisions are essentially the principles of timing and spacing applied to walk cycles. However, unlike a performance shot in which these decisions can be eyeballed and changed, you'll want to be sure you are working within your set standards so that the result is predictable, manageable, and most importantly, usable.

What is stride length? Simply put, stride length is the distance that a character travels in one complete cycle. If you are animating a biped, one stride would be two steps. If you are animating a quadruped like a dog or a cat, the stride length is the distance the character covers after all four paws have stepped. Another way to think about stride length is it is the distance the character travels in the time it takes for any one of its feet to complete one cycle (go from being on the ground, to lifting, to moving forward, up to the instant it touches the ground again). This way of thinking about it works no matter how many feet a character has, assuming that all of its feet move only once in a complete cycle.

Why is calculating stride length so important? If you are working on a project with many animators who are all going to share cycles on the project, then it is extremely important that you create a cycle that will loop perfectly for infinity. Without knowing your EXACT stride length, it is impossible to truly create a perfect cycle. This is one of the most overlooked aspects of creating cycles, but you'll see when we get into this cheat how problematic "eyeballing" a cycle actually can be.

The easiest way to calculate stride length for a walk cycle is to pose a character taking a step using just the root control and one foot. The character should look like he is taking a comfortable step, and isn't too stretched out. Then simply observe the value in the foot's Translate Z channel, and double it to get your stride length. From then on, you will be doing multiple calculations with this number, confident that, armed with stride length, your cycle will loop perfectly for eternity.

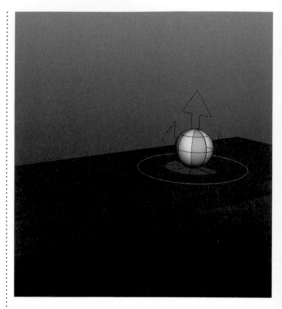

1 Open stride_start.ma. This is a bouncing ball animation, in which the ball is taking leaps forward. A good way to think of this for the purposes of stride length is that the ball is a uniped (one footed), and the "foot" is the entire character.

4 Play back the animation. Looks great? Right? Now expand the timeline to 480 frames. Play back again. Still looks fine, so what's the problem? Go to f1. Select the ball_Master_CTRL, and right click on the Translate Z channel. Choose "Unmute Selected".

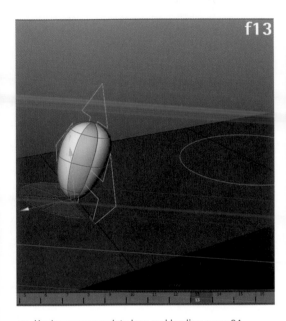

f13

stride_start.ma
stride_finish.ma

2 He does one complete leap and landing every 24 frames. All that's left is animating the Translate Z channel to give him forward motion. Select the ball_anim control. On f13, translate it forward to about where the next edge in the ground plane is showing. (If the edges are not showing click on Shading > Wireframe on Shaded.)

3 On f24, with the ball_anim control still selected, hit **S** to set a key. Open the Graph Editor and change your Translate Z to linear interpolation like the one above. Now select the curve and change the Post Infinity interpolation type to "Cycle With Offset."

HOT TIP

The stride length method presented here is the simplest, but it's also possible to animate stride length with an inverse method: by translating the Root control forward, countering a cycle that has been animated in-place. See the additional content on the How to Cheat in Maya website for a Walks chapter where that method is demonstrated.

5 The master control is counter-animated against the ball_anim control to keep it in place while we work. It is moving backwards according to a set stride length, but since we eyeballed the ball's Z movement, it moves further away from its home position every cycle that goes by.

6 Let's investigate why our cycle is getting off of center. Select the ball_anim control and open the Graph Editor. Select the two keyframes on the Translate Z channel that are on frames 13 and 24. Look up at the value box to see what value is on these frames. Mine is 7.365.

Stride Length (cont'd)

7 Is it really 7.365? Go to f13 in the time slider and then in the Edit menu in the channel box, click Settings > Change Precision. Type in 15 (the maximum) in the box and hit enter. Now look at the Z value. Mine is 7.364636278760326!

8 It turns out that when you eyeball poses in panel, Maya puts very precise values on keyframes that are nowhere near clean, integer values. Since our stride length is supposed to be 7 units, in the Graph Editor select the Translate Z keys on frames 13 and 24, type in "7" in the value box and hit *Enter*.

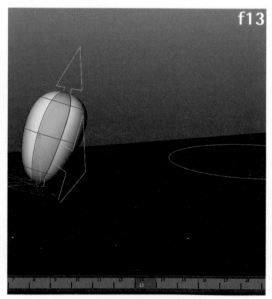

11 Now let's set some keys. On f1, type in "0" on the ball_anim control's Translate Z channel. Right-click on the Translate Z channel and choose "Key Selected". We're going to be careful not to add any keys on channels that we don't need to.

12 Advance to f4. Right-click on the Translate Z channel and choose "Key Selected". On f13, move the ball forward using only the Z axis on the translate tool, and try again to line it up with the edge on the ground plane ahead of the start position.

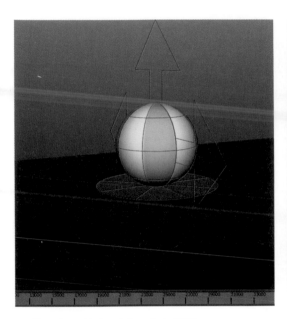

9 Now the stride length is perfect. If this were a character, all of the legs would cycle correctly knowing the stride length. Let's be totally sure; expand your timeline to 50,000 frames. Notice how the ball is still cycling perfectly in place.

10 A more common workflow is to eyeball the stride length in panel and correct it later. Select the ball_anim control and right click on the Translate Z channel in the channel box. Choose "Delete Selected". On f1, select the ball_Master_CTRL Translate Z channel, right click and choose "Mute Selected".

13 Pros will eyeball a pose and then choose nice, round numbers for their stride lengths. After you've set a controller's position, type a value in the Channel Box. Notice that even with 15 decimal places of precision, when you type it in, it is EXACTLY the value you chose. Type in 7 in Tz, right-click on the Tz channel and choose "Key Selected".

14 Set another key on f24. In the Graph Editor, make the Tz curve interpolation linear, and the Post-Infinity curve type to "Cycle With Offset". By eyeballing and then correcting, we have a workflow that gives us fast, accurate stride lengths. Unmute the Tz channel on the ball_Master_CTRL and check the animation on frame 50,000 for fun!

HOT TIP

Making your stride length close to an integer value makes keeping the stride equal on all controls easy. But you may have to do a little bit of math: If the stride is 8 units, and the root starts at Translate Z=0, then it obviously moves to 8. But if one foot's Translate Z starts at −3 and the other at 6, then they need to finish at 5 and 14, respectively.

Walk Cycle

W E ARE GOING TO LEARN how to find the stride length of a walk cycle quickly. This will be invaluable to your workflow, because a good animator should know how to put together an accurate, looping walk cycle in a short amount of time. Use this cheat whenever you start any looping animation that needs to travel in Z; for walk cycles that stay in place without having a master control counter-animated against the world IK controls (like in games), you need only make sure that, as the animation cycles, there are no visible pops in the animation.

Remember, the stride length is the distance that a character travels in one complete cycle. For a biped, this means two steps. We are going to assume a 20-frame walk cycle, meaning 10 frames per step. Also, the first and last frame need to be the same so we're going to be doing a lot of copying keys, and a lot of math input in the Graph Editor's stat boxes (see the Graph Editor chapter for detailed info on the math operations). However, knowing our stride length, this is a simple process and will quickly become an indispensible part of your workflow.

We are not going to animate the full cycle, only find the stride length and animate the feet accurately (see the additional content at howtocheatinmaya.com for a complete walk cycle tutorial). The rest of the animation on the body that doesn't travel in Z is very simple to make cycle: copy the first frame to the last frame of the cycle, and make sure the Post-Infinity curve type is just "cycle"! Let's give it a shot.

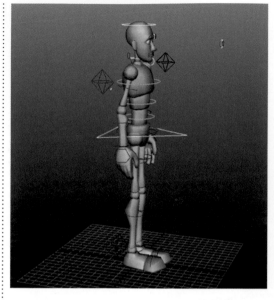

1 Open walk_start.ma. Goon is standing still, ready to animate. Remember that we're going to be using a lot of math operators in the Graph Editor, so open it up in preparation for this.

4 Go to frame 10, and now pose Goon with his left foot forward, along with the root moving forward as well. Keeping everything exact is not important because we're going to be typing in the Z values once we've found our stride length.

f01

walk_start.ma
walk_finish.ma

2 Pose Goon with his right foot forward, his root comfortably between his feet and a little bit downwards in Y. We normally make a "milestone" frame 1 of a cycle, like the foot planting, as we've done here.

3 Set a key at f01 on all of the world IK controllers that are moving in Z. These are his left and right feet controls, and his root. Take note of what the value is on Goon's right foot. Mine is 10.967.

HOT TIP

You can also make your cycles accurate by changing each Translate Z value to an integer as you go instead of applying the math function at the end. Our first step was 10.976, so we could have made our first value 11, and then known right away that our stride length was 22. Just another time-saving cheat to get perfectly looping walk cycles!

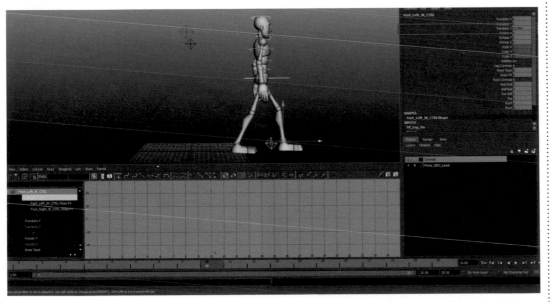

5 Now look at the translate Z value on the left foot. Mine is 21.96. Hey! That is roughly double the first value we had. We now can approximate our stride length. The nearest, nice, integer value is 22. Voila! We have our stride length.

Walk Cycle (cont'd)

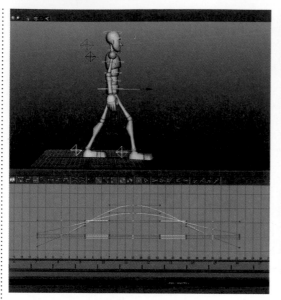

6 On the timeline, middle mouse drag and copy frame 1 to frame 20, with both feet and the root selected.

7 Now select the Translate Z channel in the Graph Editor on all three controllers (both feet and root). In the value stats box, type in "+=22". The last key has now been adjusted to reflect our stride length. Using a math operator means we know the values are exact.

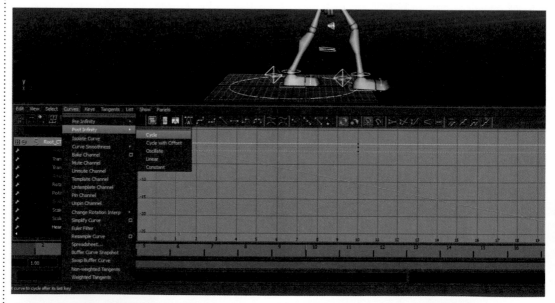

9 Now let's make sure these keys have the right cycle type. Select all of Goon's controls and in the Graph Editor, go to "Curves > Post Infinity > Cycle".

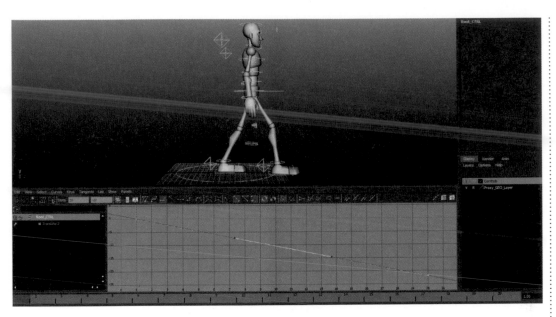

8 Flat all tangents in the Graph Editor. Now select the root_ctrl on the ground at Goon's feet. Set a key on frame 1 and then on frame 20, set a key on Translate Z on -22.

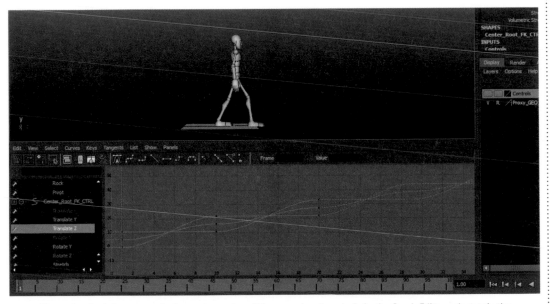

10 Now select both foot controls, the center root, and the ground root control. In the Graph Editor, select only the Translate Z channels. Go to Curves > Post Infinity > Cycle with Offset. Expand your timeline and watch Goon cycle perfectly in place! The rest of the cycle now comes easy.

Flying Cycle

FLYING CREATURES are a popular item in games, a major portion of the animation industry. Flying characters also find their way into popular feature films, TV shows, and commercials. From cartoony characters to the ultra-realistic, a flying cycle is an interested exercise in the art of offsets. To cycle a flying creature, we are going to be taking advantage of some of Maya's great tools that we learned about in Chapter 4, Graph Editor. We're going to want to be able to see immediate results in the panel from making minor adjustments in the Graph Editor.

The first and best thing for an animator to realize about a flying cycle is that downward motion (thrust) of the wings will produce upwards motion in the body. It seems common sense, but we're going to make sure this concept is deeply engrained in your process by creating the wing motion and body motion together, then practice offsetting again.

We'll start with a demon version of Goon, with horns and bat-like wings added to our familiar rig to demonstrate fly cycles. It's worth mentioning that a hovering fly-cycle like the one we are going to create has application in many different situations, from butterflies to dragons. However, you will quickly find that the principles of bird flight (simply put, forward motion creates the lift in the wings) are wildly different. It will take very extensive research and reference gathering to accurately create any realistic flying cycle. That said, though, the workflow cheats presented here will serve you with all your flying animation.

1 Open flycycle_start.ma. With flying cycles, keying the extremes and offsetting is a quick and easy way to get the motion you want. We will create poses for the up and down wing positions, and then offset the keys on the different controls to get a more natural bend on the wings.

4 Remember that a cycle needs the same first and last frame. Select all of the wing controls, and from frame 1 on the timeline, MMB drag to copy the key to frame 18. Let go of the MMB, and hit **S**. Open the Graph Editor and make sure the frame was copied; then flat all tangents.

f01

f09

flyCycle_start.ma
flyCycle_finish.ma

2 First make a pose with the wings up. This can be done entirely in-panel. Using the round controls on the wings, set a key on frame 1 with the wings in an upward position. I like this.

3 Now let's make the down pose. It looks really cool if the wings are curled under the body for big creatures. Key the wings down on frame 9 (we're making an 18 frame fly cycle.)

f04

f13

5 To make the breakdown poses for flapping wings, we need to remember that the wings are not flapping in a vacuum – they're pushing air! So on frame 4, key the tips of the wings bending upwards as if they are being pushed, and on frame 13 key the tips down.

6 Now it's time to key the up and down motion of the character. We're going to get some great practice doing offsets here. Go back to frame 1 (we're going to create all of our poses on frame 1 and 9 and then offset). Key the root_CTRL at Translate Y=5.

223

Flying Cycle (cont'd)

7 Select all of the controls in the body and set another key on frame 9. Translate the root control down in Y to about –5.

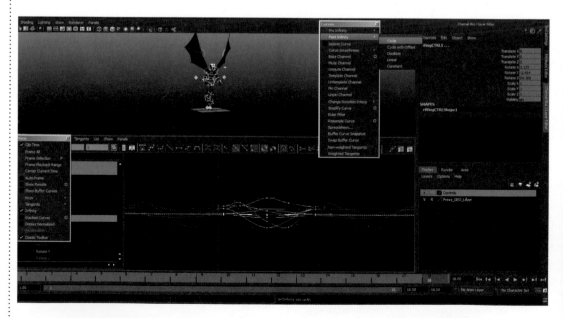

9 Select all of Goon's controls, and in the Graph Editor, select Curves > Post Infinity > Cycle. Also click Curves > Pre Infinity > Cycle. Remember this setting tells Maya to cycle the animation on any frame before our first, and after our last set keyframe. View these curves by clicking View > Infinity in the Graph Editor.

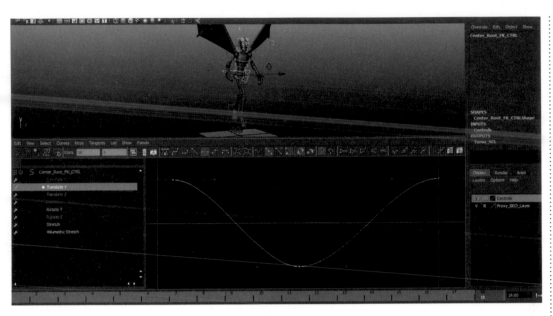

8 Middle-mouse drag and copy frame 1 to frame 18 in the time slider, open the graph editor, and flat all tangents. Noticing a pattern in the workflow yet?

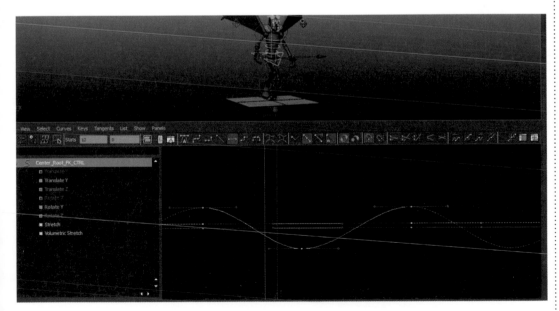

10 Let's offset! Select Goon's root control, and select all of the curves in the Graph Editor. One awesome feature of Maya is that you can make a change in the Graph Editor while the animation is playing and watch the result. Hit play on the timeline and move the selected curves backwards six frames in the Graph Editor.

HOT TIP

When creating cycles, experiment with making sections of the cycle slightly different lengths to get a more organic feel. For instance, sometimes in a walk you can make the right foot's step take 9 frames and the left foot 10 frames. Small differences that you imperceptibly feel but don't see can make an animation feel more lifelike.

Flying Cycle (cont'd 2)

11 Cool! It now looks like his wings are thrusting him in the air! Let's build another layer of offset animation. Since we'll be selecting Goon's spine and legs a lot, let's make a quick select button. Select his spine and leg controls, and click Create > Sets > Quick Select Set... Name it SPLEG and click "Add to Shelf".

13 On frame 9 key Goon's spine bent forwards, and his legs slightly extended. Click the SPLEG shelf button, and copy frame 1 to frame 18 by MMB dragging in the time slider like we've become used to. We have our timing engrained in our mind by now, so creating animation on set intervals and offsetting is super easy!

12 Now you have a handy button that selects these controls for you. Deselect everything, then click on the SPLEG button. Now on frame 1, key Goon's spine bent slightly backwards, and his knees slightly bent like above.

14 In the Graph Editor, set the Pre- and Post- Infinity curve types to "Cycle" as before. Select all the curves, flat all tangents, and offset! Drag his spine and leg curves backwards two frames. Play back your animation and adjust if necessary. Awesome!

HOT TIP

Don't stop working with your offsets after sliding the curves around. Keep subtly working more in by having the wings flap a frame or two apart from each other. Then use the tangent handles to give each wing a slightly different spacing through their individual flaps. Lots of little tweaks will add up to a big difference!

227

Style

by Kenny Roy

WHAT IS STYLE? How do you know when you are copying a style, and when you are coming up with your own? Is style even something that you need to worry about upon entering the industry?

Absolutely!

First, what is style? Stylistic choices start with the design process. Many of the stylistic choices of a film are made when the director first sees the characters and starts brewing ideas for how they are going to move and act. Are the characters going to follow normal proportions, or are they going to be distorted? Many directors have very famous styles. Who can forget the long necks and sinewy bodies of Peter Chung's *Aeon Flux*? How about the thick legs and and wide-set eyes designs that made Chris Sanders famous, easily spotted in *Lilo and Stitch*, and in the design of Toothless from *How to Train Your Dragon*? I know a few accomplished designers myself, who believe (and rightly so) that the designs inspire almost all of the style of the rest of the film. It is for this reason that it is important to get your style clear in the design process. Though design certainly informs and inspires the animation style, the design, model, and texture phases are normally complete or well under way before you are brought on to a project, be it a film, TV show, or commercial. Let's worry about the animation style for now.

Simply put, animation style is the set of choices in performance and animation technique that deviate from the established norms.

What kind of choices? Performance choices can be anything from how far characters stand from one another when they are talking to one another, to how much eye contact they make. A stylistic choice in this vein (albeit mostly due to budget) is how in anime, the character's faces don't move except for the mouths when speaking. This is part of the anime style. Another performance choice might be for the characters to all hold the very last dramatic body pose when they are fighting; making such a dynamic moment feel so static could bring the audience into

a world of slow-motion without even realizing it. It can be as subtle as the director saying that he/she wants only 1 frame eye darts, or that every single walk cycle has to include an extreme pose with the foot that is about to plant fully extended and the heel barely grazing the ground (a style choice I've heard from a Pixar animator talking about one of their films). Or it may not be subtle; style can also dictate overall timing choices for an entire show. For instance, *Flushed Away* was done in what many people called "stop-motion" style. Since the film was a co-production between DreamWorks and Aardman (of *Wallace and Gromit* fame) that makes a lot of sense. However, what people simply called "stop-motion" style actually was a broad set of stylistic choices. For instance, the animators used very fast or instantaneous pose changes, "popping" into anticipation or follow-through, and keying the entire body on 1's and 2's, etc.

When we really stop to consider the style, we start to realize how powerful it can be. *Flushed Away* is a great example of how a strong style choice can move an audience. The kung-fu frogs were absolutely hilarious in the film, and much of the humor came from how funny their actions looked when the animators emulated stop-motion animation. Now think about some other animations recently that have strong animation choices and how it contributes to the film as a whole. In *Rango*, we see how keeping character as close to reality as possible goes very hand-in-hand with an extremely detailed, realistic animation style. In *Horton Hears a Who!* the characters all move beautifully to match Dr. Seuss's original designs. In that film, the "cartoony-ness" of CG animation was pushed really far, from the scene in which Horton inflates himself as much as he can to make himself lighter, to when the Mayor gets a dozen Novocaine shots in his arm, which subsequently turns into a piece of spaghetti dragging behind him. Hilarious.

When you are hired onto a film, learn from your leads and your supervisors. Ask your colleagues and pay very close attention to the director at dailies. The most important thing about style is that every animator needs to be striving to achieve the same thing. Creating a film is hard enough, but making sure that the style from shot to shot stays consistent is even harder.

In your personal work and in your professional career, style should be at the front of your mind. Brainstorm new ways to move characters and to come up with unique answers to questions of performance choice and animation technique. Strive to push the envelope even further than your predecessors ever dreamed of. Work hard, be diligent, and your style will be born.

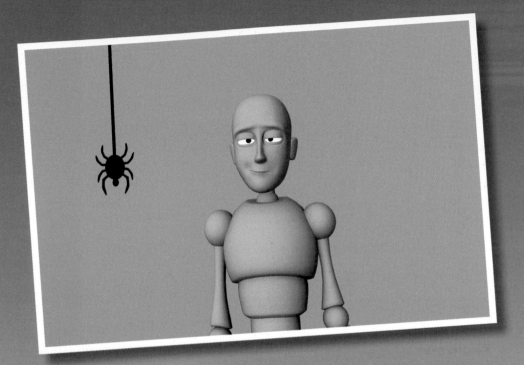

■ We'll take an animation from the Techniques chapter and apply some polishing techniques to make it look much better.

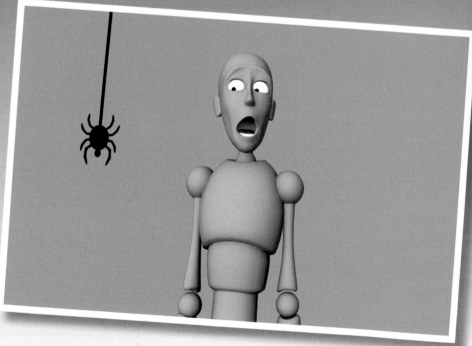

Maya
10
Polishing

IT'S THE LITTLE THINGS that really make an animation
sing, and the polishing phase is where they happen.
Polishing is the detail work; adding those little nuances
that take the animation and push it to a higher level.
When we reach this part of the process, we're no
longer making big changes to the acting or timing or
poses. We're simply going in and making everything as
appealing as possible. Polishing is where we go through
our animation with a fine-tooth comb, and make sure
we're employing the 12 principles everywhere we can.

While the polishing needs will vary depending on the
animation, there are some techniques that will be called
upon in most cases. Those are what we'll go through here.
Get out your animation wax, it's time to make things
pretty!

Cushions

WHEN YOU GET TO the polishing stage, you'll most likely have some movements that just stop on a pose. There may be an ease in, but chances are there are a lot of places where body parts move to the pose and stop at a flat curve. Things can look pretty good at this stage, but often times, adding cushions can be the tiny, almost imperceptible thing that really gives the character a nice, fluid feeling.

Cushions are really just very small ease ins. They're simple to add in, and can work on everything from hand gestures to blinks. Going through your animation and cushioning the places that are a bit too flat is one of those "greater than the sum of its parts" techniques. Have them throughout the animation in the right spots, and suddenly the character feels more alive and natural.

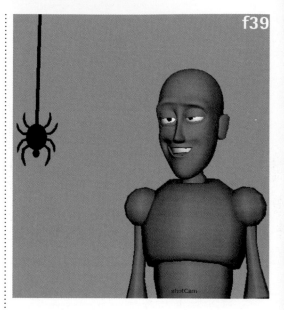

1 Open cushions.ma, which is a more refined version of the animation we used in Chapter 4. Good candidates for cushions are spots where the character stops at a pose, like f39 after the head turn.

4 Do the same for the upper chest's rotate Y at f40-f44.

cushions.ma
cushions_end.ma

2 Select the head control and look at its rotate curves around f36. We can see that once we get to the pose, the curves just stop and remain flat.

3 Insert a key four frames down at f40 (select curves, hold ⬛ and middle click). Then adjust the keys at f36 to do a very small ease in. You want the cushions big enough where you feel them, but not so it softens your timing noticeably.

5 The mouth corners and jaw at f39 are another spot where cushions will help. Add them at this pose as well.

6 The spot where his arm comes up in the anticipation to the scream is another good spot for cushioning. Continue going through the animation and adding subtle softening where you feel it's necessary.

Moving Holds

THERE ARE PLENTY OF TIMES where a character needs to be fairly still. Whether it's a subtle acting shot, or a background character listening attentively, computer animation generally does not have the luxury of just letting things freeze for a moment. If it does, the character suddenly transforms into a doll or statue and looks completely lifeless. 2D animation can get away with held drawings, but a computer animator needs to employ moving holds.

Just like the name says, the character is holding a pose, but still moving so as to not freeze in place. It's simply adding a subtle amount of drift in the curves so the character still feels alive. This reconciles with real life, because nobody is ever perfectly still. We breathe, shift weight, drift around our balance, and more.

Moving holds are pretty simple to add into your work; the trick is figuring out the right amount of drift and having the right amount of slightly different drifts between different body parts. In this cheat, we'll add some moving holds while the Goon grins and before he registers the spider. We'll also put some drift on the spider as well. Be sure to look at the scene file for this one, as it definitely can't be seen on the written page.

1 Open movingHolds.ma. The first place we need a moving hold is the start, where the Goon is just obliviously grinning. I like to think of moving holds on a 2D plane, so the drift mainly happens right and left here.

2 Select the body's Translate X curve. I'll make the drift travel from his left to right, since he turns to his right. Select the first key and drag it up almost to 0.1. Shape the drift so it's not too even, but not too defined either.

6 Select the head control and add a very slight, almost imperceptible drift in Rotate Z; just enough where you don't notice the head moving, but it's also not frozen in place.

7 After his shriek, have the Translate Y on the body move through the end of the animation at f70. This keeps him pushing upward to not stop in the middle of this emotional response.

movingHolds.ma
movingHolds_end.
ma

3 He finishes his turn at f38, so make the drift go the opposite way while he stares at the spider, before it registers that he's afraid of it and starts to do the take.

4 Next we'll put some drift on the arms so they don't look frozen. On the left arm's Rotate Z, do a subtle sway back and forth.

5 Do the same in the right arm and give it a subtle drag when he turns to the spider. Counter-animating the arm backwards, then catching up to the body keeps everything from moving at the same time and feeling stiff.

HOT TIP

For most styles of computer animation, moving holds are necessary to keep it feeling alive and organic. If you have flat curves in the body, arms, and head, chances are they need some appropriate drift added in those places.

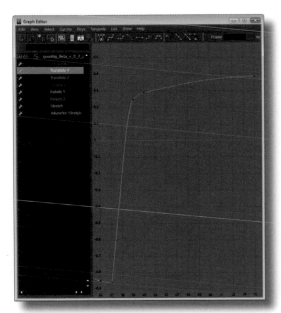

8 Now let's fix the spider. I made this hold quite a bit bigger and more noticeable than the Goon's, more like a bob, to make it feel creepier. This also helps compensate for the fact that we can't move his legs.

Texture

TEXTURE IS VITAL in making our animation interesting and fun to watch. Many times animators speak of "adding texture to a shot", which I have come to interpret as embodying two fundamental concepts: detail and variety. These two concepts can be employed in any or all of the principles, and masterful animation will possess it in just about all of them.

In terms of detail, computer animation gives us a tremendous ability to create detail, sometimes to a fault! When we think of detail in the polishing phase, it's often things like making sure the fingers spread out all a little differently, the way the lips press together and then relax, or anything that most people won't notice the first time they see an animation, but rather feel it. Thoughtful detail can add sincerity and believability to a performance.

Variety is nothing being quite the same. This can be difficult in computer animation, as the computer's gravitational pull is always toward evenness and regularity. If a character is nodding yes, each back and forth can have a slightly different number of frames and a slightly different amount of rotation. If there are several head turns or accents in the jaw, try making them all different in some way. When we polish, we go through our animation over and over, looking for these places where we can do these things and make the character more believable and organic.

In this exercise, we're going to add some texture in his shriek. Right now it's pretty plain and straightforward, so adding some trembling throughout his body will be a nice detail and go a long way in improving this animation.

1 Open texture.ma. We'll start with the body, adding some left-right shaking. Select the body control

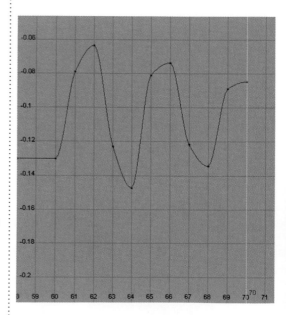

4 With fast two frame movements, you can add variety into the spacing and break up the evenness of flat tangents by inserting keys between them. Make them ease ins of varying amounts.

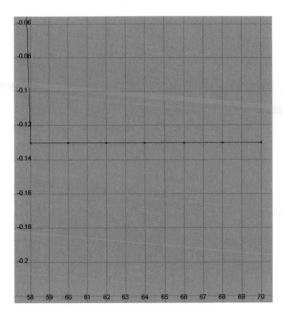

2 Starting at f60, add a key on the Translate X on every other frame.

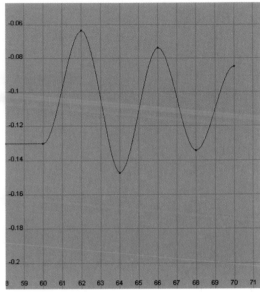

3 Pull the keys out, making sure that they're all a bit different in value.

texture.ma
texture_End.ma

5 Next is the head, which I'll animate in all three axes, but make each one contrasting. First is the Rotate X, which I'll simply continue tilting upwards throughout the movement.

6 Rotate Y will be a one frame jittery shake back and forth. Keep the value small but varied.

Texture (cont'd)

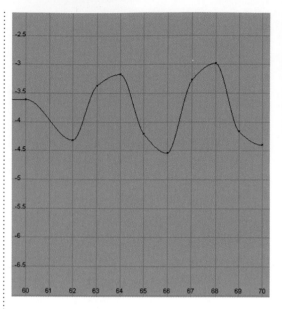

7 Rotate Z has a two-frame jitter, again using the ease ins to break up the spacing variety a bit more.

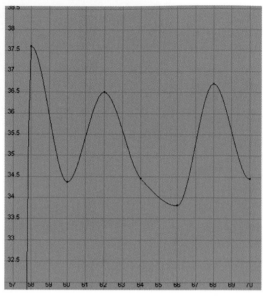

8 Next I worked on the jaw's Rotate Z. It's the same type of movement, but I'm just looking for ways to make it a little different than the others. This one has a mix of one and two frame movements and some spacing variation.

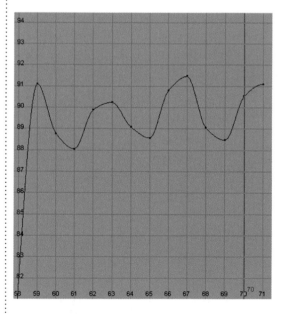

11 The left arm is the same idea, yet started a frame earlier and doing the opposite motion so both arms don't look the same.

12 For an extra detail, I added an eye dart from f16-18.

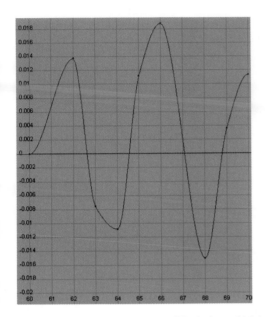

9 This contrasts with the Translate Z in the jaw, which is more straightforward in its spacing.

10 The arms are animated on the Rotate Z channel, doing a shake and using the same ideas of variation.

13 We'll do some finishing touches in the next cheat, but feel free to add more to this animation where you feel it needs it. Some potential places are the chest, and the tongue, for a start.

Finishing Touches

W E ARE NOW AT the finishing stage of this animation. The main idea here is going through it and making sure the 12 animation principles are at work throughout. That may sound daunting, so it helps to isolate everything as you do this. Make a list if it helps you, and focus on a principle and if it's happening (or needs to be) at each part at each specific movement.

As an example, let's use anticipation. Start with the body control, and at each movement ask yourself "Ss there an anticipation to this movement? Does it need one? Should it be seen, or does it just need to be felt?" and so on. Then move on to the arm and repeat the process. Once you've gone through an anticipation pass on everything, go through doing a pass at overlap, then ease in/out, and so on and so forth.

Polishing is something where the end result is greater than the sum of its parts. Each little tweak may not seem like much on its own, but together they can really make your animation sing. This cheat is just a few of the possible areas for polish to get you started. Happy animating!

1 Open finishingTouches.ma. The first detail I'll add is a tiny bit of movement in the brows with the blink at f07. You don't always want to move the brows in a blink, but this one is slow enough where it makes sense. Have them lead the blink by a frame and overlap the center with the sides and cushion the end.

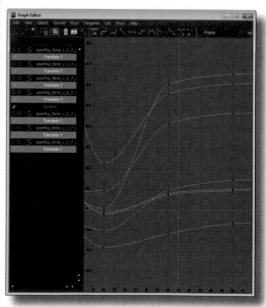

4 Put a nice cushion on that raised brow pose at f40 so they keep pushing up during the look.

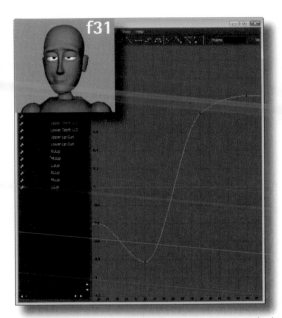

finishingTouches.
ma
finishingTouches_
End.ma

2 When he turns his head at f28, I used the Mouth UD (up/down) to drag the head by a few frames. Just a subtle amount gives a better feeling of fleshiness to the mouth.

3 Also on that head turn, do a small anticipation with the brows going down before he raises them into the pose where he's looking at the spider.

HOT TIP

Flat curves, particularly in the body control, spine, and head, are a good indicator of places to look for polishing work.

5 We can add some overlap with the squash and stretch in his head to make him feel more organic. With the squash control on the head, stretch it out at f52 so it's dragging behind his body's downward anticipation.

6 The squash then catches up by f56...

241

Finishing Touches (cont'd)

7 ...still slightly squashed at f58 on the way up...

8 ...and then overshoots at f60, a frame later than the body's extreme up, to overlap...

11 Key the brows at f70 and have them keep pushing up as far as possible until the last frame.

12 Little overshoots on the shoulders (with the arms offset by a frame) when his arms snap down at f59–f60 help loosen things up as well.

f62

9 ...and settles back into normal position two frames later a f62.

10 This is the curve I came up with for the head's stretch control.

13 Keep polishing the animation, looking for more spots you can improve. Some other ideas are seeing his mouth smirk a bit in the opening, moving his tongue during the shriek, and offsetting the eyes during the blinks or when closing.

Getting Feedback

by Eric Luhta

IT WAS NOT TOO LONG AGO I realized something that completely changed the way I approached my work. Animation is, above all, a group art form rather than a solo one. Sure, much of the time it's a single animator doing the actual animation work on a shot (save for the gigantic crowd ones), but if the animation looks sweet, you can bet they received lots of feedback on it throughout the animation process.

Feedback is probably the single most important element of developing as an artist. I'll say it one more time for emphasis: Feedback IS the single most important element of developing as an artist. You can learn quite a bit on your own, sure, but without comments, criticism, and feedback from others, your work will stagnate.

I think most people struggle with taking criticism of their work at some point. After all, it's an artistic endeavor and artists pour so much of themselves into what they do. Anyone who says that it's easy to listen to someone tell you everything you did that's wrong is lying! It can be hard not to take criticism personally (and it's almost never meant that way) because it's natural for us to attach ourselves to our work. That said, if you want to be an animator anywhere besides your home, you will have to reconcile with taking feedback and seeing it as what it really is: making your work better.

Why do we need feedback? Because the amount of focus we are putting into animating something causes us to lose objectivity. We work with a minimum measurement of 24 frames per second. The minutiae of that is really incredible when you stop and think about it! When you watch something over and over again, your brain will adapt to how it looks. Watch anything a few times, and stuff that was glaringly wrong suddenly seems OK because it's familiar.

This phenomenon isn't unique to animation. When I was working as a musician, I noticed that I could record a take playing something, and the first time I played it back any mistakes would stick out like a sore thumb. If I listened a few more times, more and more they stopped sounding like mistakes; my ears had become used to it. The same happens with our eyes.

Feedback circumvents this by having someone who's not focused the way you are

giving you an objective opinion. They are watching it from the point of view of an audience. They will immediately see things that don't look right, or be able to tell you if they understood what's going on. When we know what we're animating, it makes it harder to tell if what's on screen reads clearly to someone who doesn't know.

Show your work throughout the process, not just when you feel you're done (and you're not... the law of animating is if you think you're done, you're halfway done). I can't tell you the number of times I would have saved myself a lot of work simply by showing others my blocking earlier. Problems I never would have realized are obvious to a neutral party.

Feedback from non-animators is just as important. Showing work to your friends or family will give you a perspective of an audience member just watching something naturally. Animators have developed an ongoing sense of analyzing what they're watching, so it's almost impossible for us to see things from this perspective. Non-animators may not be able to say specifically what doesn't look right to them, but if they comment about it, that alone should tell you there's something that needs attention. And, there's no better test to see if something reads clearly or is funny or entertaining than someone watching it and reacting the way you want them to.

Finally, from a practical standpoint, taking feedback is half of an animator's job. Ask any professional, and they will tell you that a big part of the work is hearing what they did was wrong, what they need to change, and what isn't working. Everyday I'm told I need to do something differently than I did! On any commercial project, it's an animator's duty to take criticism positively, graciously, with a good attitude, and do what is asked of us. Get feedback on everything you can, as much as you can, and you'll be able to navigate the waters of critique with ease.

What's his motivation? The face is a huge part of conveying this clearly and convincingly through a performance.

11

Facial Animation

ANIMATING A CHARACTER'S face is one of the most interesting and enjoyable parts of the animation process. We can convey much with the body poses, but this is the really good stuff: the detail that literally breathes life into our characters. The drama and emotion that the face contains really makes us look inside ourselves and seek to understand and identify with a character. If animating the body makes us entertainers, then animating the face makes us actors.

Facial animation could fill many volumes on its own, but here we'll get into the bread-and-butter techniques that give us a great starting point. No two animators work through the face the same way, and you can build your own dramatic philosophies on the essential tools in this chapter.

Facial Animation

Planning and Prep

W E ARE GOING TO WORK THROUGH some facial animation techniques using a simple example of a typical close-up shot. This keeps the staging simple and makes it easy to focus on just the face, while also being a very common shot style found in film, TV, and games. To make the exercises as straightforward as possible, the body has been blocked in for you, so you only need to worry about the face.

When doing any kind of dialog shot, it's important to thoroughly plan your animation. Don't just dive right in and start keyframing. Listen to the audio by itself, over and over, until all its accents and nuances are thoroughly ingrained in your mind. Also think about the context of the line, along with the character's internal thought process and motivation for saying it. It's quite possible to animate a line in completely different ways, yet when played in context with the surrounding shots, only a specific approach will ring true.

In our case, we don't have a context, just a single line to use for practicing some animation technique. For the sake of consistency, we'll pretend that the ideas in this planning section are what a director has instructed us to do. In the real world, this planning and prep would have been done before the body was animated, as it would influence our decisions in that regard as well.

"I have nothing to say."

1 In the Sounds folder in this chapter's project directory is a .wav file with a short dialog clip (nothingtosay.wav). Open it in your favorite media player and listen to it on looped playback. Use headphones if possible. Write down the line and listen to its nuances.

"I have..."
-slow blink on head raise
-head tilts back
-eyebrows raise

"...nothing to..."
-eyes flare slightly
-upper lids still touch iris
-head tilts more
-make brow pose asymmetrical

"...say."
-head comes down
-tilt is opposite of up position
-brows lower some
-eyelids stay lowered

4 Reference is always a good idea. Act out the line and create some video reference for yourself. Make notes on the brow poses, eye darts, blinks, etc. You can also make thumbnails, have a friend act it out, whatever you find useful in determining what you will animate.

"I have nothing to say."

"I have nothing to say."

attitude: uncooperative, resistant, possibly hiding something, knows more than he is saying
subtext: "I have nothing to say to you, I don't want you to find out what you are asking me."

2 I hear two distinct accents in the line, on the "noth–" (first syllable) in "nothing," and on "say." The pitch goes up to "nothing" and down on "say." This is also reflected in the body animation. Mark the accents down in your notes.

3 Next I think about the tone of the line and the subtext it may be communicating. The way he says it sounds like he's being uncooperative. It feels like he means "I have nothing to say to you in particular", to whomever he's speaking to. This is more material for our notes.

HOT TIP

To import a sound file into your scene, go to File > Import and select the audio file. Then right click on the timeline and choose the file from the Sound menu.

5 Once you've decided on the acting choices and know why you've made them, it's time to start working on the face. Some animators do the lip sync first, while others do it last. I find it helpful to first do a few full face poses to use as a structure. Open FaceAnimation_START.ma. The body has animation, but the face is stuck in its default blank stare, which we'll fix soon enough!

Core Poses

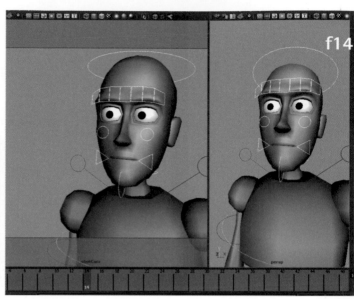

1 In the FaceAnim_start.ma scene, there is a quick select set for the face. Go to Edit > Quick Select Sets > face, and set a key at f14.

I T'S VERY FEASIBLE to animate the face in a layered fashion, but I've found I get better results when I first block in some initial expressions to use as a foundation. The accents we indicated in our planning stage create a perfect framework on which to base these poses. This also helps make the work stronger, since we can focus on just a few expressions and not worry about making fluid motion yet. We'll put in four poses total: the accents on "nothing" and "say," the anticipation pose on "to," and the starting pose. Things will get moved around a little when we refine them, but you'll likely find that these core poses really help keep you on track.

5 At f32, set a key on the face controls. Bring the brows down, lift the lids some, and expand and shape the mouth for "say."

6 Copy f14's pose to f18 by selecting all face controls and MM dragging in the timeline to f18 and setting a key. This will hold that pose for five frames.

f14

FaceAnim_start.ma
CorePoses.ma

2 The Goon's default pupil size is a bit small, so I increased the Dilate attribute to .2 on the eye controls, and will keep it there the entire animation. This will make him a bit more appealing once the expressions are in.

3 Start with the brows, raise them and make the shape slightly asymmetrical. Raise the lower lids a bit and make the L eye upper lid slightly higher to complement the higher L brow.

4 For the mouth, bring the corners down and inward. It's roughly the mouth shape for "ha-", but we don't need to be concerned with it too much right now. Curl the lips out a bit and shape the mouth.

f24

f01

f01

7 Key the face at 24. Raise the brows even more, lift the lids, and shape the mouth for the "to" sound.

8 Key the face at f01 and create the starting pose. We want to convey him being slightly defiant. Lower the brows, but not enough so he looks angry.

9 A slightly open frown helps show that he's displeased about the situation, but not gruff or stewing.

251

Lip Sync 1 - Jaw Motion

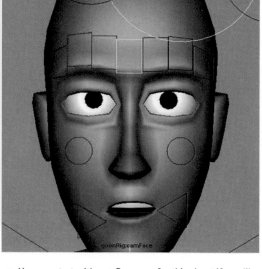

1 You can start with corePoses.ma for this cheat if you like. If you want to use the face cam, in the viewport menu go to Panels > Perspective > camFace. The angle will stay straight on the face no matter what the body does.

WITH THE CORE POSES COMPLETED, we're in a good spot to start on the lip sync. As we've seen time and time again, the approach of starting broadly and adding detail in phases will work beautifully here. We won't worry about mouth shapes yet, just the jaw's Rotate Z movement. Once that is working, everything else usually falls into place pretty smoothly.

It's easy to overlook the variety of timing in the jaw movement. In a given line of dialogue, there is usually a wide range of sharp and smooth movements. One trick that helps make them a bit more tangible is to say the line while holding your hand underneath your jaw. You'll be able to feel the words with sharper timings and then translate that into your curves. I found that the biggest accents were on "I," "nothing," and "say."

The goon rig comes equipped with a face cam, which some animators like to use for lip sync, particularly if the body is moving all over the place. It's simply a camera constrained to the face, so it keeps the same angle even when the body is moving.

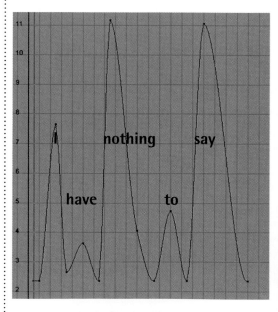

4 This is the curve I came up with for the first pass. Notice the accents on "I," "nothing," and "say," while "have" and "to" are much smaller.

CorePoses.ma
LipSync1.ma

2 It will help to delete the mouth's animation and start fresh. Select all the jaw keys in Rotate Z except for f01 and delete them.

3 Do a first pass just to add the open/close movement. Just get the general timing for now. Do an open/close for each word, or five total. Keep in mind that you want the open to be a few frames before the actual sound.

HOT TIP

Animate the physical movement of what's being said, rather than simply basing it on the words. If you open/close every syllable, the mouth will chatter pop. Analyze yourself saying the line and only put in what you actually see.

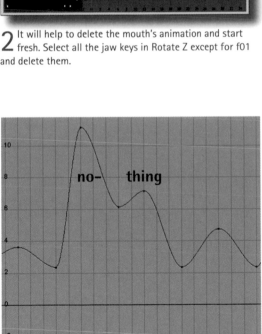

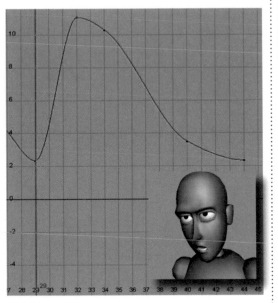

5 Tweak the timing and get the little bump that happens on "-thing." I like to save these secondary bumps for after the main accent so the mouth doesn't get too chattery.

6 Work on the timing of "say," which he draws out longer in the clip. I added a key to hold it open longer, and a longer ease in at the end.

Lip Sync 2 - Mouth Corners

1 At f07, move both corners out for the "I" sound.

2 Move to f13 and bring them in some for the "ah" sound in "have."

THE JAW IS JABBERING AWAY, so it's time to work on the mouth corners. With this rig, the corners are the primary shaping controls. Other rigs might have more controls for the mouth shapes, but the idea at this point is the same: add another level of detail without going overboard. There's plenty of passes left to refine, so we don't need to do everything at once. Because the mouth rig is so simple, we're basically only worrying about if the corners are in or out at a given time. As for up and down, they will stay in a downward frown position for the entire shot.

This is the point where we can start thinking about basic mouth shapes and phonemes. If you're new to animating lip sync, there are plenty of charts online and in classic animation books to study extensively. For this exercise, we'll just walk through the ones we need for the dialogue. To keep things simple, I'll start by posing the corners on the same keys as the jaw. Remember, we're not doing the full mouth shapes yet, just the positioning of the corners to get us on the right track.

6 At f26, bring the corners in again for the "to" sound.

7 Hold that shape until f29, then at f34 the corners come out again for "say." Bring out his L corner more to give a nicer shape on this last word, so it has a slight drawl to it.

LipSync2.ma

3 Two frames later at f15, we need to make an O shape for "noth-".

4 At f18 the corners will expand back out some.

5 Then they expand out more at f20 for the "-ing" sound of "nothing."

8 Finally, we want a nice ease in to the ending pose as the mouth relaxes into his final expression.

Lip Sync 3 - Mouth Shapes

f07

f09

LET'S CONTINUE REFINING our lip sync by
fleshing out the mouth shapes. This is
one of the more organic parts of the process,
where you need to experiment a little and do
some back and forth to get things working. The
following cheat is a guideline, rather than a
step-by-step process.

1 On the "I" sound, I lifted the
upper lip controls a bit to give it
a slight flare. Then the mouth corners
were pulled out more to create more
contrast to the next shape.

2 On "have" I opened the jaw a bit
more at f08. At f09 the bottom
lip starts to curl underneath the upper
teeth.

f26

f29

6 Refine the O shape at f26 a bit
more using the lip controls.

7 At f29 for the S sound I closed the
jaw more, pulled the corners out a
bit, and flared the upper lip some.

f12

f13

lower lip

jaw

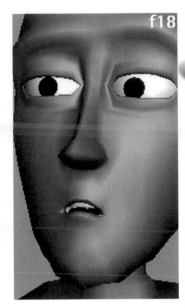

f18

LipSync3.ma

3 The jaw is closed a bit more and the lower lip is curled under the teeth on frames 11 and 12. Any shape like this needs to be held for at least two frames or it will pop and look like a glitch.

4 At f13 the jaw is moving down into the O shape, but I raised the lower lip controls to drag them behind the jaw. The transition from the V blends better and feels more organic.

5 At f18 I closed the jaw more to make the "th" sound read better. Once we add the tongue it should work nicely.

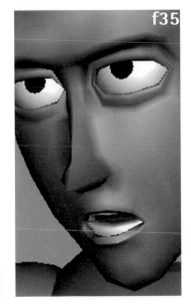

f35

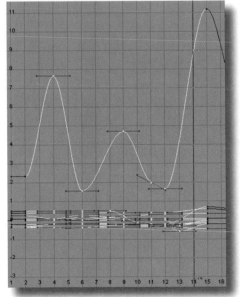

8 From f32 into f36, shape the "ay" sound by curling the lips out slightly, and using the upper lip controls to give a slight flare to help communicate his understated defiance.

9 After looking at a playblast, I decided "I have" was hitting a bit late. I selected the jaw and mouth corner controls and moved all the keys from f05 to f14 one frame earlier, then f08-14 an additional frame earlier.

Lip Sync 4 - Tongue

persp

THE FINAL STEP TO REALLY SELL the lip sync is getting the tongue moving on the right sounds, in particular "no-" and "-thing," the T sound on "to," and the S sound on "say." Unless it's an extreme close-up or something like that, the tongue mainly just needs to be seen when it's touching the top of the mouth, such as on N sounds, and when it moves back to the lower palette. Otherwise it generally just needs to stay out of the way.

1 Since it's a little difficult to select, make a quick select set for the three tongue controls. Select them and go Create > Sets > Quick Select Sets. We'll just move and key them all together for this exercise.

f19

f21

4 Make the tongue touch the roof of the mouth at f19 for the "th-" sound, and then it arrives back to the bottom at f21.

f12

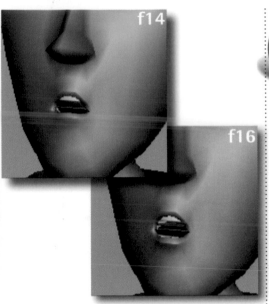

f14

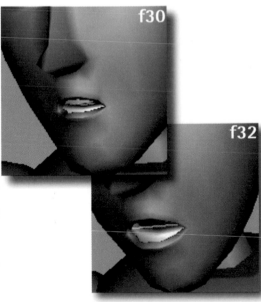

f16

LipSync4.ma

2 The tongue touches the roof of the mouth for the N sound of "nothing." Key the tongue at f12 at its default. It will start moving to the top while he's making the V sound in "have."

3 At f14, rotate all three controls up in X so they're touching the roof of his mouth and key them. Then key them back at 0 on f15 and f16 so the tongue travels back down.

HOT TIP

Most of the time you don't need to get crazy detailed with the tongue for lip sync, unless it's an extreme close-up or realistic style animation. If it's at the top of the mouth when it should be, and we see it travel down when it needs to, that's usually enough to sell it for many situations.

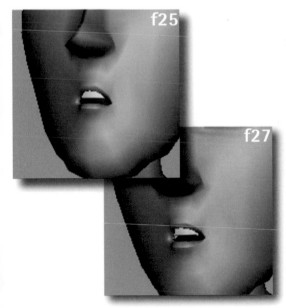

f25

f27

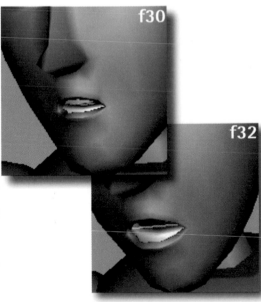

f30

f32

5 The tongue will be at the top of the mouth again for the T sound in "to" at f25, and back down at f27.

6 Finally, have it up at f30 for the S sound in "say," and travel down to f32.

Blinks

1 Open Blinks.ma and switch to a front view. Select the eye controls, and at f01 key the upper and lower lid controls at 0.

B LINKS ARE A VITAL PART of facial animation and acting, and a great way to add more life and interest to your character. Before we continue with the lip sync animation, let's take a look at doing a typical, standard blink. This is a common approach to doing them, but you want to make sure you don't do all your blinks this way. There are many different kinds of blinks – fast, slow, half blinks, fluttering eyes, takes, disbelief, etc. The approach you use will be dictated by the emotion and thought process of the character. Nevertheless, this is a tried and true way to get a nice, organic looking blink and is a great starting point for building a "blink library" in your animation toolset.

4 At f04, the lids are completely closed. I like .75 on the upper lids and .25 on the lower (adding up to 1.00).

7 At f07 both lids are almost back to the starting pose. Unless the eyes are completely open or closed, I generally like to keep the lids touching the irises on the way up or down, as it makes the blink feel smoother.

f02

f03

Blinks.ma
Blinks_End.ma

2 At f02 key the upper lids down at .1 to create a slight ease out.

3 At f03 bring the upper lids down to cover the tops of the irises, and start bringing the bottom lids up very slightly, about .05 or so.

f05

f06

5 We'll hold the closed pose for two frames, but I moved the upper lids down a bit more (to .78) on f05 for a subtle bit of compressing together.

6 At f06, the eyes are opening back up. For a standard blink, I like to have the upper lids be around halfway past the irises on the way back up. The lower lids start to go back down as well.

HOT TIP

Another nice touch for blinks can be adding some very slight up and down in the brows. It depends on the situation, but sometimes adding a barely perceptible amount of motion here can help make things more organic.

f10

8 Instead of ending on f08, do a nice ease in from f07 to f10 to cushion into the pose and make it feel more organic.

9 For an extra bit of polish, do another four frames of very subtle ease in cushioning on the upper lids. This is what the curves look like. Look at Blinks_End.ma for the final result.

Blink and Brows

L ET'S REFINE THE BROWS and add a blink to our face animation. We'll have the Goon blink when his head raises, since its speed fits well with the motion we have going. We'll keep it fairly close to a standard blink, except that the closing will be a bit slower since that fits his uncooperative, slightly indignant attitude. Then we'll tighten up the timing of the brows raising, and add an accent in the brows and eyes to bring out the the final word of the shot, "say."

1 Start the blink at f05. Key the lids open and close attributes at their current position.

4 A slower opening fits this blink as well. The eyes start opening at f11, and at f14 the tops and bottoms of the irises are still touching the lids.

BlinkBrows.ma

2 Let's make the transition down into the closed pose a total of four frames. Here are f07 and f08. Notice that we always see part of the iris when the eyes are open any amount.

3 On f09 and f10 we'll have the closed pose.

HOT TIP

When doing any kind of blink, keep the irises partially visible in all of the opening and closing poses. This avoids flashes of only eye whites, which will pop in an unappealing way.

5 The eyes continue to ease in to their pose at f18.

6 Now let's work on the brows during the blink. We want to have some overlap, with the brows going up leading the eyes opening slightly. Select all the brow controls.

7 Move the start of the brows' motion to f08, right before the eyes are closed at f09. At f14 they should hit their up pose.

Blink and Brows (cont'd)

8 A quick trick for doing cushions for the flat curve sections is to move to the frame before they hit the pose, in this case f13.

9 MM drag in the timeline from f13 to f14 and set a key. Now f14 is almost the same value it was, but drifts through to f19. Fix the tangent handles and you instantly have a nice subtle drift to make things more organic and not frozen for a stretch of frames.

13 At f36, set a key on the brows so they have the same pose as f32. Then at f32, pull the brows down just a small amount to create a little overshoot.

14 Key the brows at f40 and add a little cushion starting at f36.

10 To add a bit more fleshiness to the brows, I often like to make the apex lead the rest by a frame. Select the three brow controls shown here.

11 Those are the apex of the brow pose, so select their keys at f08 and f14 and slide them one frame earlier to lead the rest of the brows. It's subtle but a nice little touch.

12 Let's move to the end of the animation, on the word "say." Right now the brows and eyes just stop on that last pose at f32, so let's add a little accent. Select the brow controls.

HOT TIP

The brow sections that lead the rest depend on the pose you're hitting at a given time. Use the apex as a guide.

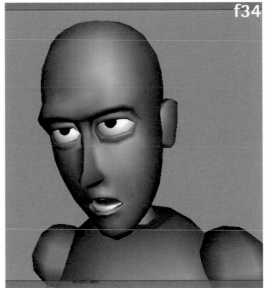

f34

15 Select the three middle brow controls and move from f32 onward one frame earlier so they lead the rest of the brows.

16 Make a very small complementary squint with the eyes that trails the brow by a frame. It will help feel that his face is working as an organic unit, rather than an assembly of moving parts. See BlinkBrows.ma for the end result.

265

Eye Darts

Facial Animation

ANOTHER IMPORTANT ELEMENT of organic facial animation is eye darts. They're often used for "keep alive" moments, where a character isn't really moving much but needs to still look like they're living beings. They show that a character is thinking about something and that they have an internal monologue happening. And on just a practical level, our eyes rarely stay focused on the exact same spot for more than a second or so, and usually less.

Eye darts can definitely go deeper than that, however, and should be thought about with as much attention as any other element in a character's performance. An eye dart at the right moment can communicate things that nothing else could. A character's eyes darting away as they're trying to convince someone of something can convey them thinking, "Are they buying this?", or show worry, realization, doubt, or any other internal emotion. This is something that we as animators need to be constantly thinking about.

We'll go through a simple eye dart workflow, but keep in mind it's a starting place. Your decisions about eye darts ultimately involve what you need to communicate about the character's internal mental state.

Rather than bouncing them around randomly, it helps to create a subtle pattern with the darts. Shapes like triangles, rectangles, etc. can be good guides for plotting the path the darts make, provided you don't make them too obvious. Varied timing and amounts of movement can help with this. Shapes make sense because we often look back and forth between a person's eyes and mouth when we're conversing. For this exercise, we'll do three darts, and form a triangle shape with their path. They're traced in the example as they're very hard to see in still pictures. Be sure to follow along with the Maya file.

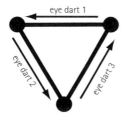

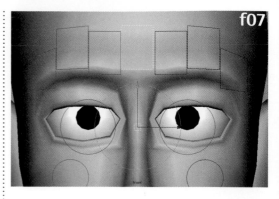

1 Open EyeDarts_START.ma, which starts with the blink exercise we did previously. Key the EyeTarget control at f07.

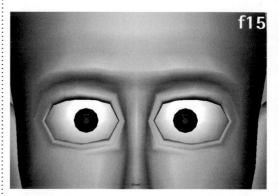

4 Do another eye dart, with the ease in, from f13 to f15. We'll work back to the original pose, but rather than do a lateral move right back to where we started let's go downward.

7 In our face animation, let's add an eye dart at the end for keep alive and for conveying that he's speaking to someone directly. Our eyes often dart back and forth between the other person's two eyes when addressing them.

f09

f08

EyeDarts_start.ma
EyeDarts_end.ma

2 Eye darts are generally two frames (at 24 fps), so move to f09 and key the eyes slightly screen left, about -.3 in Translate X.

3 It helps to do a tight ease in to the next pose, rather than leaving it linear. A quick trick is to use TweenMachine. I went to f08, pressed the 60% button, and it's done.

Our eyes tend not to smoothly track things, at least not without turning our head with it. If the head isn't moving, it's common to do a series of sequential darts, rather than a smooth pan across.

f27

5 It often helps to think of the eye darts moving in the path of shapes; in this case I'll use a triangle. This helps keep them interesting, rather than lateral or too random. f25-f27 gets us back to the original pose.

6 Here's what the curves look like. Notice the ease ins, and that we didn't space them evenly apart. Variety in the timing is another characteristic of appealing eye darts.

f40

8 I did a dart from f38-f40. It's subtle but another small thing that helps add up to a more convincing performance. FaceAnimation_darts.ma has the end result.

267

Final Touches

W E'RE AT THE HOME STRETCH with this face animation! All that's left is some tweaks and polishing to make it look as good as possible, which we'll go over in this cheat.

Hopefully this exercise in facial animation has given some insight into both what to think about and how to execute it in Maya. The face rig we're using is only the basics; you will run into more sophisticated rigs throughout your career, but the principles remain the same. The face is working as an organic whole, yet some parts are influencing others (brows can influence the lids, mouth corners can push up the cheeks, etc.) From ears to nose flares to a dozen lip controllers, modern production rigs are capable of most any expression possible. Study reference and performances by great actors, think about motivation, internal monologue, and thought process, and work through your own Oscar worthy performances. Happy animating!

1 The first thing to do is give a slight anticipation down before the brows move up. It's another detail that will help things feel less mechanical and more organic. Select the brow controls.

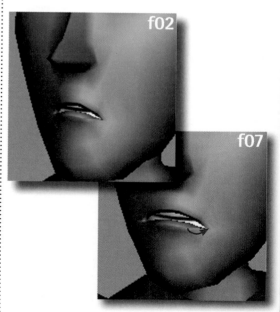

4 Another subtle polish thing is to make sure the mouth corners have nice little arcs in them when moving in and out. It's another one of those details that isn't obvious, but just helps everything feel a little nicer.

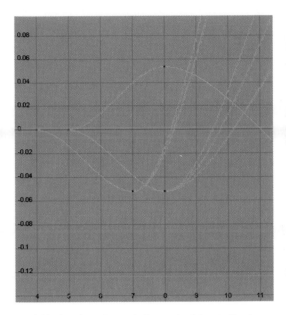

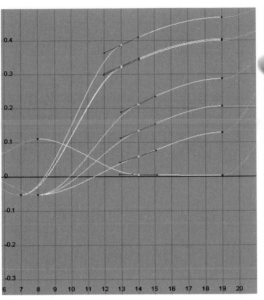

FaceAnim_end.ma

2 Add a key three frames before each of the starting keys and then pull the original keys in the opposite direction about .05 or so. Now there's a slight down in the brows that makes them feel nicer going up.

3 On second look, it looks like the up pose at f14 is still hitting a bit too hard. Select the keys at f13 and f14 and pull them down to make the cushion a little bigger. Now they won't stop so quickly and will look more natural.

5 "-thing" is another syllable that can have a nice arc on the corners. A subtle loop into the closed position will work nicely.

6 Create another nice little loop on "say." It doesn't need to be very noticeable, just there. Continue tweaking the animation until you're happy with it.

Repetitive Stress Injury

by Eric Luhta

REPETITIVE STRESS INJURY, or RSI, is a very real hazard of working on a computer all day, as animation requires us to do. The stress you can put on your hands and wrists doing tiny movements day in and day out can add up to a very painful and debilitating condition that can jeopardize your ability to work. Taking precautions, being conscious of ergonomics, and working smart can keep you happily keyframing for many years.

I've been a victim of RSI, though it was before I became an animator. When I was in music school, I was practicing the piano 8 hours a day, and also worked part-time as an IT supervisor for the university's music computer lab. If I was awake, chances are I was playing or typing and using a mouse. Everyday I was constantly using my hands without much of a break and it didn't take long before I pushed myself to the breaking point. The pain had been building up gradually in my wrists and forearms, but I shrugged it off until it became too much to ignore. This was before RSI was common knowledge as it is now, and I went from doctor to doctor trying to figure out what was wrong. Eventually I found one who was experienced with this growing phenomenon of the computer age, and could treat me.

It wasn't an easy road to recovery though. At the worst point, I couldn't turn a doorknob or drive because of the pain. I didn't play music for about four months, and had to deal with the possibility of not playing ever again. I had to get lots of physical therapy, quit my job that helped support me through school, postpone classes, and put everything I loved to do on hold. It was an extremely difficult experience to get through, but ultimately an invaluable one because it taught me how important it was to take care of my body. If you can't imagine a life of not animating or at best being in pain whenever you do, you need to make working smart a priority.

Animation is extremely mouse intensive, and until we come up with a better interface, we need to be cautious about our working style. The standard computer mouse is actually one of the worst ergonomically designed devices in the history of civilization. Hold your forearm with the opposite hand and rotate your palm down as it is when using a mouse. You will feel your forearm bones twist over each other,

tightly pulling your tendons and muscles above your wrist together. Tension equals friction, and over time your tendons will become inflamed and possibly develop scar tissue that exacerbates the problem.

So step number one: get a better mouse or mouse alternative. I use a Wacom tablet to animate, and since I started with it years ago, I've had no issues with RSI (along with doing some of the other practices I'll mention). It takes a week or so to get used to it, but once you do, you'll find it puts much less stress on your body. Many artists use tablets nowadays, and every place I've worked at had them available upon request.

If you really like using a mouse, research and find a quality ergonomic one. Evoluent (www.evoluent.com) makes a great vertical mouse that's very comfortable to use. It's oriented vertically to avoid the forearm twisting mentioned earlier. I've seen plenty of these in animation studios as well.

Take lots of breaks! Every hour or so you should take at least 5-10 minutes away from the computer to rest your eyes and hands. It may be hard during a crunch but in the long run it will make you more productive. Besides, it gives you a legitimate reason to make use of the studio's ping pong or pool tables!

Use good posture when working. If you work at home, the investment in a good chair and desk will pay for itself in keeping you healthy. Research ergonomics and find a combination that works for you.

Exercise and eating right is the last element of staying in the animation game. Exercise releases the tension that builds up in your body from sitting and working long hours. Doing some weight training will stretch your tendons and muscles and make them more resilient and flexible. Since I've stayed with a weight regimen and followed the above advice, I've been working happily with no issues and no pain my entire career.

RSI is very real and its effects can be devastating to your career. Do your homework, insist on working only in proper conditions, and your body will reward you by always being there for you.

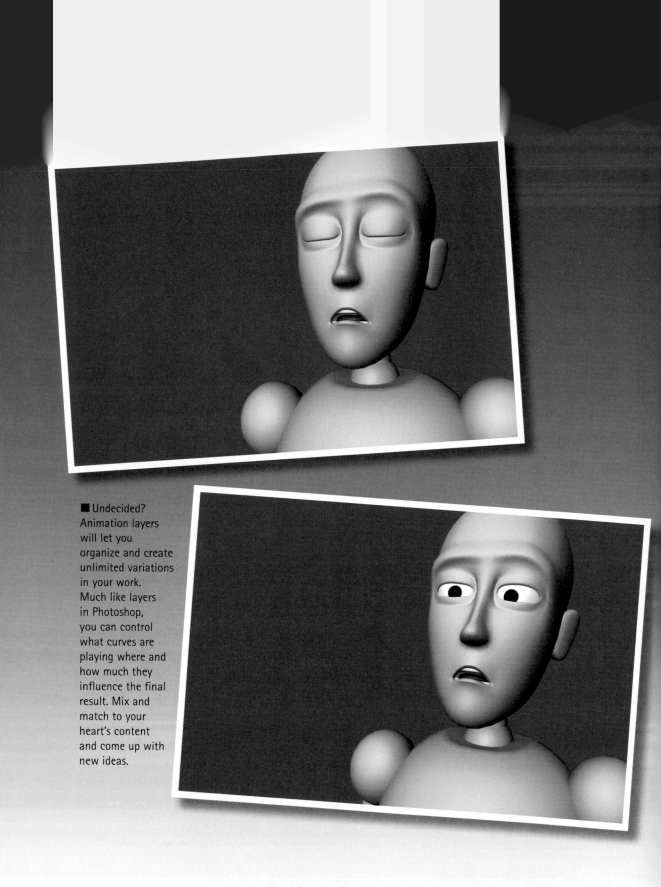

■ Undecided? Animation layers will let you organize and create unlimited variations in your work. Much like layers in Photoshop, you can control what curves are playing where and how much they influence the final result. Mix and match to your heart's content and come up with new ideas.

Animation Layers

12

SINCE THEIR INTRODUCTION, Animation Layers have
been one of the most powerful tools yet in computer
animation. They exponentially increase the ease of
creative tasks like trying different approaches and
variations, and they make working with curves much
simpler and more compartmentalized.

However, they're still a relatively new tool in Maya.
I've met many professionals who don't even know they
exist, yet their benefits can't be overstated. They allow a
flexibility and simplification of animation curves that is
completely on another level from how many of us learned
Maya. This chapter will show you how to employ this
incredibly powerful feature into what will likely evolve
into a new and vastly improved workflow for you.

How Animation Layers Work

IF YOU'VE USED GRAPHICS PROGRAMS like Photoshop, then understanding Maya's Animation Layers will be a short leap from there. Layers let us stack multiple versions of spline curves on top of each other, which Maya then mixes together the way we want. This default behavior is one of two available layer modes, and is called Additive mode. A simple example would be two layers for the Translate Y attribute:

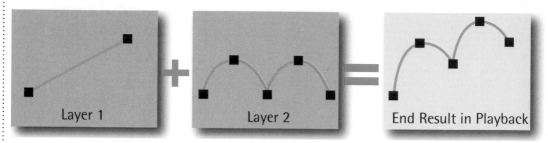

You can see how the two Y curves are mixed together for the end result. While this alone can make working with curves simpler, particularly with more complex examples, the real flexibility is how we can adjust the weight of each layer, much like opacity in a graphics program.

Instead of editing the curve itself, simply turning the weight of Layer 2 down to 50% reduces its influence on the final result by half. It looks like this:

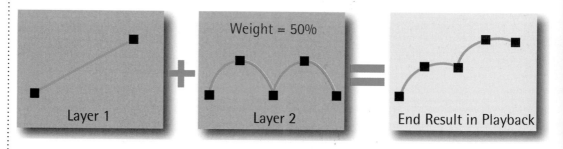

Likewise if we switched that concept, and reduced the weight of Layer 1 to 50%, we get this:

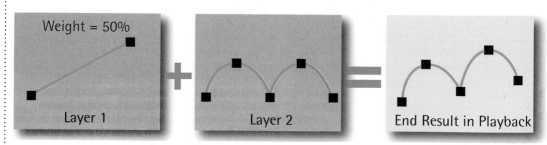

Since the weight is just a slider, we can instantly experiment with any ratio of weights, giving us exponentially more options with no extra spline editing.

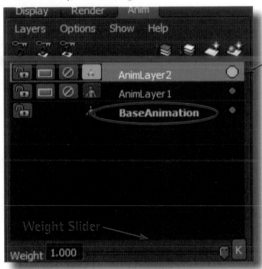

Green = layer currently being keyed (possible for multiple layers to be keyed simultaneously)

Weight Slider

HOT TIP

When working with layers, lock the BaseAnimation to keep it from getting accidentally keyed.

When we use layers, any animation we've done before the first animation layer was created will be labeled as BaseAnimation in the editor. BaseAnimation is not actually an animation layer, so we can't adjust its weight or turn it off.

Creating animation layers stacks them on the base layer. As far as Additive mode layers go (which is the default), the order doesn't really matter and the results should look the same. Override, the other mode, does take the order into account. When we set a layer to this mode, it essentially mutes any animation on layers below it that share the same controls/attributes. Animation above an Override layer will be added into the end result.

Override Layer (bold)

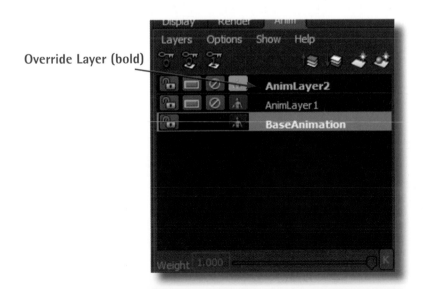

Animation Layer Basics

NOW THAT WE UNDERSTAND how animation layers work, let's see in Maya the example that was just illustrated. The Translate Y curves are exactly the same as the previous pages' example to keep things consistent. You'll be able to experiment for yourself and see how the weighting of a layer affects the animation. Weighting can also be animated just like anything else, so curves can have different amounts of influence throughout an animation, continuing to expand the possibilities. Finally, layers offer some nice organizational colorizing, complete with different colored ticks in the timeline, which can be a lifesaver if you're using many layers.

After this cheat, we'll revisit the facial animation we did in the previous chapter and continue to improve it, as well as create some new variations.

1 Open layerExample.ma and switch to front view. Right now only the BaseAnimation is active, which is the ball translating in X from left to right.

4 Re-mute Layer1 and unmute Layer2. You can see the translate Y curve from Layer 2 in the illustration at work.

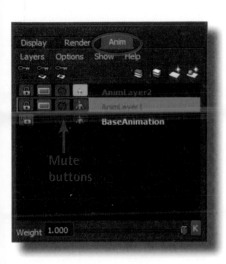

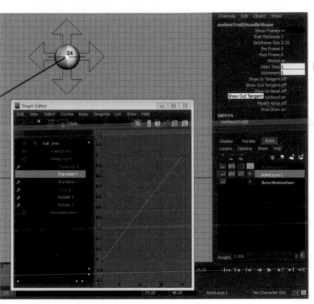

layerExample.ma

2 In the Layers panel, switch to Anim layers. There are the two layers above the base, with the same animation as in the example we just talked about. Currently both layers are muted.

3 Click the Mute button for Layer1 to unmute it. Our translate Y curve from the illustration is now active and the ball travels upward. Muting is a great feature for comparing how different curves affect the end result.

HOT TIP

If you have lots of layers and the Graph Editor is getting crowded, right click in the Graph Editor's left panel and select Animation Layers Filter > Active. Now only the active layer's curves will appear.

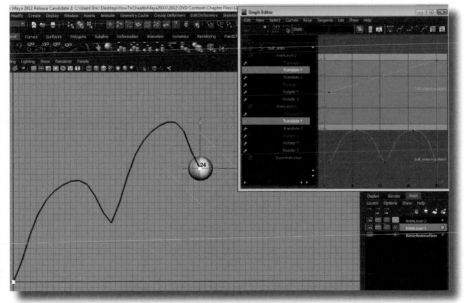

5 Unmute both and they are added together in the final result. You can see that there are two separate Translate Y curves in the Graph Editor, separated by their layers.

Anim Layer Basics (cont'd)

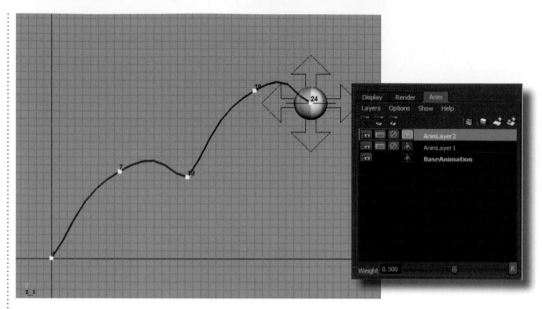

6 Select Layer2 and move the weight slider down to .5, or 50%. Now the peaks of the Layer2 Translate Y curve are half of what they were. Remember that we haven't changed the actual curve at all, only the amount of it that is combined into the final result.

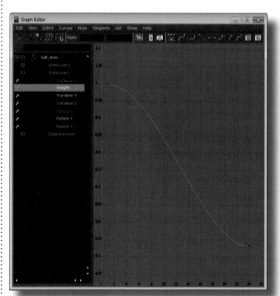

8 The K button next to the weight slider keys the weight attribute. You can set a layer's weight to different amounts throughout an animation. Once you set a key on it, a curve called "Weight" will appear under the layer's name in the Graph Editor, which you can edit as normal.

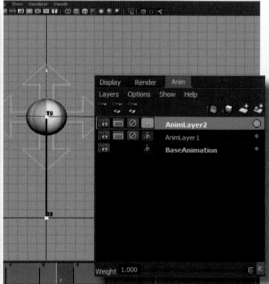

9 Right click on Layer2 and select Layer Mode > Override. The name turns bold and the ball only moves up and down. Override causes a layer to not evaluate the layers below that have the same controllers. Since the ball's move control is animated in everything below, they are overridden.

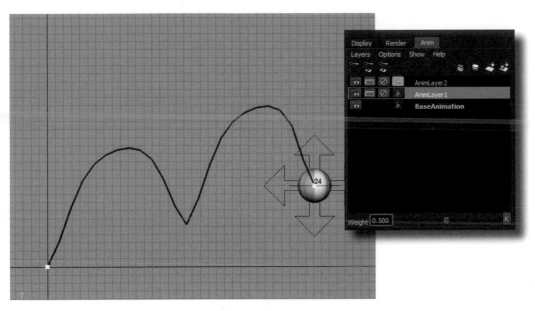

7 Set Layer2's weight back to 1 (100%) and slide Layer1 to .5. Now the ball only reaches half the height it used to at the end, but the bounces are back to their full amount.

HOT TIP

A layer in override mode mutes any layer below that has the same controller/ attributes, including the BaseAnimation. You can put variations on separate override layers, and mute back and forth to compare.

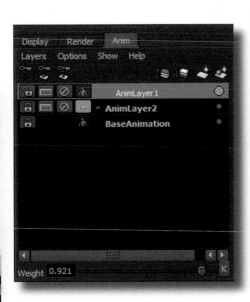

10 MM drag to reorder layers, and the lock button protects them from being keyed or changed.

11 Right click on the colored Ghost button to set the layer's color. This will make all the key ticks for that layer in the timeline the color you choose. Clicking on the Ghost button will also enable ghosts for that layer in the color as well.

Creating Variations

ONE OF THE COOLEST THINGS about Animation Layers is they give you freedom to try new things without messing up what you've already done. This is especially useful if you're doing work for someone else, and they're undecided about which direction they want. Rather than having to save multiple versions of a scene and jump back and forth, you can keep everything in a single scene, yet separated the way you see fit. Better yet, I've been in plenty of situations where I've shown three or four versions, and they liked something from each. That can be a nightmare to put all together sometimes! Animation layers eliminate all of these hassles.

We'll open the facial animation from the last chapter, and pretend that the director likes what we've done, but wants to see what it looks like if his body moves are a little bigger and more exaggerated. We'll use layers to augment what we already have, and switch between the versions with a click of the mouse.

1 Open variations_Start.ma. Select the body control and in the Anim layers panel, click the Create Layer from Selected button. This automatically puts the control into the new layer. Name it bodyExaggerate.

4 At f22, key the body up, pushing his peak higher.

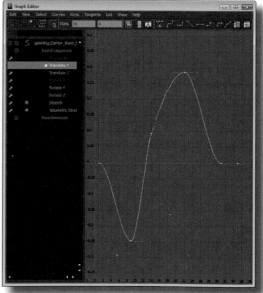

5 At f31, the new Y curve goes back to zero. Continue to tweak the curve until you're happy with his up/down motion.

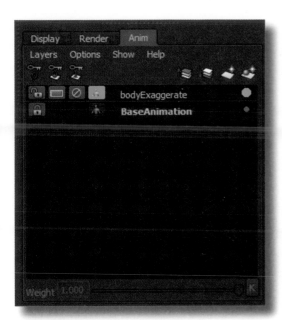

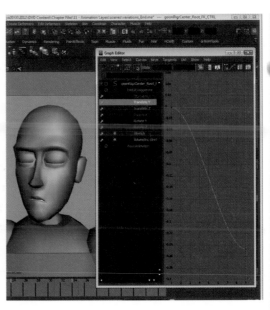

variations_start.ma
variations_end.ma

2 Click the lock button on the BaseAnimation so we don't accidentally alter our original. Then right click on the bodyExaggerate layer's Ghost button and change its color.

3 In the new bodyExaggerate layer, key the body at f01, then give him a bigger dip downward in Translate Y at f09 so his body arcs downward before it travels up.

HOT TIP

If you need to add or remove controls to/from a layer, select the controls, select the layer, and right click and choose Add (or Remove) Selected Objects.

6 I also pushed him screen right more in X to go along with the bigger Y movement, again zeroing out at the end of the motion.

7 He now has a bigger body movement and we can switch between it and the original simply by muting the bodyExaggerate layer. If we wanted to see something between the two, adjusting the layer's Weight will work beautifully.

281

Creating Variations 2

SIMPLE VARIATIONS, like we just did, are pretty straightforward. But sometimes it's useful to start with animation we've already done and alter it in a new layer. This lets us use the original curve and change it where we need to, while still keeping the original version to compare. Maya makes this a simple process, and it can be very powerful when wanting to see subtle variations in an animation.

In this exercise we'll pretend that the director wants to see him close his eyes when he raises his head to make him a little more arrogant. He'll keep his eyes closed until he comes back down on "to say." First we'll extract the original animation on the eyes and put it on a new layer, then copy that layer again for another version to make changes on. When you extract animation, you remove it from the original source, BaseAnimation, and place it into a new layer. Copying the extracted layer lets us keep the original, while having a duplicate to make any adjustments on. Then we'll use the Override mode so only one version is played back at a time.

1 Open variations2_Start.ma. Select the Goon's right and left eye controls and in the Layer panel menubar, select Layers > Extract Non-Layered Animation for Selected Objects. This takes the eye animation and places it onto a new layer.

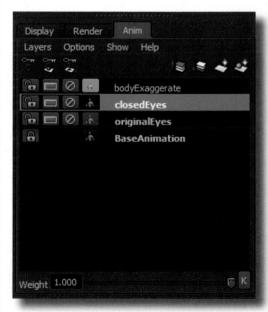

4 Name the new layer closedEyes and choose a new color for it. You can also lock the BaseAnimation and originalEyes layer to keep them from being accidentally changed.

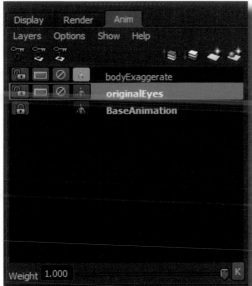

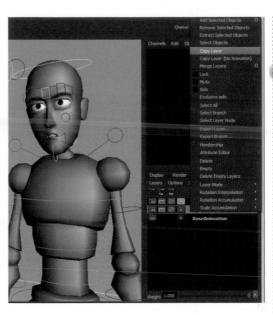

variations2_start.
ma
variations2_end.ma

2 Rename the new layer (double click the name) to originalEyes and choose a distinctive color for it. This is where we'll keep the original version of the animation. Note that extracted layers are Override mode by default (name in bold).

3 Right click on the originalEyes layer and choose Copy Layer to make a new layer (in Override mode) with the same eye animation.

HOT TIP

Instead of extracting, you could have also just copied the curves from one layer to another in the Graph Editor. This keeps the curves on the BaseAnimation. It's just personal preference to separate the variations into layers for organization, hence the method here.

5 On the closedEyes layer, adjust the eyelid curves so they stay shut until f24 or so.

6 Since the eye layers are both in Override mode, you just need to mute the closedEyes layer to see the originalEyes animation. Remember that an Override layer cancels out any of the same controllers/attributes below it.

Layers for Texture

THE ANIMATION IS LOOKING quite a bit better with our recent additions, and we can instantly go back to the original version at any time. Such is the power of layers. Yet it still needs a little something. A little shake when he raises his head and closes his eyes will add a nice bit of texture.

Creating layers to add in texture is a technique that can save you tons of work, especially if working for a picky or indecisive director. It's easy enough to add in the headshake as normal, but if you're then asked to tone it down or take it out, you have to go back in and edit the original curve quite a bit. Using a layer for the shake, you can simply turn the weight down until they're happy. And best of all, it makes your curves simpler to work with. If you were asked to start with the head rotated further in Y, you can simply adjust the original curve while the head shake stays the same in its own layer, rather than having to tweak where Rotate Y starts and all the shaking keys after it.

In short, layers have lots of uses and you'll figure out plenty more as you continue to use them and tailor them to your workflow. Happy (easier) animating!

1 Open texture_Start.ma and select the head control. In the Anim layers click the Create Layer from Selected button. Name it headShake and give it a unique color.

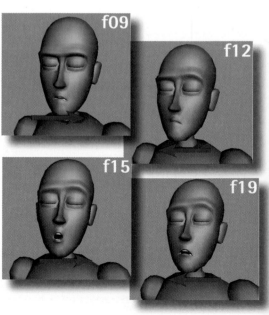

4 The subtle shake.

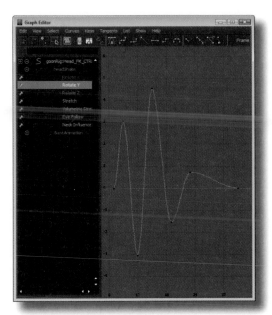

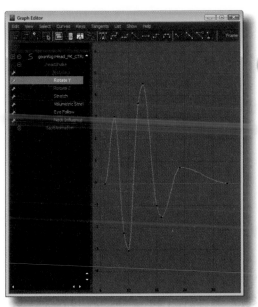

texture_start.ma
texture_end.ma

2 In the headShake layer, starting at around f07, rough in a back and forth "no" movement in Rotate Y as he raises his head.

3 Work with the curves until the shake looks good to you. I added some more ease in on some of the shakes.

HOT TIP

Layers can be parented to other layers. This isn't like parenting with props or anything though, it's simply Maya's way of organizing layers, like folders in Photoshop.

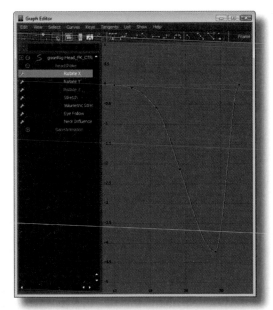

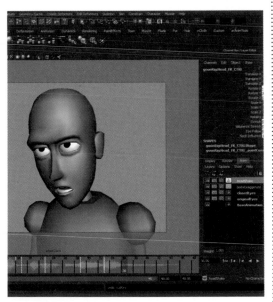

5 With the bigger movement in the body, I noticed his head needs to drag more in Rotate X. Add that in on the headShake layer, or put it on a new layer if you like.

6 Now you can really tweak things to your heart's content. Using the layers and their weights, experiment with different amounts of head shake, body exaggeration, eye versions, and anything else that you want to try!

Your Demo Reel:
New Guidelines for a Changing Industry
by Kenny Roy

THERE HAVE BEEN MANY demo reel guides written over the years. However, the industry is changing so fast these days that an updated guide to creating the ultimate demo reel is in order. Use this guide if you are sprucing up your current reel or if you are creating your first reel as well. The advice given here is written in part as an animator who's worked at the largest studios on major films, but also in part as an employer myself. Having made the transition, I have some advice I think you'll find handy.

The first rule that is changing rapidly is the rule about how often to apply to a studio. Back when I started in this industry, it was common that a studio would keep your reel on hand for a year or longer, and that if you fit a particular project, you would be contacted by the studio. With a huge influx of students from schools entering the market, the sheer number of applicants has made it so the major studios are too inundated with reels that arrived that week to really take the time to hunt down candidates that might have shown promise a year ago. If you are one of these students, it makes sense that you will want to send your current reel as soon as it is ready. On the other hand, if you have a reel that garnered no responses the first round of sending it out, it's time to really consider how the industry has changed. This change means you should spend very little time polishing old work on your reel in lieu of creating new work. The reason is, you can send a new demo reel into a studio as long as it has been over two months since you sent the last one, and you have at least two major new pieces of work on the reel. A 10+ second multi-character dialogue shot would be considered major, as would a character modeled, textured, rigged, and animated in a few short 3-5 physical tests. A flying logo animation, particle simulation created from default settings, or mocap editing would not qualify.

Studios want to know that applicants are constantly bettering themselves. They want to know that, on the job, you are concerned at all times with creating the greatest result you can. Constantly updating your demo reel is a great way to demonstrate that you are familiar with the rigors of the job and are ready for production. So remember, wait to resubmit your reel for at least two months and until you have at least 20 seconds of new, polished animation on your reel; otherwise send it as often as possible.

The second change that is happening in the industry is again due to the large influx of students graduating from school. Playblasts will no longer suffice, unfortunately. The reason is that many animation curriculums start with a general CG education in Maya, then move on to the finer points of performance and character animation. While it is debatable how well this prepares students for the larger studios where specialization is essential to competing, this situation does change the rules for an animator's demo reel somewhat. Since only a small percentage of the available jobs in this industry are in major 1000+ employee visual effects and feature animation powerhouses, the small-to-midsized studios are enjoying the benefits of having animators that are more generalists, and more well-rounded. Again, while most high-end projects need the kind of expertise that typically only an animation specialist can deliver, you need to cope with the fact that your competition may know how to model, UV, texture, rig, light, and write MEL script. If your demo reel is a series of grey-shaded playblasts, it will take a serious amount of disparity in the animation quality for a potential employer to overlook the fact that you have no generalist skills. I know from owning a boutique studio that I can relax just a little bit if I know that a generalist that I can hire based on their animation quality alone will come through in a pinch when I need help on other areas of the pipeline. So, to compete in the largest pool of the animation industry (small-to-midsized studios), light and render your animations for your demo reel at the very least. Spend a little time finding rigs to animate with that have nice textures and shaders, and experiment with lighting setups and render settings just a little bit. Spend the most time polishing your performances, but don't be left behind because of your boring playblasts.

Since the animation industry only gets more competitive, your reel should be even more specific. This is an old demo reel tip, but it is even more important now. Professionals used to say, "Your demo reel should match the work you are applying for. Don't send animations of gory insect-robots to a company that makes fluffy animations for children's games." This is still applicable, but you should realize that

you are probably competing for a job against people that have some VERY specific animation on their reel. Case in point: one of the animators on King Kong was a lighter before that film who turned in a reel comprised of a dozen or so gorilla tests. Naturally, with so many examples of gorilla animation on his reel, he was a shoe-in for a spot on the animation team. One of the lead animators on that film who worked on the sequence of the brontosaurus stampede had just finished a film in which he worked on a stampede of elephants. Employers truly do cast their animation. So what can you do to be more specific? Follow the trades and visual effects blogs for news as to which films are ramping up their animation and create a short piece of animation tailored specifically for that project. It is not too hard to find news on major studios' websites as to what projects they have coming up. Best-case scenario, tailoring your animation tests will put you in the lead position for a job on a specific show; worst-case scenario, your reel just got updated with more, fresh work!

Another guideline has to do with demo reel length. Most advice out there right now says to put all of your best animation on your reel, and to keep it under two minutes. This could be a problem if you just graduated. If you graduated from a popular school whose rigs are very well known, employers are already getting a little tired of seeing the same characters over and over. Even at the expense of demo reel length, it is a good idea to get original-looking animation on your reel. Many deformable rigs are available online, which is a good start to get a unique look to your reel. This also means that your bouncing ball and flour-sack tests should be the first thing to go in lieu of time. I've heard of animators being hired from a reel that is only :30s long. Speaking as an employer myself, I can say that it is much better to have a very short reel of consistent quality than an even marginally longer one with different qualities on display. Why? Because I know that the animator can do at least what I've seen. If older work is on the reel, I start to think what I'm seeing might be what the artist can achieve at most. I will ask an animator whose reel is too short but has great work on it for some more supplemental material, or if they would be willing to do a test for the work. Definitely keep the reel under 2 minutes though; that rule still applies!

To DVD or not to DVD? Ten years ago, a DVD was a must for an animation applicant. Today, however, normally a digital file will suffice. You have to call or email the recruiter at the company you are applying to and ask them what they prefer. You will find that most studios prefer digital files these days; we work with digital recruiting databases, and the ability to link your demo reel file to a clickable

link on your recruiting file saves everyone that is part of the hiring process valuable time. DVDs also take up space, can deteriorate or stop working, may have region or format issues, as well as cost money to produce and ship. It's no wonder they are falling out of style. What this means for you, however, is that you should learn to compress your demo into a file that is high quality but small filesize. H.264 compression is a standard that nearly 100% of PCs and Macs will have no trouble playing. Play with bit rate, compression quality, image size, and sound codec to keep your reel under 50mb for a "high quality" version, and under 10mb for a "low quality" version. In your email to a recruiter, give them both links to a fast URL they can download them from, and remember to specify each version's filesize.

Finally, never put anything on your reel that you don't have permission to show. This is another one of the old tips that still pertains. Ten years ago, I remember it was commonplace to sneak out a couple of shots to show recruiters. The thinking was "I'm only going to show it to the recruiter, what's the harm?" Well, now that the industry is so full, and the world is getting smaller and smaller with communication between studios, you are going to be in a lot of trouble if you sneak even your playblasts out of the studio. People will talk, and you will be avoided. In the time of DVDs, it was a little different because you could be sure to take the DVD with you when you left the interview. I even had a couple interviews like that early in my career. But now that we are sending digital files, you must remember the internet is forever; sending a digital file that you do not have permission to send is inviting a world of trouble.

The old guidelines have been repeated over and over, and they are still very good; only put your best work out there. Don't copy a well-known character. Don't use offensive imagery or themes. Don't blast heavy metal music; use music that is very low-key, if any at all. Clearly label your reel with your name, phone number, and email at the head and the tail. Don't bother recruiters every day with phone calls or emails; they WILL contact you if they are interested.

As the animation industry changes at a rapid pace, however, you must adapt and learn to work within some new guidelines in order to be competitive. Remember just one thing: no amount of demo reel magic will improve the animation quality, and the quality alone will get you the job. Focus on improving your craft of performance, polish your workflow, and then do what the rest of us do: send in your demo reel and cross your fingers!

Chris Williams

CHRIS WILLIAMS IS AN ANIMATION SUPERVISOR at Sony Pictures Imageworks where he has worked on a variety of projects encompassing both visual effects and character animation. His credits include the *Spider-Man* trilogy, *Open Season*, and *Cloudy with a Chance of Meatballs*.

HOW DO YOU APPROACH FINDING THE BEST ACTING CHOICES FOR A CHARACTER?

This to me is the hardest part of the job. The thing with acting choices is that they are very subjective in nature. There are so many ways to approach a shot. Any or all of them could be right and what one animator thinks works might not land for someone else. And who knows. Maybe the director is so clear on his/her vision, I don't need to make any choices at all! But if it's up to me, I start by listening to the audio track over and over (and over) again. My goal here isn't necessarily to envision the whole shot and lock it down. Instead I'm trying to establish a handful of strong poses that really define the performance to act as anchors for the shot. I appreciate that there are a lot of animators out there that like to act out and thumbnail the whole shot from the get go, but I find that by dropping in just a few poses, I get a much more organic workflow. My end result is never what I first envisioned because I allow the shot to evolve. So although this is the hardest part for me, it's also the most rewarding when I really see the shot come to life.

WHAT'S THE MOST CHALLENGING SHOT YOU'VE EVER WORKED ON AND WHY?

This is a tough one. I feel like any shot can be hard in some way or another. But I'm going to go with a shot that was done for the extended Spider-Man 2 DVD. The shot was initially meant to be about 30 seconds of intense fighting between Spider-Man and Doc Ock, and although it was subsequently broken up with new camera angles, I still remember it as one big challenging shot. Here's why.

Firstly, the initial concept was to have a fairly static camera moving along the side of the train. How does this make the shot hard, you ask? The static camera meant I had nowhere to hide. The shot had to look realistic and the choreography had to be exciting because I wasn't going to benefit from some generous camera shake or big moves to conceal shoddy animation.

Secondly, the choreography. The trick with these fight shots for me was making sure I got the audience to look exactly where I wanted them to look. I guess that doesn't sound too hard, but if you have a bunch of tentacles moving around, you can get yourself into trouble fairly quickly because your eye will jump around in all directions. When Ock grabs Spidey's hand for example, I made sure the tentacle reared up and held a strong silhouette before grabbing while the foot tentacles waited for their mark, so to speak. Only once I got a read on the tentacle grabbing the hand did I move the foot tentacle down onto the train. And only then did I rear up the right tentacle to grab the other hand. Essentially, the challenge was to find the balance between keeping it exciting and ensuring the action was clear and readable. I need to guide the audience on where to look so they can absorb the action on a first pass.

Thirdly, the tentacles. Need I say more?

The fourth element was the cloth. Although I didn't have to animate Doc Ock's jacket and vest, I still had to give the cloth team enough room to work their magic once my animation was done. What this meant was making two characters appear to be grappling and fighting, but in terms of the actual geometry, they could never touch. So when Spidey is straddling Ock and pulling him up by the collar, he isn't actually sitting on the geometry, nor is he grabbing the collar. It all had to be cheated to camera. Think of it as WWF wrestling. They look like they are fighting, but they never really hit each other. Take that, wrestling fans! Essentially, it's another layer to manage as you try to get a hard shot out the door.

Finally, I have to say the schedule. It was short! I never really felt I had enough time to begin with, but when they changed the camera angle for two sections, it got even crazier trying to rework the animation! Still, I think it all worked out. Hopefully you have a copy kicking around to check it out.

WHAT IS YOUR TYPICAL WORKFLOW FOR A SHOT?

That depends on the style of animation. If I'm doing a realistic visual effects show, I tend to work straight ahead. Pose to pose just doesn't work for me when I'm trying to assess whether a character has the appropriate amount of weight or velocity, etc. I

need to see it in motion all the time to know whether or not the speed accurately represents real-world physics. Consequently, the question I constantly ask myself while I'm animating is "Does this look real?". Seems like an obvious one, but it forces me to look very critically at my work. I think it's possible to get romanced by a cool pose or some fancy choreography, but if it doesn't look realistic, and I'm meant to be animating something from the real world, then I get a big old fail on the shot.

For a character like Spider-Man, I always approached him like he was a stunt double. That meant no shortcuts where I would allow myself to say that he has super-human speed because he has super-human strength. If he moves too fast, he looks light. For a swinging shot, I start by animating his overall body mass and some rough key poses. The goal is to simply get him moving at the correct speed. Only when I was satisfied with that would I move onto finessing the keys poses, transitions and inbetweens required to bring him truly into the real world. The final polish stage is where I will throw in all the texture for the shot. Texture might be a slight body adjustment, or a little shake on a leg to break up the smooth feel of the shot. Think of a gymnast on a beam. Usually, they do very small adjustments with their limbs so their core can stay balanced. In addition to breaking up the shot, it also provides some more real world detail that can really take your shot to the next level.

For a character shot, I work a bit differently. Like I mentioned earlier, I spend a lot of time in the beginning simply listening to the audio performance and imagining what the character could be doing. Eventually, certain acting choices become very clear to me and that's where I start. I don't worry about blocking the whole shot with breakdowns because I personally like to allow the shot to evolve as I'm working. Simply put, throwing in a few solid posing choices and playing them with the audio track always opens new and unexpected avenues for me to pursue while animating the shot. For all of us, getting started is often the hardest thing to do because that blank canvas can be pretty intimidating. So dive in with as few poses as possible needed to define the broad strokes of the performance. Even two or three will be fine. Then allow your shot to grow.

One thing I don't do at this stage of a character shot is worry about facial poses or lipsync. There are two main reasons for this. Firstly, bad lipsync distracts me and I know that if I try to block something in, my focus will constantly drift into the smaller confines of the face. But perhaps more importantly is the idea that you can really sell the emotional feel of a shot with good facial poses. Just by having a sad face on a default pose will make the audience read the character is sad. By not including the expressions, I'm forcing myself to make the body poses convey as much of that

292

emotion as possible. If I can sell the emotional state of the character without facial poses, then I know that when I do finally get to the face, the shot will just get that much stronger.

Once I get a strong pass of key poses and breakdowns, it's time to convert my shot from stepped mode to spline. It's always painful, but I try to manage my suffering. The first thing I do is break the shot up into manageable chunks. You can usually find a beginning and an end to a specific action, or perhaps a line of dialogue. I'll key all on either side of that chunk, convert to spline and leave the rest stepped. By doing this, I never get overwhelmed by the amount of massaging I need to do. Baby steps. When I'm satisfied with the first portion, I'll move on to the next section and so on. Once this phase is done, I should have a pretty solid timing and performance pass with the addition of facial expressions and basic lip sync. Then, just like I do with my visual effects work, I layer in the texture. Essentially, I always layer from broad action to detail work with the idea that my detail work should plus an already successful shot. I never want to use facial work as a crutch for weak body and performance choices. Rinse and repeat.

WHAT DO YOU FEEL ARE THE MOST COMMON PITFALLS FOR BEGINNING ANIMATORS?

I think the biggest thing for me is that beginning animators try to cram too much into their shots. Quantity does not equal quality. This creates a couple of issues. Firstly, the shot gets a little muddy and the audience is unclear where to look, or the actions all feel rushed. But the larger issue is how hard the shot becomes to troubleshoot. By jamming all those ideas into your 5 second shot, how do you assess what's working and what isn't? What do you strip out to make the shot sing? So, I recommend layering up. Start with the basic concepts you are most attached to, then add the texture as you see fit.

LOOKING BACK, WHAT WOULD YOU HAVE DONE DIFFERENTLY AS A STUDENT?

I learned to animate the old-fashioned way with a pencil and paper. My issue was that I wasn't a fantastic artist. If you throw in my need to keep things on model, what you got was a student spending way too much time on the minute details of a character and not the broader elements of motion and performance. So if I could do it all again, I'd throw away the model sheets and animate with a grease pencil. Make sure your work is loose!

P.J. Leffelman

P.J. LEFFELMAN IS THE ANIMATION LEAD at 2K Marin. Prior to that he was a Senior Animator at LucasArts. His first foray into animation was at DNA Productions where he worked on *The Ant Bully* and two Jimmy Neutron TV specials, *The Jimmy Timmy Power Hour 2* and *3*.

WHAT'S A TYPICAL DAY LIKE AS A LEAD ANIMATOR ON A AAA GAME?

Every day is different, which is one of the things I enjoy so much about my job. I view my job as keeping things flowing so that everyone else on the animation team can do their jobs to the best of their abilities. That can mean that occasionally I don't get to animate as much as I'd like but I get to participate in different parts of the production process. Aside from working with the animators on a daily basis, the closest thing that happens on a daily basis is working with the game designers and engineers to make sure that they're getting what they need from us and vice versa.

WHEN DOING ANIMATION FOR GAMES, WHAT DO YOU NEED TO FOCUS ON TO BE SUCCESSFUL?

The thing that makes successful game animation in my mind is that the animation is efficient. Since gameplay is directly affected by our work, we have to work within constraints that make the game fun. Strong, readable poses that have really dynamic timing is what I enjoy seeing the most as both an animator and as a game player. A fine line that we have to constantly be aware of in games is how far to push personality and uniqueness in our gameplay animation. While it's of course important to convey as much personality as possible, if you veer too far away from the beaten path just in order to make a statement with the character it can very easily be lost in the fray of the game. For example, when we were working on an enrage animation

for one of our characters who is a teenage girl, we tried a variety of actions all centering around her specific character. We tried to stick as close to an angsty, pouty teenager as we could, and from an animation perspective it worked great. However, in game it was very difficult to read the action that this character was doing because it was so atypical and so far from cliche. We eventually tried a simple "Grrrrrrrr, I'm the Hulk and I'm mad" animation and it immediately telegraphed what we were going for.

WHAT IS YOUR TYPICAL WORKFLOW FOR A SHOT?

I always start every shot with as much research as possible. If it's a gameplay animation, I talk with the designers to find out what their gameplay goal is with the action. I follow that up with the engineers to find out if there's any oddities in the system that I need to account for. If it's a scripted scene, I talk with the level designers and artists to find out what they know in order to make sure we're all on the same page and that we're taking into account all of the wacky things a player in a game can do. After I know how my work is going to be working in the game, I start thinking about how the character would perform the action and if that's consistent with what other people have been doing with the character. If it's a locomotion animation, I tend to just act it out and shoot video of it. If it's a combat animation, I'll look up some video of fight scenes or a particular martial art to come up with a more unique or interesting looking attack than I would do on my own. Once all of my thinking has been done, it's just a matter of animating the shot. Gameplay animations are generally 20-40 frames long so a few poses later, you can test the animation out in game to see if it's hooking up properly and is worthwhile to take past blocking. I'll get feedback from my co-workers and, after that, it's just a matter of putting in the breakdowns and making it look pretty.

WHAT ARE THE DIFFERENCES BETWEEN ANIMATING FOR FILM AND GAMES?

I think the biggest difference is that film has a luxury of time that games don't have. The animation in games needs to be more direct in order to make the game fast and fun to play. For example, an attack animation in a game generally needs to get to the hit frame within 5-7 frames which doesn't leave a whole lot of room for anticipation. This forces a style where you have very fast and dynamic animations that have a more drawn

out settle. Another difference is how animations hook up. In film you have to worry about how your shot segues across a cut with the animator before and after you. In games, more often than not, your start pose has to be your end pose as well. So you have to come up with a fluid and natural way for that to happen which can be pretty difficult at times.

Another big difference is that games are far more collaborative when it comes down to the individual animator's role. It's expected that a game animator talks with the designers or the engineers when they come across a problem. They're expected to attend meetings where they have feedback on parts of the game aside from the animation. When I was in film, it was very much get a shot from layout, animate it, hand it off to lighting and that's the last I ever heard about it. In games, ideas are bounced around a lot more freely given the iterative nature of the process. If you can't work in a group setting, it's very difficult to work in games.

WHAT'S THE MOST CHALLENGING THING YOU'VE ANIMATED AND WHY?

It's the shots that look the easiest that always end up being the hardest. There was one shot on *The Ant Bully* that wasn't anything special, just a wasp flying toward camera with the other characters on his back. Dailies after dailies, I couldn't hit the path that the director was looking for. There were some layout changes which made me rework the shot a couple times as well. Eventually I got the shot done through persistence. The weird thing about the shot is that the characters on the wasp's back never made it past a blocking plus stage. However, since they really weren't the focus of the shot, it didn't really matter too much. That's a shot to this day I still just roll my eyes at when I look at it.

HOW DO YOU APPROACH FINDING THE BEST ACTING CHOICES FOR A CHARACTER?

Just like everything else in animation, it comes down to research. You need to gather all the information you can that tells you about the character, where he's been, where's he's going, what his goals are, things of that nature. You then take all of that information and distill it down to something that you can relate to, drawing on the various experiences you've had in your life. Drawing inspiration from how other people have handled a similar acting challenge is a good place to start, but a lot of why animators animate is to get to act and show their unique take on a situation. If you can take a situation and realistically place yourself in it, and if that lines up with

the director's vision, then you're in good shape.

The other thing that should be encouraged more is to check in with other people. Choose a co-worker who impresses you and ask them how they'd work through the shot. Everyone around you has their individual take that's worth considering and they may offer an acting choice that you just wouldn't come up with. Whether or not you use someone else's idea in full, in part or not at all, it will help you to look at things from other people's perspectives.

HOW DOES MOTION CAPTURE FACTOR INTO YOUR WORK?

We used motion capture for one of the characters in our game. Ultimately though we ended up redoing most of the gameplay critical animations by hand. The gameplay is directly affected by our animation so if a character is moving too slowly, it's way easier to adjust hand-keyed animation over mocap. Mocap is great for getting something that looks more or less complete really quickly. However, if you're trying to force it to be something different, like slowing it down, changing poses, altering the acting, then it's really best to just hand animate it.

What mocap excels at is capturing ambient human behavior. If we need a variety of idling behaviors, it's far quicker to capture people actually milling about than it is to shoot video reference and try to layer in all of the subtlety that people inherently have.

WHAT ADVICE DO YOU HAVE FOR SOMEONE WHO WANTS TO WORK AS AN ANIMATOR IN GAMES?

One big thing that someone should realize is that they don't have to be a video game nerd to work in games. There are people at both ends of the video-game playing spectrum at work. What everyone shares though is a desire to work together to make a really fun and entertaining experience.

On the animation front, we're looking for people who are just good at what they do. If you are great at acting, we'll find a use for you. If you are great at physical action, we'll find a use for you as well. If you are really technical, we'll find a use for you. If you're a rocking 2D animator that hates computers, we'll find a use for you as well. A shorter way of saying all of that is that we're not looking for any specific quality in an animator. We're looking for people that have good ideas and do good work. If you can bring that and you're up for learning how your skills can work in the game we're working on, quite likely you'll get a job offer.

Sean Burgoon

SEAN BURGOON IS A TECHNICAL ARTIST at ILM, and was
previously the Lead Technical Artist at Cryptic Studios where he
has served as an Animator, an FX Artist, a Technical Artist, and a
Combat/Gameplay Designer. He has worked on *Champions Online*,
Star Trek Online and other internal projects. Sean is the creator
of the Goon Rig used throughout this book, and it's also available
free via his website, www.seanburgoon.com. Sean also writes
and continues to work on a variety of creative projects in his free
time.

WHAT'S YOUR BACKGROUND AND HOW DID YOU END UP WORKING IN ANIMATION?

I always loved animation, but my first love as a kid was always computers, and
specifically video games. I learned some simple programming in BASIC back on my
Commodore 64, and just kept learning from there.

Educationally it was always kind of assumed I would be a lawyer, so I ended
up getting my degree in Political Science from the University of California, Santa
Barbara, with the intention of going to law school. That didn't exactly work out
(school wasn't really for me), so after I graduated I started thinking about what I
could do to make some money, and maybe actually enjoy my job. I knew I still loved
animation, and I was still pretty good with computers and simple programming
despite my liberal arts studies, so I decided to take a stab at getting into 3D
animation.

Not having easy access to any rigs, I was forced to make my own from day-one,
and so that became second nature to me very quickly. Once I realized I needed some
formal animation training, I signed up for Animation Mentor, and they helped get
me over the hump to get my job as an Animator at Cryptic. I wound up doing a lot
of our R&D work for animation, and a lot of the more technical tasks, in addition to
animating, and so over time I slowly evolved into my current role as Lead Technical
Artist. I handle all of our rigging and scripting in 3dsmax, as well as doing some
actual programming when necessary.

WHAT'S A TYPICAL DAY LIKE AS A LEAD TECHNICAL ARTIST?

At our studio there really isn't a typical day for a Lead Technical Artist. Part of that is due to the nature of the game industry, and part of that is just due to the nature of my specific skills and roles at Cryptic. My days are generally split between talking to various members of the software and art teams about features we'd like to see, or issues they're having, troubleshooting any problems that do arise, and managing the rest of the technical art team (handing out and reviewing work, as well as assisting with any issues they might run into).

Rigging actually becomes a less common part of the job, in my case, because I've managed to get almost all of our rig-types setup with auto-rigging scripts, so any time a new humanoid rig is needed, we just run a script on the skeleton and a rig is spit out, all ready to go. Same goes for quadrupeds, and a variety of other creature types. Aside from the general tool development and troubleshooting, we also spend a good deal of time optimizing or making new materials (shaders) for the artists to use, or assisting the art team with optimizing their existing assets and levels. Overall the main goal is to make sure the art team is able to efficiently create assets, focusing on the art and not a complicated pipeline, and that once those assets are in the game that we still meet our performance guidelines. That's one trick with games vs. film. In games, you can make the best-looking art in the world, but if it doesn't run at 30 frames a second then it's not going to work.

HOW DOES YOUR ANIMATION SKILL AND KNOWLEDGE CONTRIBUTE TO YOUR WORK?

For anyone making animation tools, actual animation experience is incredibly valuable. Having used rigs, and done the sorts of things your animators are trying to do, gives you a lot more insight into what sorts of things will make their life easier. Sometimes, because of the combination of animation and technical skills, you'll actually come up with ideas the animators never would have thought to ask for. It also really helps raise the quality of tools you create. It's one thing to get a request for a tool, or come up with the idea for a tool, but having in-depth knowledge of how an animator would want to use it, minute to minute, is extremely important. Animators are busy people too, and generally having one swing by to give constant feedback on

how your rig or tool works isn't even close to practical. Being able to put on your animator hat and take a critical look yourself is huge.

HOW DO YOU APPROACH LEARNING NEW TECHNIQUES AND SKILL SETS?

I always try to keep a balance between what I'm doing at work, and the personal enrichment projects I work on at home. There is always a tendency at work to fall into a routine, especially when you're in the middle of a production cycle and everything is going reasonably smoothly. You may not have a new, unique challenge every day to keep you on your toes, so what I do is provide those challenges to myself at home. If I'm doing a lot of programming and scripting at work, I try to push myself to do more art at home, and vice versa. Also, for every side-project I do, I try to make sure there is at least one component that is something I've never done before, whether that's low-level graphics programming or a different type of rig for a character. First off, it's fun (and if it's not, you might be in the wrong line of work), and second, it really helps keep your mind fresh and ready to deal with whatever challenges randomly crop up at work down the line.

Other than that, when I'm trying to actually learn something new, it's a lot of research to see how other people have solved similar problems, followed by a lot of guess work, trying to come up with a way to improve on what I've found, or better adapt it to my needs, and then a whole lot of failing forward. The biggest trick for me is to be ready to fail a few times. You will screw up, you will go down a path and then find out it's fundamentally flawed and have to start over. That's all just a part of learning something new. Don't over-plan, just start doing and trying new things. Some of it will work, some won't, but in my experience, you learn a lot more from having to fix something you messed up the first time than you do from any amount of thinking about it beforehand. Obviously you need to balance the risks you take with the schedule of the project you're working on (if you're a month from release, you should probably err on the side of caution), but if you're in an R&D phase, or even better, just working on a casual project for your own benefit, constructive failure can be one of the best teachers around.

WHAT ADVICE DO YOU HAVE FOR ANIMATION STUDENTS?

My advice is, learn to take criticism! Force yourself to enjoy it. Even if you think you're a better animator than the person critiquing your work, the fact is they see

something they think could be better, and unless you're Milt Kahl, chances are it could be. I say this because taking criticism is something I have always been bad at, and was bad at for a long time. I hated getting it, especially from people who weren't animators themselves. What I finally learned, though, was that the more people tore my work apart, the better that made me, and even though I ended up shifting into a more technical role, if I ever decide to push back into animation, the first thing I'm doing is getting a bunch of people to tell me everything I'm bad at. It's painful at first, but it works wonders.

Also remember, just because someone tells you to change something doesn't always mean you have to do what they suggest. If it's your lead animator telling you, or director, then, yes, do exactly what they say, but if it's a peer, or any random person off the street, listen carefully to what they are saying, and then think to yourself, "What makes them think there's a problem here?" Sometimes the person giving the critique won't know the best way to fix the issue, or even exactly what they're noticing, but 9 times out of 10, they noticed something. It's your job to do the detective work to figure out exactly what that is.

Aside from that, just make sure you enjoy what you do, because you're going to be doing it a lot. Animation, in games or film, as well as related fields like Technical Art, takes a lot of work and a real passion that other professions don't necessarily demand. You can't just phone this job in; it doesn't work that way. You need to be constantly practicing and evolving your skills and keeping up with all the new, hungry young whippersnappers pouring into the industry. If you love what you do, that won't be a problem, but if you don't, it might just drive you nuts.

Symbols